ART, CULTURE,
AND ENTERPRISE

We live in an age of priorities, not ideals. Under any form of govern-
ment, there is not enough money to fund everything worthy of
support. And why should the working-class taxpayer subsidize en-
tertainment for the educated elite anyway?

In recent years, the arts world has sought to defend its corner in
terms that tend to be smug and untenable, while free marketeers have
argued with increasing confidence that support for art and culture is
best left to the market place. Justin Lewis suggests that the question
we should address is rather different: what of cultural value is the free
market unable to provide? In so doing he confronts the issue of
cultural and artistic values head on, and attempts to rescue cultural
values from definitions that are elitist, unjust, and increasingly irrele-
vant. His assessment includes popular commercial art forms – TV,
radio, pop music, cinema, and video – as well as the more traditional
highbrow arts – drama, opera, and the visual arts. He also appraises
the 'community arts' and 'cultural industries' approaches to arts
funding, looking in detail at work in cultural democracy, arts market-
ing, and the promotion of culture as an economic strategy. He draws
examples from specific venues all over Britain, showing how innovat-
ive projects work in practice. He is thus able to make specific pro-
posals on cultural development at both a local and a national level,
and to provide a new cultural strategy for the 1990s.

Art, Culture, and Enterprise is essential reading for artists, admin-
istrators, and funders; students of the media, the arts, and popular
culture; and anyone interested in the future of public art and culture.

D0912640

ART, CULTURE, AND ENTERPRISE

The politics of art and the cultural industries

Justin Lewis

A Comedia book published by
ROUTLEDGE
London and New York

First published 1990
by Routledge
11 New Fetter Lane, London EC4P 4EE

Simultaneously published in the USA and Canada
by Routledge
a division of Routledge, Chapman and Hall, Inc.
29 West 35th Street, New York, NY 10001

Photoset and printed in Great Britain by
Redwood Press Limited, Melksham, Wiltshire

British Library Cataloguing in Publication Data
Lewis, Justin
Art, culture, and enterprise: the politics of art and
the cultural industries. – (A Comedia book)
1. Great Britain. Arts. Economic aspects
I. Title II. Series
338.4'77'00941

Library of Congress Cataloging in Publication Data
Lewis, Justin
Art, culture, and enterprise: the politics of art
and the cultural industries/Justin Lewis.
p. cm.
'A Comedia book.'
Includes bibliographical references.
ISBN 0 415 04449 9. – ISBN 0 415 04450 2 (pbk.)
1. Art patronage – Great Britain. 2. Arts – Economic aspects –
Great Britain. 3. Arts – Great Britain – Management.
I. Title.
NX705.G7L4 1990
306.4'7'0941 – dc20 89–24208

Dedicated to my mother, Shirley,
with love and thanks

CONTENTS

ACKNOWLEDGEMENTS

Many of the arguments and ideas I have tried to develop in the pages that follow are, of course, my own. I am, nevertheless, deeply indebted to those, who, through discussions, suggestions and criticisms, have helped me along the way.

My thanks go, first of all, to the series editor David Morley for all his suggestions, criticisms, and advice, and to the members of the Recreation and Arts Group of the London Strategic Policy Unit for their support. I am also indebted to the Recreation and Arts Committee of the LSPU and to the Community Services Department of Haringey Borough Council for supporting some of the research undertaken for this book.

While there are too many other people to mention individually, I would particularly like to thank Pete Sketchley for his inspiration, Lynne Wardle, Carmen Wilson-Palmer, Ingrid McBurnie, and Peter Reid for their help and support, and Dermot Killip, Phyllida Shaw, and Keith Allen for their collective wisdom.

The information and ideas presented here could not have been gathered without the help and co-operation of the many dynamic, imaginative, and thoughtful people working for cultural projects and venues all over Britain. My thanks and good wishes to all of them.

INTRODUCTION

We live in an era of priorities, not ideals. Under any form of government, there is not enough public money available to fund everything worthy of support. Money spent on art and culture needs, like everything else, to be justified against other areas of public subsidy. It is not good enough to protect your own corner of public expenditure without considering the consequences for others. An expansion of the budget for art and culture means a reduction of the budget for social services, education, housing, or some other area of public provision. Without a substantial increase in all forms of public spending, it is socially irresponsible to spend money on art and culture if it cannot be rigorously justified.

While this book argues that the cultural system provided by the free market alone is inadequate and limited, it acknowledges that the defence put up by the arts establishment against the free marketeers is smug and insubstantial. Why should working-class people as taxpayers, subsidize entertainment for the educated middle classes?

There are answers to this question, but I find them increasingly unconvincing. In the pages that follow, I shall suggest that the question we are forced to address in Britain today is rather different. What, of cultural value, is the free market unable to provide? In answering this I have tried to confront the issue of cultural and artistic value head on. This is something that many critics of current funding values have preferred to avoid; understandably perhaps, since the arts establishment has apparently captured the idea of artistic/cultural value and made it its own territory. We cannot, nevertheless, avoid a value system of some kind – how else do we decide what to fund? This book is an attempt to rescue cultural values from definitions that are, in practice, elitist, unjust, and, in the context of British society, increasingly irrelevant.

1

I shall be analysing and developing approaches that have been argued for elsewhere – such as community arts development and the cultural industries – and placing them in the context of an overall cultural strategy for Britain in the 1990s.

Although the arguments in this book are addressed primarily to Britain and based mainly upon British experiences, they are not parochial. They apply to many other western countries, whose mixtures of state supported and commercial culture are often based upon similar values and ideologies.

I should add, finally, that this is by no means a purely theoretical tome. It draws heavily upon the experiences of cultural projects all over Britain, and on examples of good practice that I hope many will find useful and inspiring. They represent, I hope, the future of cultural development in Britain.

1

BUT WHAT DOES IT MEAN?

THE 'WHAT IS ART?' QUESTION

With some resignation and great reluctance, I feel it is necessary to begin with this awkward and well-worn question. As questions go, 'What is art?' has not worn particularly well. Any glamour or spark it once had has become weighed down by layers of pretention and intellectual pomposity. For some reason, most writers or philosophers that I can think of have felt the urge to tackle it at some time or other. We have had the artist as genius, as superman, as revolutionary, as myth-maker or, more eloquently, as fragmenter of existing discourses. Not surprisingly, the question has become increasingly unfashionable. Like the monocle or flared trousers, people are liable to snigger when it appears in public.

It is difficult to deal seriously with the subject of art (or culture) without saying what you mean by it. There are, certainly, a number of ways of avoiding the question. One is to assume we (in the arts world) all know the answer, and carry on as normal. Another is to challenge that normality, and to promote a wider group of activities in the name of 'culture'. A third approach, related to the second, is to avoid talking about 'art' whenever possible. This approach, as Owen Kelly writes, is fairly common in the 'community arts'. In *Community, Art and the State*, he writes with frustration about a report which fails

> to even hint what it is that community artists actually *do*. There is almost no mention ... at all of the kinds of things which community artists might have been found doing. Instead, we are told they do it with children, that they are not especially concerned with what finally gets produced, and that it usually happens within a limited geographical area.

3

Replacing the word 'art' with 'culture' gives quite a lot more leeway, but doesn't really solve the problem. Geoff Mulgan and Ken Worpole have opposed traditional notions of what art is by promoting something else in its place – the cultural industries, or in other words, the 'forms of culture which the majority of people now use and through which they understand the world – radio, television, video, cable, satellite, records and tapes, books and magazines ...' (*Saturday Night or Sunday Morning*). This shift in perception is a very important one – suddenly, publicly funded 'art' becomes something far more than the minority pursuits patronized by organizations such as the Arts Council. The battle for the cultural industries really *is* a battle for people's hearts and minds, between the *Boys from the Blackstuff* and *The Price is Right*.

The problem with 'culture' as a term is the amount of space it opens up. In the *1986 Culture and Democracy Manifesto*, produced by members of the Shelton Trust, the authors use the word culture to indicate social activity that 'creates, communicates or sustains social value. However, we refer here only to those activities which predominantly create and sustain social meaning. We include in this all forms of public communication.' This moves us towards the complex range of activities dealt with by the discipline of cultural studies – a branch of social science that emerged from the Birmingham Centre for Contemporary Cultural Studies in the 1970s and early 1980s. The range of practices dealt with here is enormous, from literary criticism to the culture of mods and rockers.

This raises a serious difficulty. If we propose the public funding of 'culture' rather than 'art', how on earth do we decide which cultural forms publicly to fund? We might legitimately use the freedom of the term culture to fund people to roam around pubs and launderettes encouraging people to talk to each other. Not a bad idea, you might say, but if such an approach were taken to its logical conclusion, the public funding of culture would alter so drastically as to become unrecognizable. That, again, might be a good thing. What is certain is that it opposes so many dominant forms of thinking that it will not happen for a very long time.

This brings us back to the original question. Are there forms of culture or cultural practice that we can usefully designate as art? Is a pantomime art – and if it isn't, why not? It is possible to argue that the theatre is seen as artistic and the pantomime merely as entertainment because middle-class people go to the theatre while all sorts of people watch pantomimes; and since the middle class controls those defi-

nitions, it has elevated its entertainment to a level where it is seen as worthy of public funding. If most people were honest about their experience of the theatre, the argument runs, it usually fulfils many of the same functions as a night at a show – it entertains, it provides us with a social experience and something to talk about.

This is a very persuasive argument, and, although I have used it myself many times over the last few years, I have never been fully convinced by it. It remains persuasive nevertheless, if only because attempts to define the 'artistic' experience (using ideas such as 'creativity', 'self-expression', 'emotional response' or 'understanding something in a new or different way') invariably flounder in their generality. You can be creative washing up, express yourself by making love, respond emotionally to a friend's misfortune or understand the laws of physics in a new way. It is also true that, as the surrealists demonstrated, art is art when somebody says it is. A domestic object like a toilet only becomes 'art' because an 'artist' has asked us to define it in that way. This gives the definers of art – controlled by a middle-class establishment – a great deal of power.

Although definitions of art are in the end more or less arbitrary – no one is right or wrong – it is important to mark out the territory we are dealing with. Without defining the terms of this framework, it becomes impossible seriously to challenge the form and content of arts funding in Britain. This, I hope, will become clearer in the following pages, when the question of value is broached. The only way to avoid vague generalities or class-based definitions is to use a purely functional definition. This may be limited and a little loose at the margins, but at least it is serviceable. Art could then be defined as a cultural practice that involves the creation of a specific and definable object – a play, video, or piece of music for example. The function of that object is as a self-conscious, personal, or collective expression of something. This distinguishes bingo from ballet. It also incorporates fashion and film as artistic practices.

This definition is not particularly original or controversial, yet within its confines there is enormous scope for analysing and questioning the assumptions that support existing practices of arts funding. The most important of these assumptions concerns the question of value. This may be a rather woolly notion, but it is a significant one. It represents the main criterion for deciding which activities are supported by public subsidy and investment, and which are not.

VALUE AND VALUES

The idea of artistic value has inevitably dominated discussions of arts subsidy. This is neatly articulated by the former secretary-general to the Arts Council, Sir Roy Shaw. At a recent conference on arts funding, Sir Roy pointed out:

> The problem is that the customer very often chooses arts which an arts council or French ministry or whatever is not providing. In this country only three per cent of the population want opera. Only 10 per cent want classical music. Only about twenty per cent want serious theatre. Nevertheless most of us are committed to providing these things and I think rightly so. So the operation of subsidy involves making value judgements.
>
> (R. Stewart, *The Arts: Politics, Power and the Purse*, 1987)

It is a curious idea: public money is spent according to the aesthetic judgements of small groups of people. Unlike most forms of public spending, these judgements are almost impossible to measure – criteria of commercial success, value for money, quality or quantity of service simply do not apply.

Criticisms of the elitism inscribed within the system are not new. There is, on the one hand, the populist critique that rises to the surface when the Arts Council funds something particularly obscure or whacky. The purchase of piles of bricks for the Tate Gallery is the most famous example of such an outburst, the tabloid press taking the Tate to task for spending money on such 'squalid rubbish'. A related but more thoroughgoing critique challenges not the values used by the arts establishment, but the value system itself. The populist derides the obscure aesthetic values of the arts establishment in favour of a popular aesthetic, i.e. asserts one set of values above another. The critique of value systems, on the other hand, discredits the whole idea of aesthetic value. Owen Kelly (*Community, Art and the State*, 1984), for instance, has argued that the

> process of persuasion, or trickery, through which sculpting in bronze is designated a living art form and model aeroplane making is relegated to the status of an adolescent hobby, is almost entirely concerned with an ability to engage the interest and approval of those agencies which have achieved a *de facto* power to license activities, or classes of objects, as art; and almost nothing at all to do with any specific 'value' in the activity itself. A visit to a large model railway exhibition will

6

readily confirm this, for many of the more ambitious layouts are self-evidently the result of vision, planning, craftsmanship and tenacity. They could legitimately be described as an evocative, and peculiarly British, form of social realist sculpture, and indeed, if they had happened to be built by an accredited 'artist' as part of a private and 'artistic' obsession, and if they had happened to be located in an accredited gallery, that is how they would be described.

The comparison of model aeroplane making with sculpture is instructive. It locates two cultural practices within a society in order to demonstrate how the value accredited to them depends upon your position in that society. 'Value' is not present in the cultural object itself, it is a set of judgements with specific social origins.

Looking at this example in another way, it could be seen to demonstrate two very different forms of cultural practice. Using the fairly loose definition of art I have proposed, it is possible to place model aeroplane making outside it. The model aeroplane maker is attempting to reproduce scale models of real aeroplanes. While this may involve a number of difficult technical procedures, the maker is not using the model aeroplane to *express* anything – apart from her/his ability to make model aeroplanes. It is a distinction that divides the costume designer from the costume maker.

Owen Kelly uses the model aeroplane maker example quite deliberately, going on to embrace a broad definition of art and the artist, using the word 'creative' in its broadest sense. On one level, this is fine. The problem with this approach arises when a system of value is introduced. The range of cultural, technical, and industrial practices that are united by this broad definition is both enormous and diverse. This makes it more difficult to evaluate what goes on under this heading, to decide what is worth funding and what is not. The point I want to stress is that *a system of value is unavoidable*. However you redefine or restructure it, it is inscribed within the practicalities of public funding.

Before going any further, we need to understand the basis of the sytems of artistic value, the aesthetic judgements, that dominate arts funding at the moment. One of the reasons I have introduced a more limited and, in some ways, more traditional definition of art is that it makes this task easier. A member of the 'arts establishment' could sidestep Owen Kelly's challenge merely by asserting a definition of art that precludes activities like model aeroplane making, without

really addressing the value system that operates within their own definition of art.

We can scrutinize this value system more effectively by using a different sort of comparison. What, for example, distinguishes a pop band's compositions from those of a more classical musician? Both are products of a self-consciously creative and expressive cultural practice. Both products are remarkably similar. They are both compositions of sound played on musical instruments – including the human voice – with the same physical form, whether as a record, a tape recording, or sheets of music. As cultural practices go, they are almost identical. They will, none the less, be clearly differentiated by systems of value.

To criticize the value system of dominant cultural values merely by asserting its class base is a little too easy. I have often heard the Arts Council's approach to music derided as rarefied and middle class by people who would also assert that the music produced by, say, the Smiths or the Bhundu Boys is better than that produced by Barry Manilow. It could be argued that this person is, in fact, using a value system that is not dissimilar to the one being criticized. This is rather closer to bigotry than criticism.

Pierre Bourdieu has explored the idea of aesthetic value in more detail, analysing it as an ideological system within a class society. He has written about the accessibility of art and culture in order to see how aesthetic values work amongst different social classes. He has developed this in terms of the notion of 'cultural capital'. In order to absorb a work of art

> specific competences are required, that is to say a knowledge of the codes specific to a given art form, competences that are not innate but can only be acquired either through inculcation in the setting of the family through experience of a range of artistic objects and practices and/or through formal inculcation in school.
>
> (N. Garnham and R. Williams, *Media, Culture and Society*, 1980)

'Cultural capital', in other words, will or will not be accumulated depending on where and how we were brought up and, in the most general sense, how we were educated. This process then equips us (or fails to equip us) with the 'cultural competence' upon which we rely in making aesthetic judgements.

This 'cultural competence' – the 'codes' necessary to understand a work of art – is clearly related to class and education, a connection

Bourdieu makes fairly directly. As Mulgan and Worpole put it: 'Sadly, it is the case that complex works of art do not explain themselves like a speaking clock just because the watcher, listener or reader goes to them with all the good will in the world. . . . There are many things that stand in between, and which are largely to do with education.' The role of education in the dominant aesthetic value system is the key to understanding it.

ART AND EDUCATION

Bourdieu argues fairly persuasively that 'artists' have used their skill to maximize the complexity of codes involved in their product or performance, making it more difficult to understand. The level of cultural competence required to unravel these codes becomes more and more exclusive. This is demonstrably true of most contemporary art forms – whether music, dance, modern art, or avant-garde film. What this does, Bourdieu suggests, is to reinforce class divisions – while enabling the cultural elite to dismiss those without the required cultural competence as 'philistine'.

This critique suggests that the systems of value that dominate arts funding are based upon a specific set of class interests. Moreover, it demonstrates that these value systems are *not* the arbitrary whims of the professional classes. They are both coherent and workable. The education system is itself based upon the idea that the greater the level of knowledge or 'cultural competence' acquired, the greater the value. This value is then attributed in the form of 'O' levels, 'A' levels, degrees and PhDs.

'Artistic value' will similarly be bestowed upon artistic forms or objects that involve high levels of 'cultural competence'; that are, in other words, difficult. Value becomes a scholarly commodity, an academic aesthetic. It is no coincidence that the 'high arts' are taught and studied at colleges and universities as academic subjects: music, literature and drama, art and art history. This not only gives those forms credibility, it reinforces that credibility by the creation of critical traditions.

These critical traditions surround the object with ambiguity and complexity. This means that an artistic object may be given value by the proliferation of ways of understanding it. Some artistic objects – such as Ulysses or a Cubist painting – are only really made comprehensible by criticism and theory. Others such as 'pop art' or 'film noir' movies, are fairly accessible already, but are given artistic value

9

by the critical or scholarly work that focuses on them. These traditions are, despite the intentions of some critics, very conservative. The growth of Marxist or structuralist literary criticism has not, on the whole, challenged this system of value at all. Marxist critics or scholars will tend to concentrate on the same body of work as critics or scholars before them. They will usually work within the recognized literature of university curricula, rather than looking at the literature that most people actually read. The novels of Jackie Collins or Mills and Boon are ignored by Marxists, structuralists, and Leavisites alike.

There are, of course, exceptions to this. Richard Hoggart's *Uses of Literacy* is perhaps the first and most famous attempt to redefine cultural value *outside* the literary academy. Hoggart's celebration of the use of literature, within the urban working-class community of his childhood, broke with the dominant aesthetic tradition and helped to provide a new way of understanding culture. A more recent example of this kind is Janice Radway's work with readers of popular romantic fiction in the United States (*Reading the Romance*): a genre that has traditionally been dismissed as sexist reactionary pulp. Such a cursory dismissal, she discovered, ignores the creative and liberating role romantic fiction plays in the lives of many of the women who read it.

Both Hoggart and Radway have influenced or been influenced by the developing field of cultural studies. Cultural studies is a diverse theoretical and empirical adventure that grew out of the Centre for Contemporary Cultural Studies in Birmingham in the 1970s. It sought to rescue popular culture from the margins of sociological traditions, where it had begun to stagnate, in order to recognize and analyse its importance in the meaning of people's everyday lives. John Fiske, while he is aware of the difficulties involved in such a rescue mission, writes with optimism about this shift:

Not many generations ago, the humanities were exclusive: universities were the guardians of the best that they considered the (Western) world to have thought, written, or visualized, and their educational function was to initiate the elite of each generation into this treasure house. . . . The broadening of the canon to include film, and more recently television and popular literature (and possibly now, horror of horrors, rock and roll) is a sign of the democratization of academia, since it allows popu-

lar forces greater influence in deciding what should be studied in academic institutions.

(*Critical Studies in Mass Communication*, 1988)

We should, as Fiske does, offer some provisos before we celebrate these changes, since *how* we study is as important as *what* we study.

Moreover, unfortunately but not surprisingly, cultural studies remains marginal to the concerns of the academy. Partly because of this, and partly because it pursues analytical study rather than public policy, its influence on debates about cultural funding is negligible. Like an errant and precocious youth, it has been allowed to pursue a subversive course, while the adults keep their hands firmly upon the cheque book.

So, to summarize: artistic value is an arbitrary aesthetic system. It is based upon and inscribed within social positions. It is not an 'essence' that lurks within the artistic object, to be discovered by those who somehow naturally 'recognize' it.

There is a dominant system of artistic value, which is instrumental in evaluating what receives public funding and what does not. This system is based upon levels of cultural competence, gained through education, as well as inscribed within the education system.

While this system is arbitrary – we could attribute artistic value in any number of ways – it is both powerful and coherent. Its power derives from its base in educational institutions such as the school and the family. Power in our society is generally held by people who have been to university and/or who have come from 'culturally competent' backgrounds. As Bourdieu suggests, this means that this system of artistic value is maintained by the power structures that govern the society in which we live. Its coherence is based on the logic of cultural competence. Once this system is in place, it no longer appears to be arbitrary at all.

Having reached this point, we can now raise two very important questions. The first is: since any system of artistic value is, at its root, inevitably arbitrary, what is wrong with one based on levels of cultural competence? It is both workable and, within western culture, fairly universal. As Sir Roy Shaw stated, we cannot avoid a value system – it is a necessary part of the process of public funding. There has to be a way of deciding *what* to fund. Secondly, if we do decide that this system creates a number of problems, how do we create a new system to overcome them?

It is these two questions that I shall try to answer in the pages that

follow. I shall begin by looking at the social consequences of our current system of attributing artistic value and, with it, public money.

2

PUBLIC ARTS FUNDING – WHO BENEFITS?

THE TRADITIONAL ARTS AUDIENCE

The link between education and artistic values spelt out in the previous chapter has direct and predictable social consequences. The people who benefit from the public funding of art are, overwhelmingly, the educated middle class.

The evidence for this is indisputable. Those who attempt to sustain the mythology that art is accessible to everyone – and many still do – justify it with anecdotes and 'personal experiences' of arts audiences. Nevertheless, all the surveys and audience profiles carried out in recent years reveal the same thing; namely that the barriers to most people's participation in consumption of publicly funded art are class and education.

Education and class are, of course, closely linked. Apart from being a defining characteristic in itself, education will largely determine a person's occupational class. This is reflected by surveys of arts audiences, where the indices of class and education consistently divide arts attenders from non-attenders.

Before going any further, I want to make it quite clear that what I am referring to are those artistic activities that are endowed with aesthetic value by our dominant culture. These are the scholarly arts, characterized by the high levels of cultural competence required to understand them. They will tend to be, appropriately enough, tied to particular cultural institutions such as theatres and art galleries. In the realm of music, public subsidy tends to support classical music, opera, and, most recently, jazz; rather than, say, music hall, independent pop music, samba, contemporary African music, or brass bands. Performance art will focus on theatres and drama companies at the 'literary end' of the genre, rather than pantomime, television, film,

and radio. Dance means ballet and contemporary dance. It does not, on the whole, mean break dancing, tap dancing, or tea dances. Visual arts funding is more likely to go into art galleries than into places in which people live, work, or take their leisure. Subsidy for film and cinema, through the British Film Institute, will support the production and performance of 'art movies', rather than the films most people want to go and see.

There are, of course, exceptions to this, usually funded by local authorities and Regional Arts Associations. These exceptions will be described and referred to in chapters 3 to 7: groups such as the Sons and Daughters of Liverpool or Tic Toc in Coventry, and venues such as the Leadmill in Sheffield or Southampton Art Gallery. They remain, however, very much exceptions. The bulk of arts funding is allocated according to the traditional definitions of value.

AUDIENCE RESEARCH

There are, broadly speaking, three kinds of surveys on arts audiences: general or focused population surveys, user surveys, and qualitative research. Taken together they provide us with a fairly clear picture of the traditional arts audience.

General or focused population surveys

These are surveys based on short interviews with particular samples of the population. These samples will either be broadly representative of the general population, in terms of basic socio-demographic variables such as age, sex, education, occupational class, etc., or they will be more specifically aimed at particular sections of the population, such as unemployed people or Afro-Caribbean people in Brixton.

These surveys are most useful in identifying who does and does not attend arts venues or events. The table below, taken from a 1986 British Market Research Bureau survey for the Arts Council, highlights the class and educational background of traditional arts audiences. The more education you have received, or the higher your 'social grade', the more likely you are to show an interest in the traditional arts.

The member of classes A or B (professional and managerial) is 4 times more likely to go to the theatre, 4 times more likely to go to an art gallery or exhibition, 5 times more likely to go to watch contemporary dance, $5\frac{1}{2}$ times more likely to go to the opera, and over 6

Table 2.1 Social grade, education, and arts attendance (%)

	Social grade					Terminal education age			
	Total	AB	C1	C2	DE	19 plus	17 or 18	16 or less	Still in education
Sample:	5874	822	1340	1745	1967	578	726	4201	330
Events attended:									
Theatre	26	49	38	21	13	54	37	20	35
Plays	19	43	28	13	8	49	28	12	33
Musicals	14	29	22	10	7	31	20	11	18
Pantomime/ Children's shows	21	26	24	21	16	30	24	19	20
Ballet	5	13	7	3	2	15	8	3	6
Contemporary dance	3	5	4	2	1	9	3	1	6
Opera	4	11	5	2	2	13	5	2	3
Classical music	10	27	13	5	4	29	15	6	9
Jazz	7	11	10	5	4	13	9	5	15
Art galleries/ exhibitions	18	35	28	14	9	42	25	13	27

Source: British Market Research Bureau, *Survey of Arts Attendance in Great Britain*, The Arts Council of Great Britain, 1986.

times more likely to go to a ballet or classical concert than a member of classes D and E (semi-skilled or unskilled manual workers).

The statistics on educational background show exactly the same pattern. If there is one factor that identifies the arts attender more than any other, it is taking part in further education (in the survey this is defined as beyond the age of 19). The figures show that this group, above all others, are the prolific arts attenders.

The only events that attract an even spread of social/educational backgrounds are pantomimes and children's shows. These activities, significantly, are endowed with less artistic value than the others, and are less likely to receive public funding.

A focused population survey (based on samples of women in Deptford, black people in Brixton and unemployed people in Dalston) carried out by Comedia in the same year (1986), makes a similar point. The survey divided the sample into two educational groups: those with 'O' levels or higher educational qualifications, and those with CSEs or no qualifications. The more traditionally artistic a cultural activity, the more it is dominated by the educationally qualified group.

Pierre Bourdieu's work in France analyses these links in relation to musical taste. Using complex survey data, he is able 'to distinguish three zones of taste which roughly correspond to educational levels and social classes'. These are identified as legitimate taste, 'middle-brow'

Table 2.2 Art or entertainment visited in the previous month (%)

	Up to CSE	*'O' level plus*
Art gallery	3.5	22
Theatre	3.5	20
Live music	12	31
Cinema	27	47
Nightclub/disco	21	26
Social club	10	6
Bingo	9	2.5

Source: J. Lewis *et al.*, *Art – Who Needs It?*, Comedia, 1987.

taste and 'popular' taste (*Media, Culture and Society*, vol. 2, no. 3, 1980). The types of music preferred by the highly educated people with legitimate taste are given high aesthetic value and will tend to be publicly subsidized, while the 'popular' aesthetic is given less value and left to the commercial sector.

The 'legitimate' group are obviously comfortable with the high level of cultural competence required to enjoy the world of the traditional arts while the 'middle-brow' group will only be on the periphery of that world. The more involved an audience becomes in the arts, the more exclusive it becomes. It follows, then, that the educational and class divide is even greater amongst frequent arts attenders. A survey by NOP for the Society of West End Theatres (SWET) found that amongst the 11 per cent of the population who went frequently to the theatre (3 or more times in the previous year), those from social classes A and B were *10 times* more likely to be in this group than members of classes D and E.

Similarly, these surveys reveal the socially homogeneous nature of the 'arts attenders' group. The British Market Research Bureau survey found that, for example, opera-goers were also likely to go to art galleries, ballet, etc. In other words, the person with the cultural competence necessary to indulge in one 'high' or 'legitimate' art form is also equipped to indulge in others. The existence of this cultural clique demonstrates how coherent the dominant system of aesthetic value is. It applies across most 'high' art forms and features the same educational links.

Is there anything else that characterizes the arts user or attender? Here, survey results are a little less consistent. Overall, men and women are fairly equally represented. Audiences tend to be white – although it is difficult to tell how much this is simply due to the

disadvantaged position of black people in social class and educational terms. Do black people abstain from arts attendance because they tend to be working class or because of the dominance of white cultural forms? There will, of course, be no general answer, as the interplay of race and class will work in a variety of different ways, with a range of cultural effects.

Age differences, on the other hand, tend to vary with art forms. The British Market Research Bureau survey found that 'the median age of attenders would be: opera 53; ballet 49; classical music 44; musicals 47; art galleries/exhibitions 44; theatre 42; plays 42; panto-mime/children's shows 34; contemporary dance 34; and jazz 30'. Others surveys have found similar differences, which probably have more to do with fashion than any acquired cultural competence. The Broadcasting Research Unit's (BRU) analysis of cinema audiences, for example (D. Docherty *et al.*, *The Last Picture Show*, 1987), suggests that cinema-going is very much a young person's pastime. The film industry is, of course, fully aware of this trend, and has attempted to attract slightly older audiences with films such as *Fatal Attraction* or *Three Men and a Baby*, dealing with the 'adult' issues of marriage and child-care.

The age range of arts attenders also conforms to other patterns of leisure: young and middle-aged people tend to go out more often than the elderly, and their presence at arts events reflects this.

User surveys

User surveys are normally carried out by venues in order to find out more about their audience. Amongst other things, they confirm the existence of educational and class barriers (and barriers are very much what they are, if access depends upon education and the cultural competence that education brings).

A survey at the Institute of Contemporary Arts (ICA) revealed that only 3 per cent of the people who went there were 'blue collar' workers, while as many as 60 per cent were actually involved in the arts in some way themselves. A survey by the British Film Institute (BFI) found that half the members of the National Film Theatre had occupations described as management, professional, or 'intellectual', as opposed to the 8 per cent who had manual or clerical jobs. Three-quarters of the sample had experience of higher education, and half of them read the *Guardian*. Both surveys also showed that their audiences were regular attenders: about half the ICA survey had

visited the Institute at least seven times in the previous year, while the NFT members averaged 35 films a year.

A survey of arts and leisure services in Islington, carried out by Comedia in 1987, involved a range of user surveys. These were carried out at both traditional arts venues, such as the King's Head Theatre, and popular arts venues, such as the Thatch Irish music club, the Holloway Road Odeon, and a black music record shop. Accordingly, they found that 70 per cent of the King's Head Theatre audience had a degree or a diploma, compared with only 19 per cent at the Holloway Odeon (the local cinema), 14 per cent at the record shop and 8 per cent at the Irish music club. The only venue, in other words, with an audience characterized by a high level of education was also the only one to receive public funding. It is not thought appropriate to fund the more popular and accessible venues, whose work is not legitimated by the dominant cultural aesthetics. This reflects Bourdieu's distinction between the (publicly funded) 'legitimate' arts audience and the (commercially funded) popular arts audience.

Another good example of this is revealed in the BRU's study of cinema audiences. Most cinemas are, of course, commercial. There are, however, 37 Regional Film Theatres (RFTs) around Britain, showing independent, foreign, and 'art' movies. The BRU's survey of the RFT audiences shows them to be overwhelmingly middle class. Nearly 80 per cent of them were members of social classes A and B or students, as compared to the more even social spread attending ordinary commercial cinemas. Over half the RFT audience, indeed, were involved in full-time education.

They also found that, as opposed to those attending ordinary commercial cinemas, the 'specialist film audience is media-rich: they are theatre goers, art gallery habitues, disco maniacs and clubbers. The commercial audience seems less concerned with such frenetic activity' (D. Docherty et al., The Last Picture Show, 1987).

Qualitative research

Quantitative surveys have established who makes up the audience for the arts. In order to discover the attitudes and motivations that lie behind these statistics, it is necessary to do more qualitative research.

The most common form of qualitative research is the group discussion. The group's make-up will depend upon the researcher's particular interests: it may consist of people who do or who don't

attend arts events, or it may consist of members of a particular socio-demographic grouping, such as working-class women or young Afro-Caribbean men. Alternatively, qualitative research can involve one-to-one interviews, with, say, people who live on a particular housing estate.

Qualitative research is often an extremely rich source of information. It allows us to explore issues in some depth (such as the value of the artistic experience or what constitutes that experience) and I shall refer to some of the more recent qualitative studies in subsequent chapters. For the time being, the question is what light such research throws upon the educational divide between those who benefit from public arts subsidy and those who do not.

The degree of alienation most working-class (particularly young) people feel from traditional art forms is clearly revealed. A young working-class discussion group in the north-east defined the arts attender as 'one of them' rather than 'one of us': 'Theatre goers? Someone well off. Not just your ordinary worker ... we're North-Easters, it's a class thing' (British Market Research Bureau, *Summary Report of Qualitative Research*, 1985). The same report went on to point out that members of younger working-class discussion groups saw the arts not only as middle class, but as too 'intellectual':

> younger and less sophisticated people felt alienated by the whole idea of attending a classical concert – they felt they would not fit in with the 'middle class' or 'intellectual' audience, and that they would feel foolish and bored because they had no idea of how to select or appreciate the music.

This alienation is felt by young and old alike, although it is expressed in different ways. A report based on a mixed-age group of working-class people demonstrates how, while younger respondents will tend to be more assertive, both age groups are articulating similar feelings:

> The 'high culture' arts of opera, ballet or Shakespeare plays were never mentioned spontaneously. When introduced to the discussions, apart from two people who had actually attended, the older people became slightly defensive – 'they are just for visitors and tourists', 'too busy for that sort of thing', 'ordinary people just want a cinema and somewhere to go for special treats'. The younger people seemed amazed that they should even be asked about such things, 'if you're middle class you

might want something different', 'we just want the video in my street', 'that's for posh people'.

(GLC, 'Public opinion on the arts in London', 1983)

These feelings are even more pronounced when faced with the possibility of getting involved and participating in artistic activity. A study based on interviews with women living in council estates in the London Borough of Ealing showed this total lack of confidence:

Many of the interviewees wouldn't contemplate an activity which could be easily defined as 'art'. The results of their efforts would be tangible and, as such, readily available for criticism, which would expose them to possible ridicule or patronage. It was much more frequently the case that people said 'Oh, no, I couldn't do that' than 'I wouldn't like to do that.'

(LSPU, *No Business Like Show Business*, 1987)

It is interesting that people's *desire* is distinguished from their perceived ability: in other words, regardless of whether I *want* to get involved in artistic activity, I am simply not able to.

This clarifies the notion of 'cultural competence'. The qualitative research I have referred to shows how real that notion is. Cultural competence is what you need to appreciate or participate in 'art', it is something you acquire if you're middle-class, 'intellectual' or 'posh'. The lack of this cultural competence makes 'art' inappropriate or something quite frightening.

PUBLIC FUNDING: THEORY AND PRACTICE

I have argued that the aesthetic value system governing arts funding is ultimately arbitrary. That is the nature of any value system: value is attributed to something, it is not part of its essence. There is nothing essentially valuable about gold. We give it value because we have associated value – in this case – with rarity, and with the jewellery we turn gold into.

Once a value system is in place, of course, it seems no longer arbitrary. In the case of art, it is supported by an education and class system which makes it both appropriate and coherent. It is, for all that, not something permanent or impossible to change.

The social consequences of our aesthetic value system are usually disregarded. Public money is spent without any consideration of social or cultural needs. At worst, as Mulgan and Worpole put it, 'such a policy actually represents ... the redistribution of wealth from the working classes to subsidise the institutions of the upper

classes'; at best, it provides state support for middle-class entertainment and middle-class aesthetics.

The social and cultural goals of our funding institutions are, in fact, fairly democratic. The problem is that they bear very little relation to the reality of their funding. The Arts Council of Great Britain operates under a Royal Charter, granted in 1967. This Charter states that two of the Arts Council's main objectives are:
a) to develop and improve the knowledge, understanding and practice of the arts; and,
b) to increase the accessibility of the arts to the public throughout Great Britain.

Luke Rittner, introducing the Arts Council's 1985/6 Annual Report, argues that the 'growth and development of Britain's cultural life is vital in this post industrial era', the clear implication being that this is what the Arts Council is about.

The Minister for the Arts, Richard Luce, echoed these sentiments when he said that 'the arts cannot exist in a vacuum or be insulated from the outside world. Their interest must be to encourage the maximum public participation in their affairs' (R. Stewart, *The Arts: Politics, Power and the Purse*, 1987).

This is all highly laudable. The Arts Council is reaching out to the British public, enhancing cultural life and the general good. Luke Rittner again:

> Today, the arts can no longer be described as an elitist minority interest . . . something has changed in Britain. The arts are being pushed up the agenda by the sheer weight of public demand for the joy and exhilaration the arts can provide.

This is also, unfortunately, highly disingenuous. A look at those bodies to which the Arts Council actually gives money is like looking at a directory of high art. It goes to theatres, art galleries, orchestras, contemporary dance and ballet companies, opera companies, poetry societies, and other scholarly pursuits. In 1985/6, it gave out approximately £100 million. Out of this, only a fraction went to activities that were even *potentially* popular or against the traditional grain: just under £16 million went to Regional Arts Associations, while less than £200,000 went to 'community arts' and £3,000 was spread amongst 30 different carnivals.

The British Film Institute, however good their intentions might be, sustain a similar set of aesthetic values. As I have already suggested, the Broadcasting Research Unit study of film audiences indicates

that the cultural competence required to watch a BFI funded film production or to go to a Regional Film Theatre makes them a middle-class preserve. The ordinary 'commercial' cinemas on the other hand, attract a comparatively broad cross-section of the public, yet they receive no subsidy at all. It is not that they don't need it – the annual audience for British cinema declined from 1,640 million to 73 million between 1946 and 1986, with hundreds of cinemas closing down – it is that they are not deemed *worthy* of it.

Even in a 'mass medium' such as television, the BBC, a public corporation, has adopted a similarly elitist set of values. Radio stations Three and Four are heavily subsidized by the TV licence fee for the benefit of a small middle-class audience (particularly for Radio Three, the classical music station). The popular music station, Radio One, gets a far bigger audience and substantially less money. This is justified in 'the public interest' – yet what is being referred to is not 'the public' at all, but the educated middle-class public. Moreover, the argument that Radio Three *needs* more money than Radio One, despite its small audience, is quite spurious. Radio Three does not need to invest in music production – but it does. Radio One could also invest in production, but it does not.

On a more local level, the Arts Council devolved responsibility for some of the less expensive local or regional arts activities in the late 1970s to the Regional Arts Associations (RAAs). The RAAs, despite the rather paltry percentage of funds they receive from the Arts Council's budget, will often see themselves as the flagships for democratic culture. Their rather meagre existence is seen to balance the 'legitimate' artistic activities the Arts Council spends most of its money on. Local authorities, who are major arts funders in Britain, will often adopt a similar outlook, seeking to provide for the needs of their local communities.

On the whole, despite a host of democratic intentions, RAAs and local authorities tend to spend most of their money on much the same kinds of activity as the Arts Council. There are some notable exceptions to this, and, as I have already promised, I shall be looking at these in detail in the chapters that follow. Nevertheless, the audience for the more 'community based' initiatives they support tends to be, once again, highly educated and middle-class. There have been three recent studies of the audience for and participants in these more locally or 'community' based activities in London (J. Lewis *et al.*, *Art – Who Needs It?*, 1987; *A Survey of Arts and Leisure Activities in Islington*, 1987; and LSPU, *No Business Like Show Business*, 1987).

They have all indicated that attempts to bridge the educational divide have usually failed. Local authorities and RAAs invariably focus upon the traditional arts, while attempts to move into less traditional areas (such as video or mural painting) have often been couched within the aesthetics of cultural competence.

The stated aims and objectives of our major arts and cultural institutions are not really the problem. What they actually *do*, on the other hand, is elitist and discriminatory. It is no good claiming to promote access, or to spend money in the name of 'the growth and development of Britain's cultural life', if the aesthetic values you have chosen to adopt inevitably favour the educationally privileged and the better off.

The gap between the goals of our arts and cultural institutions and their achievements is their undoing. The true nature of their aesthetic value system is hidden beneath the rhetoric of art for all. It is a pretence, unconsciously sustained by the influential 'arts' lobby – by marching under the banner of universal access we are able to *pretend* to ourselves and everyone else that these contradictions do not exist. What is so extraordinary is that politicians and people from both the left and the right have been confused and intimidated by this myth for so long.

A NEW SET OF VALUES

Where does this leave the principle of 'art for all'? It is, in a general theoretical sense, a fairly uncontentious proposition, based upon the best ideals of public funding in general – whether health-care or national defence. Everyone is, in theory, free to go to an art gallery or the theatre. Unfortunately we are not totally free agents, but socially constructed ones. Our actions are limited and shaped by our social environment.

If this democratic principle is to become a reality, we need to establish an artistic value system that promotes this principle, rather than one that flies in the face of it. This must be worked out in the context of the complex set of economic and cultural conditions in which we live.

Any evaluation of art that does not work within the possibilities and limits of our existing culture (in its broadest sense) and society, is bound to run into difficulties justifying itself. There would be no point in supplying hospitals with units to tackle outbreaks of small-pox, since the harsh reality of smallpox has disappeared from our

shores. Health-care needs to be geared to the prevention and cure of accidents and diseases that people actually suffer. (The analogy is a useful one, because of the difficult question of medical research and development. This is expensive and of no immediate benefit to anyone – yet it is vital for the future of health-care. The same function exists within art – a point I shall take up again later.)

Most traditional arts funding is gloriously inappropriate to the leisure trends in Britain today. As Mulgan and Worpole write:

> The shift towards greater spending on cultural hardware (TV sets, VCRs, hi-fi, etc.) as opposed to services has also meant that entertainment is increasingly located in the home. The growth in take away catering, canned beer, has gone hand in hand with the decline in audiences for cinema, football matches and pubs. The privatisation of pleasure – driven by basic economics – has become a fundamental issue, whilst traditions of civic, municipal, and public cultures are being swept away. In their place, fragmented cultures are being formed by the market – specialised TV channels for consumption in the home, and specialised 'life-style' based entertainments in the city centres. When television is available at around 2p an hour, why bother with the expense and trouble of travelling to the city centre (most local theatres and cinemas have long disappeared), going out to eat, risking increasingly violent streets and arranging for child care?
>
> (*Saturday Night or Sunday Morning*, 1986)

This is a process to be engaged with, not ignored. It also opens up the question of value. What is wrong with a home-based mass culture? What, of value, will the free market fail to secure if left to its own devices? This, in the current economic climate, is the question public funders must answer.

The traditional aesthetics of cultural competence would respond by suggesting that the 'difficult' art forms that are currently funded – opera, contemporary dance, art exhibitions, etc. – are of value partly because of their complexity, but they are too expensive and/or too unpopular to survive in the free market. They therefore need public subsidy for their value to be sustained. This, in the context of the cultural inequalities inherent within these traditional values, is rather a lame response.

Why is this response so unconvincing? I have already detailed the disastrous consequences once such a value system becomes a public

policy, but there are many other reasons for its inadequacy. It is an aesthetics steeped in nostalgia for the old traditional forms. While there is nothing wrong with a little nostalgia, an aesthetics informed by it is unlikely to breed anything truly innovative or dynamic. It is also a form of public intervention precipitated by commercial failure, a system whereby the worthiness of the recipients is partly measured by their unpopularity. It is one thing to criticize the free market for equating popularity with cultural value, but quite another to adopt an inverted version of this crude formula. Such a position does not question the logic of the free market, it simply turns it upside down. Faced with such a limited choice of positions, you have to admit that at least the free marketeers have a majority on their side!

This leads us to the most profound flaw in our current system of cultural funding. Inscribed within it is the idea that the popular domain organized by the free market – the commercial culture that most of us consume – is an arena where notions of public intervention do not apply. It is as if the culture promoted by the commercial cultural industries is too rigid, too mundane, or too 'low' to be worth thinking about, and that aesthetic value can only be pursued outside this commercial world. This is an extraordinarily inept basis for a cultural strategy. It is like one party on the far left addressing themselves only to the limitations of another party on the far left – you are destined to a life meddling on the sidelines.

If we accept the idea that we need a culture that reaches beyond the confines of the free market, a culture that includes practices and forms that a commercial system will not automatically provide, then two things follow. We must, first of all, clearly articulate a set of cultural values that the free market is or is not providing. We should then try to understand how the free market operates in relation to these cultural values. Can certain cultural values be promoted by regulating or strategically investing in the commercial culture? If not, which other cultural forms is it most appropriate to promote? Only by answering these questions can we develop a cultural strategy worthy of the name, instead of the ill-conceived mixture of pragmatism and prejudice that has guided us until now.

The question of 'cultural value' is difficult but unavoidable. Our cultural values, after all, constitute the guiding principles of our cultural policy. I shall, in the following paragraphs, offer six broad areas of 'cultural value' that allow us to address the shortcomings of the free market. While they may be developed, contested or refuted (although they are not, in an abstract sense, particularly controversial)'

they are, in one form or another, a necessary cornerstone for building a new cultural strategy.

The value of diversity

'The market alone', write Mulgan and Worpole, 'for all its dynamism and concern to meet unmet wants, is incapable of sustaining diversity except on its own terms.' Taste will be at worst dictated by, at best be geared to the economics of production. This, in the age of home-based entertainment, is bound to work against artistic diversity, for two basic economic reasons. Firstly, the economies of scale in the production process apply to culture as much as anything else. It is generally more profitable to produce a small range of products for a lot of people than a diverse range for a number of small groups of people. Secondly, those groups with limits on their disposable income, such as the unemployed, or with restrictions on ways of spending it, the disabled for example, will be more or less ignored by the process of cultural production. They are not, unlike other segmented markets, able to sustain the economics of production.

The free-market culture is much more likely to diversify at the 'upper' ends of the market. Middle-class people are likely to have enough disposable income to support cultural products with a more limited appeal. This is why 'quality' newspapers such as the *Guardian* or the *Daily Telegraph* survive with a much lower print run than tabloids such as the *Sun* and the *Mirror*. The former have middle-class readers with lots of money while the latter have working-class readers with rather less. This means that it is possible to sell the 'quality' papers at a higher price, while charging advertisers more (per paper) in order to reach this smaller but more affluent market. The laws of the free market guarantee that market segmentation benefits those with high levels of disposable income.

The value of innovation

The free market suppresses artistic innovation, because it is easier and cheaper to do without it. Innovation is an expensive business – it involves that area of activity known in industry as 'research and development'. This means allocating resources to activities that may spend most of the time producing little of value, in the hope that it will result in something new or something better.

Innovation also involves taking enormous commercial risks. A

business will usually invest in a formula that is tried and tested – whether it is a pop group, a play, or a film – because it will be able to predict with reasonable safety that it will be successful. Investment in something new and different is like plunging into the unknown.

The freedom to innovate is valued within the dominant system of aesthetic value, and artists are often grant-aided so that they might have this freedom. Innovation does not necessarily mean complexity, however. During the late 1970s and early 1980s, the British music industry went through one of its most artistically creative periods, with a range of different styles emerging from the seeds sown by 'punk' and 'new wave' music. This had very little to do with the major record companies and was certainly not publicly subsidized. It involved small groups, independent record labels or promoters, using cheap available technology and taking commercial risks to support new musical styles. Although cheap technology reduced the amount of money required to finance such ventures, most of this activity involved self-exploitation, and most of it, on a commercial level, failed. Some new bands and new styles did, nevertheless, break through. Once a 'market' for their music was established, the major record companies moved in and either bought them up or promoted similar bands. Innovation, in this instance, was subsidized by the enthusiasm and energy of people prepared to behave in a decidedly non-commercial manner. This, in a free market, happens very rarely indeed.

The value of art in the environment

The public and private sectors have always been reluctant to introduce questions of artistic and environmental value in their cost benefit analyses. The shabby and ugly developments that comprise most city centres in Britain is their legacy. This is because employing craftspeople, artists, and planners is expensive. The cost can only realistically be borne by public agencies.

The role of art in architecture and the environment is not a simple one. It involves, as John Willet puts it, ensuring a 'good relationship between artist, patron (and/or architect) and the affected public' (Peter Townsend (ed.), *Art Within Reach*, 1984). The value of art in improving the environment is part of civic culture, whether it is Eduardo Paolozzi's mosaics that decorate Tottenham Court Road tube station in Central London, the 'Rainbow Room' murals that adorn part of Southampton General Hospital, or the work of the

Seattle Arts Commission in North America. The work in Seattle, like other cities in the US, is based upon the 'percentage for the arts' idea. This involves the local state ensuring that a certain percentage (say 1 per cent) of money spent on new development goes towards an artistic input.

The value of social pleasure

Art is one amongst many other leisure activities that involves what we can call 'social pleasure'. Audience research consistently reinforces the importance of activities as a social experience:

> As an extension of the desire for 'escapism' and 'entertainment' there were many indications, especially from women, that one of the main pleasures of attending an event is the *'treat'* of an evening out. For most this involved careful planning, taking time to get dressed up and the excitement of a change of scene, together with the luxury of indulging money on personal enjoyment.
> (British Market Research Bureau, *Summary Report of Quali-*
> *tative Research*, 1985)

> In many cases it is not so much the particular cultural product (this or that film) on offer which is the key factor in attracting people to a project so much as a more general sense of whether or not the place offers a friendly, welcoming and enjoyable ambience in which to meet other people and have a pleasurable social experience. This factor is important to all the groups interviewed, but appears to be particularly important to women, given their particular experience of isolation in the home. The projects that offer this kind of social forum draw considerable praise in this respect – where it is lacking it is a distinct cause of negative comment and dissatisfaction.
> (J. Lewis *et al.*, *Art – Who Needs It?*, 1987)

The trend towards home-based entertainment is eradicating a culture based on social pleasure. Going to the pictures, to the theatre, or to the dance hall, as Mulgan and Worpole suggested, exist only as memories for many people. The social and cultural consequences of this are summed up by a woman in a discussion group in Islington:

> It's no life though, is it. . . . I get bored to tears. I often say I feel like an old granny sitting in here. You get frustrated with yourself because, I think my life is passing and I am just sitting

indoors watching television ... you might say you are prisoners
in your own home.... I really get depressed indoors ... look at
me ... shut in here I am like an old granny. You must be at your
husband all the time.... When you look back and think what
you used to be able to do ... your social life ... it's finished.
 (*A Survey of Arts and Leisure Activities in Islington*, 1987)

The reasons for the post-war decline in these activities are complex,
and are discussed in more detail later. What is clear is that the free
market is incapable of providing most people with the social pleasure
of art. Removing the many barriers – whether fear of the streets at
night, lack of transport facilities, or lack of confidence, requires
strategic public investment.

The value of creative expression

The creative experience is usually achieved by *participating* in the
artistic process itself – although it can also be part of its consumption.
The value of this self-expression has been described many times by
people working in various arts projects up and down the country. It
is summed up by a group of young people from the Albany Basement
Drama Project in Deptford:

'You change as a person ... I was quiet, I was shy, I've got more
confidence now and I've got a bigger mouth and a bigger
voice....'

'It gives you encouragement and expands your whole life....'

'It's just a feeling that you've achieved something....'

'You're a person who's actually done something that other
people find pleasurable....'
 (J. Lewis *et al.*, *Art – Who Needs It?*, 1987)

This kind of grass-roots participation usually takes place outside the
commercial cultural world. It is invariably supported by public
money rather than the free market. The group Graeae, for example,
wrote eloquently of the importance of public funding (in this case,
from the GLC) for people with disabilities:

This company would have collapsed without GLC funding ...
if it goes people with disabilities are back to square one after a
brief period of a more fulfilled lifestyle ... our voice must not

be stifled again through lack of money … thanks for helping us this far.

(GLC, *Campaign for a Popular Culture*, 1986)

The artistic experience, in this sense, is not only about acquiring cultural competence, but about personal development and the broadening of horizons.

The economic value of art

The 'cultural industries' approach to artistic production is an attempt to place it in an economic context. At the same time, organizations such as the Arts Council, under pressure to justify their public subsidy, have been forced to stress the economic importance of the arts. Chapter 7 will be devoted to a critical look at the use of culture as an economic strategy. In the meantime, it is worth summarizing the main arguments used to justify cultural funding in economic terms.

a) The arts are a cost-effective form of employment. They will tend to be labour-intensive (labour comprising 60–70 per cent of major performing arts companies' total budgets) and will, therefore, only require comparatively low capital costs. They will often raise at least a proportion of their own income. The 1987 study of *Arts Centres in the United Kingdom* by the Policy Studies Institute, calculates that Art Centres raise, on average, 40 per cent of their own income (this includes 3 per cent from sponsorship and donations).

b) The arts cross-subsidize education and broadcasting, providing educational resources and facilities (such as theatre in education, school visits, etc.), training actors and musicians for broadcasting and sometimes directly subsidizing the broadcasting of theatrical or musical productions.

c) Subsidy to particular parts of artistic industries can both enrich them and increase their economic viability. The British music industry, for example, was made more interesting and more profitable by the 'subsidy' provided by independent record labels. These non-profit or loss-making concerns functioned as a research and development wing of the music industry, keeping the industry one step ahead of its competitors. Other artistic industries can be made more economically self-sufficient by the provision of 'seed money' at strategic points in the sector. A cultural industry may not be profitable because a particular point in the economic chain may not be working efficiently. Investment in the distribution and marketing of independent video or community

publishing are examples of strategic intervention in sectors that have been too production orientated to be efficient.

d) Art and culture are seen as important features in the development of tourism. Cities such as Glasgow and Bradford have spent money on cultural facilities to attract tourists (who will spend money in the city, not only on art and entertainment, but on subsidiary industries such as catering) and company investment (on the basis that Glasgow or Bradford is a nice place to live). At a national level, foreign tourists spend most of their money on VAT-rated goods and services, which provides a direct financial yield to the Treasury, as well as creating employment in subsidiary industries. Surveys suggest that the arts in Britain are a major reason for their coming.

PROMOTING A NEW SET OF VALUES

This set of values (diversity, innovation, social pleasure, partici-pation, the environment , and economic generation) provides a com-plex but coherent basis for funding the arts in Britain. Like all values they are not innocent. They need to be incorporated into mechanisms that ensure the creation of a diverse, innovative, environmental and social culture for everyone, regardless of income or education. This is something that the dominant aesthetic value system, in a society where access to 'cultural competence' is granted only to the privi-leged minority, is incapable of doing. As Alan Tomkins (borrowing from Bourdieu) writes:

> The cultural field is an analogous form of economy where agents are endowed with specific cultural 'capitals' arising from educational opportunity where one class (the dominant) pos-sesses the 'cultural capital' and another (the dominated) does not.
> (GLC, *Campaign for a Popular Culture*, 1986)

Changing the nature of this 'cultural economy' means using a set of values that are incorporated within the social and cultural realities of Britain today. The values I have put forward have, for this reason, been developed within a clearly defined social and cultural context, rather than the abstract notion of 'excellence' based upon cultural competence. I have tried to define the role of public funding clearly in relation to the commercial artistic industries, by analysing what the free market can and cannot offer. The six values I have laid out are not particularly controversial – the Arts establishment pays lip service to all of them at some time or another. What is more controversial is that

they should be thought through and developed, free of the traditional value system, to manifest the principle of art for all. Not an easy task: as Alan Plater says, 'Once a tradition is established in the UK it takes a deal of shifting' (B. Baker and N. Harvey (eds), *Publishing for People*, 1985).

It entails a radical restructuring of our whole system of arts funding, through the Arts Council, local authorities, broadcasting, and other artistic agencies. This involves more than simply asserting the right principles. The few RAAs and local authorities that have attempted to promote a more accessible and wide-ranging culture have, on the whole, failed. This is because they have failed to establish a thoroughgoing *value system* to define and evaluate what they do – often by apparently abandoning any value system at all, in a mishmash of social targeting of 'underserved' groups (ethnic minorities, people with disabilities, etc.) within a framework of traditional artistic values.

The task is, unfortunately, more complicated than simply asserting a new set of artistic values. Translating these values into funding strategies requires whole new ways of thinking. What, exactly, *do* you fund or support, and how do you set about it?

I shall, in the chapters that follow, address these questions. I shall endeavour, wherever possible, to base proposals on concrete examples of work going on in Britain today. I shall be looking at a wide range of groups, organizations, and agencies all over Britain that are, in one way or another, achieving some of the objectives I have set out. Their experiences are invaluable, and I make no excuse for referring to them throughout the rest of the book.

The popular culture I will be advocating is not a 'majority' culture ruled by the lowest common denominator. This is what the free market offers. It is an exciting, innovative, varied, and enriching culture, promoted by public investment. Popular involvement needs to be nurtured and stimulated, so that it provides a thriving basis for diverse cultural developments. When William Morris, in a letter to the *Daily Chronicle* in 1883, wrote that

> No one can tell us now what form that art will take; but as it is certain that it will not depend on the whim of a few persons, but on the will of all, so it may be hoped that it will at least not lag behind the will of past ages, but will outdo the art of the past ...

he was, with hindsight, a little too optimistic. The aim of this book is to root the spirit of this optimism within the complexities of the cultural world.

3

REACHING THE PARTS
OTHER ARTS DON'T...

INTRODUCTION

To develop an arts policy on the basis of a new set of values –
embracing 'art for all' – is to begin with an enormous disadvantage. It
is much easier to start with what is already there. The Arts Council
began with the task of subsidizing *existing* activities – predominantly
theatre – that were becoming less economically viable. If we want to
create a diverse and innovative public and social culture, in which
most people can participate, where do we start?

There are only two obvious starting points. We can begin with the
publicly funded art forms – theatre, music, etc. – and try to demystify
them, to make them accessible and appropriate to ordinary people.
This, in many cases, was the approach of the early community arts
movement – bringing art to the people. Or we can begin with the
more popular cultural forms, such as television and video, which are
provided by commercial agencies. This is the 'cultural industries'
approach, developed by the GLC's Cultural Industries Unit in the
mid-1980s.

This question – where do we start? – is difficult because it is so
general. The world of art or culture as I have defined it – namely: the
production of an object or performance created in order to self-
consciously express something – incorporates *both* the cultural in-
dustries and the 'high' arts. Although this definition restricts the
range of cultural activities under discussion, it still covers everything
from video to art galleries.

The best way forward is to look at particular sectors in more
detail, in order to see how we might promote cultural value in each
case. Chapters 4 and 5 will adopt this approach, looking at those
sectors which can broadly be designated as 'commercial' (chapter

4) and those whose forms tend to be subsidized (chapter 5).

Before embarking on a sector analysis, it is useful to introduce some general themes. Accordingly this chapter will look at an institution rather than a sector – the arts centre. Arts centres cover a range of activities, the popular and the specialist, the commercial and the heavily subsidized. While this makes them awkward to analyse, it also allows a number of ideas and approaches to come into play.

ARTS CENTRES IN THE UK

The Policy Studies Institute (PSI) has carried out a major study of *Arts Centres in the United Kingdom* (Robert Hutchison and Susan Forrester, 1987). It defined an arts centre as 'a building which provides a regular base for substantial programmes of activities in more than one art form', with 'some professional input (artistic or managerial) into the centre's activities'. Excluding those buildings that were not primarily used for something else (such as education), they identified 242 centres in the United Kingdom. They discovered a further 149 that were, for one reason or another, closed during their study, or that did not quite fit into their definition. Still hundreds more, as they acknowledge, could be described as such.

Although most of these centres (approximately two-thirds) are small, with turnovers of less than £100,000 per year, a substantial number had turnovers of over a quarter of a million pounds per year. In total, arts centres had a gross annual throughput of £80 million in 1985–6, employing 7,000 people on a part-time, casual, full-time basis, or through an MSC scheme.

Arts centres tend to exist on a continuum between the subsidized and the commercial. On average, most of their income comes from some form of grant aid (60 per cent), the main funders being local authorities (43 per cent) and arts associations – mainly the ACGB and RAAs – (13 per cent). The average arts centre will generate 37 per cent of its own income, through box office sales and subsidiary activities such as hiring rooms and equipment and catering. A small amount, 3 per cent, will come from commercial sponsorship.

Hutchison and Forrester suggest that 'if there is one common purpose that drives most (but by no means all) of those working in arts centres, it lies ... in a "new generation's determination to make creative activity as well as the 'art' which is provided for their consumption".' To this end, arts centres provide a range of activities.

Most will offer theatre and performance art from ballet to cabaret, and some form of music programme, whether classical, folk, jazz, contemporary, rock, or pop. Many will provide gallery or exhibition space, and an increasing number will show films (usually in a theatre/cinema space, although a few have purpose-built cinemas).

Most arts centres also offer participatory events, such as workshops and training courses, in a variety of activities, from video and photography to training in circus skills. Most will also provide some form of social space, whether a bar (65 per cent), a café (60 per cent) or a restaurant (25 per cent).

What is the artistic/cultural value of these arts centres? How do they enrich the cultural life of the locales they serve? To answer this question we need to know who uses them, and who benefits from their existence. Unfortunately, the PSI study reported that 'few centres know much about their audiences. In over half the centres where interviews were held there had been no surveys of audiences or attendances in the past two years. Where surveys had been started they had often died through lack of time and people power to follow them through properly.' This failure, though understandable, is significant. It reflects a concern with the culture of the arts centre rather than the culture of the area it operates in.

This concern is summed up by an arts funder, quoted in an Issue Paper for the 1986 London Association of Arts Centres Conference, *Will The Centre Hold?*:

> There is a dilemma where an arts centre sees itself accountable to the local community and can be seen to be artificially directing its work to attract that community. From the artists' point of view, this discourages innovation. It takes away the freedom of the artists and pressures them into thinking of things which are more accessible.

Many of those working in arts centres would be unhappy with the elitism inscribed within this view – as the paper goes on to suggest:

> More public subsidy for the same middle class audience which benefits from subsidised, traditional arts was seen as a problem. It is not just that they continue to consume funds which could pay for community arts provision for more socially and culturally deprived groups, but their very presence, in many cases, alienates the very communities targeted by the centres.

Nevertheless, the fact that something as basic as audience research is

usually neglected shows the power of an aesthetic based upon 'the artist's point of view', rather than the needs and interests of people as potential cultural consumers.

The audience research that is available shows that arts centre audiences are, on the whole, the same as traditional arts audiences, that is middle class and highly educated. This is often *despite* the sincere endeavours of those who work there. If we are to progress beyond this cultural stagnation, two things need to be understood. Firstly, what are the barriers that stop most people going to arts centres, and secondly, how can they be overcome?

INVISIBLE 'NO ENTRY' SIGNS

I have already described how the subsidized arts have used complexity to surround themselves with an educational divide, leaving the educated middle class on the inside, and everyone else to seek their entertainment elsewhere.

This, of course, partly explains the nature of the audience in arts centres. There are, however, a number of arts centres that attempt to put on plays, exhibitions or other activities that *are* accessible – to 'demystify' the art forms that have become associated with 'high' art. Unfortunately, the audiences remain the same. The Watermans Art Centre in Brentford, for example, is one of the few arts centres to have carried out its own audience research. While the staff are keen to service a wide range of the local community, a survey of their members ('Friends') 'showed that membership is predominantly young to middle aged (29 per cent 25–34 and 31 per cent 35–44). A large number are in the AB socio-economic grouping with a sprinkling of the professions and a heavy preponderance of public sector workers (teachers, lecturers, social workers) as well as designers and advertising executives' (Irene Macdonald, *Arts Centres, Education and the Community*, 1987). Why is this? There are a number of reasons.

The image of art

George McKane, from the Sons and Daughters of Liverpool (SA-DOL), describes vividly the reactions he received when he asked young people in youth clubs whether they wanted to get involved in the arts – in drama perhaps, or writing poetry? 'They'd tell me where to get off.... I've been told to fuck off, I've had things thrown at

me....' The problem is not that the activities themselves are inaccessible. SADOL, a thriving Merseyside arts group (running their own centre) made up almost exclusively of young unemployed working-class kids from Bootle, has clearly demonstrated this. The problem is with its *image*. This, of course, is the legacy of the dominant aesthetic values.

Because of the values that dominate subsidized art, the very idea of it is conflated with an alien cultural complexity. This is a problem that most community artists are acutely aware of. There are only two solutions: either this image needs changing or we rather disingenuously give it a new name. Either way, there is a great deal of positive marketing to be done.

The marketing of art

The question of marketing, both in the pursuit of audiences and in the generation of income is important, and I shall devote more time to it in the chapter on income generation (chapter 7). Suffice to say that, almost regardless of intention, arts marketing in Britain serves to exclude a majority of people.

This issue is explored in *Art – Who Needs It?* which uncovered a great deal of ignorance in the arts world about people's real needs and interests. A whole range of marketing devices are used without any proper understanding of their social consequences. Organizations would rely upon leaflets with high word-counts and advertisements in listings magazines with highly educated middle-class readerships (such as *City Limits* and *Time Out* in London or *City Life* in Manchester). These are mechanisms that will appeal to and attract middle-class audiences.

Other devices, such as credit card booking systems, implicitly recognize the middle-class status of most of the audience. Many arts marketing agencies are indeed aware of the social composition of the average arts audience, and simply go about concentrating on maximizing the number of middle-class arts attenders.

The problem is not only the type of marketing, but the amount of it. As the PSI study found: 'Few centres are confident about their handling of this vital aspect of their work. Most were starved of resources, both finance and staff, and are also in need of professional advice and expertise and, above all, training.' Despite their emphasis upon entertainment (theatre, cinema etc.), most arts centres (57 per cent) spend less than 6 per cent of their revenue on marketing,

advertising, and publicity. Two-thirds of all centres have no specialist staff at all, and only 3 per cent have more than two.

The style of arts centres

There are two dominant arts centre styles: one is traditionally 'arty', while the other has developed an 'alternative' style in an attempt to establish credibility with 'the community'. The 'arty' style expresses the values of 'legitimate' art: it is based upon arts institutions such as the theatre or the art gallery. It signifies to the potential audience that a level of cultural competence is required to have the confidence to cross the threshold.

This, of course, can work both ways. Many middle-class people would lack the confidence to enter a betting shop: they would not know what to do when they got inside, and would be too intimidated by the apparent 'expertise' of the punters inside to ask.

The informality of most arts centres is, similarly, difficult for the uninitiated to deal with. Where do you go? What are the 'rules' of the place? The 'alternative' style works in much the same way. It is assumed that a tatty atmosphere will appeal to 'ordinary people', and that, for example, serving vegetarian food in the café is more 'community orientated'. Most people, as *Art – Who Needs It?* discovered, found such things unwelcoming or intimidating: 'too much right-on-ness puts too many people right off.' The idea that you want to go somewhere tatty because your economic circumstances mean you can somehow relate to it is, amongst other things, very poor psychology. Most importantly, it ignores people's view of what constitutes a good night out, with its trappings of comfort and attractive surroundings.

The economy of arts centres

It is often revealing to break down an arts centre's budget to discover what makes money and what is subsidized. Invariably, the highest levels of subsidy go to the most inaccessible events. One arts centre I visited in the East Midlands has both a cinema programme and a theatre programme. The cinema attracts a predominantly local working-class audience (being the only one in the town), and makes a small profit. The theatre attracts a more middle-class audience and is heavily subsidized. The aesthetic values that support this state of affairs are translated – through the system of public subsidy – directly

into financial value: the theatre, with its more complex aesthetics, is *worth more* than the commercial cinema.

A more general point concerns the general lack of financial acumen possessed by arts centre staff: as Mulgan and Worpole put it, everyone wants to be in the play but no one wants to sell the tickets (*Saturday Night or Sunday Morning*, 1986). Grant applications to arts funding agencies will focus upon the funding of 'artistic resources' at the expense of marketing and financial skills. This is a process which the funding agencies tend to encourage by spreading their limited resources thinly, so that 'low priority' resources (i.e. non-arts personnel or materials) do not get funded.

The physical accessibility of arts centres

It is an obvious but basic fact that arts centres are more likely to be in middle-class areas than working-class areas. There are, in particular, very few arts centres in or near housing estates, where large sections of the population actually live. Research in Islington and Ealing has suggested that this has profoundly negative cultural consequences.

It is becoming a cliché that the lack of cultural provision for young people on housing estates leads to frustration, boredom, vandalism and crime. Cliché or not, this has created a climate of fear that, for women and elderly people in particular, is very real. It simply means that they are afraid to go out. This cuts them off from any sources of cultural provision – particularly if they have to travel far to reach it.

This creates a cycle of cultural stagnation. There is nobody out at night on the streets and walkways to make people feel safe. Consequently, nobody goes out, and the outside world remains deserted. *Local* arts centres that were easy to reach would help re-create a lively and accessible outdoors.

Lack of mobility is also the product of more practical considerations: for women, child-care often limits the amount of free time to devote to activities that you can 'pop in or out to'. For disabled and elderly people, any lengthy journey can be a major effort. For young people, lack of money is a real problem – as *No Business Like Show Business* identified in Ealing:

> Most young people found themselves fairly trapped within their own local area. Activities were not generally accessible to them unless they were within walking distance of their homes. A youth worker told us that owning a means of transport was a major aspiration of the young people in the area, who saw it as a

key to freedom from the confines of their estates. Most of the interviewees wouldn't contemplate catching buses to activities. Parental concern was a factor in this.

Between them, these factors constitute the social and educational barriers to the achievement of many arts centres' goals. They operate for many people like invisible no entry signs. Those arts centres' cultural value is, therefore, fairly limited. Fortunately this is not always the case: some arts centres have used various strategies to become places of real cultural value to the areas they serve. Their experience provides the foundation of a way forward.

BUILDING POPULAR ARTS CENTRES

A number of arts centres have managed to embrace innovation, diversity, and creative expression on the principle of 'art for all'. These art centres are becoming (or even have become) places of social and cultural pleasure for far wider sections of the community than arts centres hitherto.

Such places are, as I have suggested, in a minority, and many of them are only beginning to realize a broader concept of cultural/artistic value. They are, nevertheless, very important. They provide the seeds of a society where 'the arts' emerge from the ghetto they inhabit to become part of normal life.

Many of the ideas outlined below are explored in more detail elsewhere in this book. The multifarious functions of arts centres makes this an appropriate place to introduce them.

Popular programming

Geoff Mulgan and Ken Worpole began *Saturday Night or Sunday Morning* with the question: 'Who is doing more to shape British culture in the late 1980s? Next Shops, W.H. Smiths, News International, Benetton, Channel 4, Saatchi and Saatchi, the Notting Hill Carnival and Virago, or the Wigmore Hall, Arts Council, National Theatre, Tate Gallery and Royal Opera House?' The answer is as clear in the 1990s as it was in the 1980s.

For better or worse, the majority of people live and experience the commercial culture on a day-to-day basis. It surrounds us on advertising hoardings, our clothes, on TV, and on the radio. The subsidized culture is, by comparison, a marginal and obscure pursuit.

The world of commercial art and culture may suppress diversity,

innovation, and other cultural values in the quest for profit, but it is the only *popular* culture we have. Arts centres are in a unique position to use forms of popular culture to promote a whole range of cultural values.

An excellent example of this approach is the Leadmill Arts Centre in Sheffield. At first glance, the Leadmill doesn't have a lot going for it. Walking south from Sheffield's city centre, past the railway station, you come to a desolate area of nineteenth-century warehouses. Most of them lie empty now – only the pigeons have survived the period of industrial decline. It doesn't need a marketing executive to tell you that it's not the most promising site for an arts centre.

Despite this, the Leadmill is a popular and lively place, whose 300,000 attenders each year are a wide cross-section of young people in Sheffield. It's the kind of place where youth workers are likely to bump into the 'youth' they work with.

The Leadmill's range of activities is not dissimilar to that of many other arts centres: it puts on theatre, dance, cabaret, rock and pop bands, jazz, classical and folk music, and hosts workshops in everything from circus skills to opera singing. Its image, however, is based upon its beginnings as a pop music venue. This image is sustained by the more profitable side of the Leadmill – as a venue for bands and a nightclub/disco.

The discos and bands attract a wide range of young Sheffielders. The Leadmill is particularly keen to provide a facility for Sheffield's many young unemployed people. Their audience surveys and the take-up of concessions on the door suggest very high levels of attendance by people on the dole. The Leadmill has a well-stocked, busy bar and café, making it a place where people can go and enjoy themselves for a night out.

Having developed this audience, they are able to build up crossover audiences for events. A typical night at the Leadmill will begin with a play, revue, or performance from around 7.30 to 10.00 p.m., and then turn into a nightclub/disco until 2.00 a.m. They have used this programming policy to turn disco-goers into theatre-goers and vice versa – an approach that ticket sales suggest is working increasingly well.

Having 'crossed the threshold', the crossover effect can work for people in a number of other ways. Someone going to see a band will be encouraged by advertising inside the building to attend workshops and other events. They will not only have access to this information but the confidence to return.

A popular programming policy can involve other popular arts. The Trinity Arts Centre in Gainsborough has a purpose-built cinema/theatre. The cinema programme is a popular one, making the Trinity the local cinema as well as an arts centre. The Zap Club in Brighton deliberately constructs crossover audiences by putting on shows with a wide range of performers. As Neil Butler, the Zap Club's co-ordinator puts it: 'On a good night, I wouldn't expect everybody to enjoy it, but I would expect everybody to talk about it afterwards.'

Popular programming works at its best when it uses *the art of the possible*. The audience for Roy Hudd or Chas' n' Dave is unlikely to return for a poetry reading, but may come back for an accessible theatre production.

Atmosphere and accessibility

One of the Leadmill's strengths is its use of bar and catering facilities to create a sociable and comfortable atmosphere for its 'target audience'. Other arts centres have used a similar approach to attract a broader range of users.

The Cornerhouse in Manchester is an arts or 'media centre' revolving around a cinema, a contemporary art gallery, bookshop, and video library. The heart of the Cornerhouse, however, is a bar and a café. The glass exterior has been designed so that both are clearly displayed to passers by on the high street (the Cornerhouse, as its name suggests, is situated on the corner of two busy streets). Unlike many other buildings of its kind, the design reflects rather than contradicts an emphasis upon accessibility.

The bar and café are promoted in their own right. They are, as director Dewi Lewis points out, 'the gateway into the rest of the building'. Once there, it is easy for people to drift into the three galleries, which put on a mix of accessible exhibitions (such as an exhibition on 'design' featuring TV programmes, advertisements, and breakfast cereal packets) and contemporary art.

The Watershed in Bristol pioneered this approach, where art can revolve around catering. The Watershed has, however, suffered from an acute lack of public subsidy: although catering and other retail outlets are potentially sources of income, gallery space will always need to be subsidized. The Cornerhouse, on the other hand, although highly cost-effective for an arts centre – receiving only around 30 per cent of its revenue through subsidy as opposed to a national average

of 60 per cent – has benefited from the financial stability provided by the local council's capital investment in the building.

The use of social areas such as bars and cafés to create a welcoming ambience is not automatic. Most arts centres have such spaces, but view them as a subsidiary part of their existence. Most arts centres do not, according to the PSI study, run their bars or catering facilities at a profit. They are invariably poorly designed and under-used.

The importance of these facilities is more than simply the 'gateway to the rest of the building'. It also creates a comfortable environment to be in, and to want to return to. One young black working-class user of the Albany Empire in South East London put it like this:

> You get all sorts of people coming down here, that's why I like coming to the canteen ... all sorts of people, the old, the young, everybody, there's such a good atmosphere. ... I just used to sit there looking at people in the canteen. You can get some canteens where you feel it's not homely, it's not welcoming and it's horrible, you just want to hurry up and eat, and get out of there. Whereas you can sit here for hours and chat away. I do. It's really good. When I first came down here, I felt it's a different atmosphere, a different smell ... it was exciting.
>
> (J. Lewis *et al.*, *Art – Who Needs It?*, 1987)

Atmosphere is, of course, about more than running nice places to eat and drink. Both the Albany and the Cornerhouse have well defined reception areas, with staff to advise people where to go and what to do. An arts centre is not self-explanatory. Easy access to basic information *should* be a prerequisite. The number of arts centres which fail to signpost adequately where they are or where to go once inside is astonishing. It is hard to imagine a commercial venture such as Alton Towers making the same mistake.

Education and the community

Irene Macdonald's report on case studies of arts centres and education in London (*Arts Centres, Education and the Community*, 1987) makes a number of revealing observations. Only one of the venues she analyses appears to attract a range of users outside the middle-class world colonized by the others: Oxford House, in Bethnal Green in East London.

There appear to be two interconnected reasons for this. Firstly, Oxford House does not call itself an arts centre. It is, rather, a

community education centre 'which promotes the arts' through its arts workshop. While this frees it from the taboo of 'artiness', it also means that the centre has looked outside the 'arts network' to forge institutional and community links. This involves local residents' associations, community educational centres, local schools, and formal links with the Inner London Education Authority. This emphasis upon education allows the staff to target their work at the more deprived sections of the community through a well developed educational programme.

This programme is designed to suit the needs of the local population, with workshops on woodwork, furniture making, DIY, handicrafts including leatherwork, soft-toy making, kite designs, batik and sewing, silkscreen printing, and photography.

The Midlands Arts Centre (MAC) in Birmingham has one of the most extensive education programmes in Britain: organizing over 5,000 sessions – including courses and workshops – in 1985–6. This has enabled it to build up a solid base amongst the population, and reflects the view of their director, Robert Petty, that 'an arts centre is a place where people participate in making art'.

The MAC tries to gear the programme to the needs of people in local Balsall Heath, a predominantly working-class district of Birmingham with substantial Asian and Afro-Caribbean populations. Many of its courses are designed with specific groups in mind, whether through street dancing, textiles, or pottery. Their audience research indicates this policy has been successful in attracting large numbers of local people to the centre.

This is substantiated by their work with schools. The Local Education Authority seconded an adviser, Sheila Whiteley, to the MAC in order to initiate a serious education programme with local schools. Working closely with teachers, a class of 25–30 would spend a whole week at the centre, learning and creating within a variety of appropriate art forms. This work would be integrated within a curriculum, rather than being a distraction from it. As Sheila Whiteley puts it: 'if you use a whole week with kids well, you can make a pretty big impact upon them – something that's not possible just by working in schools.'

The role of education in broadening the social base of arts centres is by no means a natural one. Education is, after all, chiefly what divides the traditional arts user from the non-user. The use of educational or educative programmes *could* simply reflect this inequality. The value of an education programme is that, if it is *targeted* and *designed* to

meet the needs and interests of people regardless of their previous experience, it can work to increase access to the arts.

The desire for self-improvement, in its broadest sense, is far easier to engender than an interest in 'the arts' – although the two can, of course, be the same thing. The key here is familiarity. People are far more inclined to begin with a skill they can easily relate to. *No Business Like Show Business* suggests that, on the basis of interviews with women living on housing estates:

> Once they could talk about community arts as something which could fit in and improve their lives without giant leaps of change and disruption, their confidence and enthusiasm grew. They became much more open about what they wanted to do and more imaginative in their own proposals for activities.

It is the perceived *relevance* of the educational programmes at Oxford House, and the Midlands Arts Centre that makes them successful. As Sheila Whiteley says: 'unless you build up an acceptance of the arts as a natural part of life, you're going to cut kids off from the arts later on'.

Education is not only a process but a system, based on schools, colleges, adult learning centres, and other institutions. Many of these institutions – schools for example – are an integral part of our social structure. Others, such as adult learning centres, can provide a focal point for people who are normally denied access to most cultural forms. These institutions are, in two senses, a vital component of an arts centre strategy. The arts team at Oxford House, for example, linked up with local schools to involve local kids in arts projects. Similarly, close links with schools can give young people the chance to use the arts centre as a place of learning.

This is something that other cultural institutions tend to do much more successfully than arts centres. The Geffrye Museum in Hackney, for example, is a well laid out furniture and design museum, with a whole series of rooms done out in the style of historical periods from 1600 to 1940. The museum's close ties with the Inner London Education Authority allow them to run well organized creative and educational programmes with local schools, who make up two-thirds of their visitors. Some art galleries, notably Southampton Art Gallery and Cartwright Hall in Bradford, are adopting this approach with a great deal of success (this is analysed in more detail in relation to the visual arts in chapter 5).

The importance of using schools is not just to capture the hearts

and minds of children and young people. The involvement of children, if handled properly, is a way of involving their parents. This is an approach developed with some skill by community arts groups such as Noname Community Arts near Norwich or Jubilee Community Arts in Sandwell and Dudley, who use schools as a focal point for involving large sections of the adult community (this idea is developed in chapter 6).

This approach involves close collaboration between local education authorities, arts agencies and arts centres. Irene Macdonald argues, in the conclusions to her study: 'It seems clear that local education authorities should consider the lessons arts centres have to teach and apply these more widely. Furthermore, local education authorities should recognise arts centres as a real alternative and resource them accordingly.' Education authorities should, in other words, use arts centres as educational centres. This is true, but it is also true that arts centres need to consider the lessons of educational institutions.

The education system is just one institutional link that an arts centre can develop. Many centres have been successful at making links with various organizations and institutions within the public and voluntary sectors. Jacksons Lane in North London, for example, has been particularly successful in forging links with disability organizations. The CAVE in Birmingham uses links with custodial centres and youth centres to generate activity. The potential here has, again, been most skilfully exploited by particular community arts groups.

Geography and history

Where you put an arts centre is obviously going to determine who uses it. Local pressure to build an arts centre usually comes from middle-class people in middle-class areas. If arts funding organizations give in to this pressure, it is hardly surprising if the centre goes the way of most arts venues. The meek may inherit the earth, but they are unlikely to inherit an arts centre.

Arts centres such as Chat's Palace in Hackney, the Albany Empire in Deptford, the Priory Centre in Acton, the Old Miners' Hall in Consett, the Abraham Moss Centre in Manchester or the CAVE in Birmingham are all situated in working-class districts. This does not secure them a new audience for the arts, but it helps. It is significant that many such arts centres were built or developed not in response to

local pressure, but as a palliative for the social problems of those areas. The CAVE, for example, was a probation service initiative, designed to involve people the probation service could not reach. While it is an arts centre in its own right (with a vigorous outreach programme), three-quarters of its funding comes from the probation service. The Priory Centre, on the other hand, is an Afro-Caribbean centre that was initiated with a philosophy of containment – a legacy of the inner city riots. It is both sad and unsurprising that arts centres like these, catering predominantly for black people, come into existence as an attempt at *containment* rather than *expression*. Both centres have, in spite of this, begun to create their own philosophy and identity.

The current ways of defining and funding the arts can make the siting of arts centres outside middle-class areas a utopian exercise. The failure of the People's Palace – an arts centre built with the idea of bringing culture to working-class people – in nineteenth-century East London was based upon just such a philanthropic notion, taking 'art' (that is 'high art') to the people with a missionary zeal. The People's Palace was, by and large, ignored by the local population and has since become, appropriately enough, part of Queen Mary's College at Mile End. Those arts centres that have begun to succeed have adapted their aesthetic values to suit the local population.

A more sophisticated approach is to use the arts centre as a stage in a process. Perhaps the best example of this is the history of the Sons and Daughters of Liverpool (SADOL). SADOL is a 'cultural club' for young people in Merseyside, based in Bootle, a working-class suburb of Liverpool. After several years of development work, SADOL is to be granted funding to set up a youth arts centre in the area. It is an exemplary story: skilful development work has turned Bootle from a place where nothing was happening into a lively cultural centre that demanded its own arts centre.

SADOL was set up by former youth worker, George McKane. George, inspired by working-class artists such as John Lennon and Van Gogh, felt that young working-class people were, through a lack of money and a lack of knowledge, denied access to the arts. Armed with a few musical instruments and a thick skin ('I'm a hard bastard, you have to be round here'), he set about getting some of the kids hanging around on street corners interested in music workshops. Interest developed, and George introduced the idea of drama workshops. A hard core of young people who had learnt or developed various skills then set about touring youth clubs and schools with

their own sketches and shows, encouraging more people to become involved.

As more young people became involved things began to snowball. Moving from a series of makeshift bases (such as an old warehouse in the Liverpool docks), the range of activities extended to poetry, photography, video, and art exhibitions. Festivals and events were organized, Hull Truck Theatre, Tic Toc Theatre and Red Wedge visited, a record was cut, plays and musical shows (such as 'Laugh, I nearly went to Bootle', and 'Broken Bridges', about two local un-employed kids who committed suicide) were performed. For the young people involved, the experience was exciting and exhilarating.

Without George's experience and commitment (many of their early activities were paid for out of his own pocket), none of this would have started. The secret of SADOL's success, however, has been the involvement of local young people. Having set up the Committee (no one over the age of 19 is allowed to vote), they took on the role of 'arts animators'. As one of the driving forces behind SADOL, Macker (Peter McVeigh) pointed out, 'kids round here who wouldn't normally have anything to do with arts listen to us, because we're scallies just like them. We could say: "we did it, you could do it too".'

SADOL has worked because it began with interests and enthusi-asms (music in particular) people could identify with, and then stretched those interests. It has promoted the values of social pleasure, diversity, innovation, and creative expression in the most vital sense. The arts centre is simply a stage in this process.

Marketing

I have already highlighted the failure of arts centres to publicize themselves successfully and to attract a wide range of people through the door. Those arts centres that have been successful in pulling in new audiences have put considerable emphasis upon a marketing strategy.

The Leadmill in Sheffield has always pursued an aggressive marketing strategy. Their publicity office is an impressive display of posters and publicity material – all produced at an in-house print workshop. While demonstrating how to assemble a do-it-yourself cardboard model of the Leadmill, the co-ordinator, Adrian Vinken explained to me that 'we've always tried to be imaginative and innovative in the way we publicise the place, and it's paid off'. Box

office returns and bar takings are extremely healthy, the Leadmill relying upon their ability consistently to pull in capacity audiences.

In *What a Way to Run a Railroad* (C. Landry *et al.*, 1985) have described the resistance of 'alternative' groups to marketing, and this applies particularly to 'alternative' arts organizations.

Marketing is, none the less, a vital part of any strategy to attract new audiences and participants to art and culture. It also, as used by the Leadmill or the Zap Club, allows arts centres to maximize their earned income, an approach looked at in more detail later on.

Many of these strategies apply not only to arts centres but to a whole range of artistic and cultural activities. Their application is unfortunately neither obvious nor straightforward. It requires an understanding of how specific cultural sectors work. Some will be predominantly commercial – such as broadcasting, film, and video; and others predominantly subsidized – such as theatre and visual arts. In the chapters that follow, I shall look in detail at some of these sectors, with clear implications for public investment in art and culture.

As far as arts centres are concerned, the development strategies I have outlined clearly require carefully planned public investment. There is also an implication that such investment should be withdrawn where little of any cultural value – in the social senses I have outlined – is being generated. These are major political issues, and I shall return to them in the final chapter.

4

COMMERCIAL CULTURE

THE CULTURAL INDUSTRIES

The virtue of the 'cultural industries' framework is that it begins with popular cultural forms that are already part of people's lives. The aim then becomes to use public investment and/or regulation to promote, for example, diversity and innovation. This avoids the problem of trying to adapt and re-sell old forms that have, like theatre, become increasingly less popular.

While the 'cultural industries' approach is a sophisticated development in arts funding, it contains a number of features that need clarifying. Most importantly, what exactly *are* the cultural industries?

In the opening chapter, I suggested that the substitution of the term 'culture' for 'art' meant opening up a great arena of activities that were – perhaps regrettably – beyond the scope of a practicable funding policy. The term 'cultural industry' could apply to any number of things: David Chaney, for example, has written about the department store as a cultural form (*Theory, Culture and Society*, 1983), while the football industry, the 'keep fit' industry and the brewing industry are all undeniably part of British culture. Equally, the traditional art forms, like the theatre, could also be described as cultural industries.

The term 'cultural industries' has, thus far, been associated with a far more limited range of activities. The work of the GLC and the Greater London Enterprise Board (GLEB), through publications such as *Altered Images* (GLEB, undated), *The London Industrial Strategy* (GLC, 1985), and, most importantly, *Saturday Night or Sunday Morning* (G. Mulgan and J. Worpole, 1986), has focused on a few particular areas, notably: publishing, broadcasting, film, video,

50

and pop music. Because of this, the 'cultural industries' have become associated with cultural activities 'that are distributed to a mass audience by technological means, are commercially viable and deal with clearly identifiable cultural commodities, e.g. books, films, videos, records' (report for Sheffield City Council, 1988).

What this suggests is that the application of the term 'culture' in 'cultural industries' is a fairly narrow one. It corresponds, more or less, to the definition of art I suggested in the first chapter: art being a *self-conscious, creative* process, leading to the production of an *object* or *performance* which is an *expression* of something. This means that going to a football match or the pub are outside this realm, since a football match is not a self-conscious expression of anything other than itself, and going to the pub does not – usually at least – produce concrete objects or performances.

The only problem areas are those cultural industries, such as publishing or broadcasting, that involve non-fictional material. The production of TV news or newspapers, for example, may be the results of a creative process, but whether they are self-conscious *expressions* or simply *reproductions* of the world is a matter of debate. This debate can have concrete consequences. In 1985, the GLC's attempts to fund (potential) community radio stations in London were constantly thwarted by their legal department's concerns about what could legitimately be funded under a local authority's arts or cultural powers. Similarly, in British government, it is the Home Secretary rather than the Arts Minister who is responsible for broadcasting.

These arguments, from a semiological point of view, are fairly naive. The news and the soap opera both *signify* rather than reproduce reality, even if they use slightly different codes to do so. In the case of TV news, the multiplicity of news values and editing processes that turn 'an event' into a news story makes claims that the news programme is a reproduction rather than an expression of events fairly dubious.

Nevertheless, it is clearly easier to categorize broadcasting under 'culture' than 'art', because of the breadth of the term culture. The French Ministry of Culture, for instance, has few philosophical problems about dealing with broadcasting. The Labour Party in Britain, on the other hand, has recently circumnavigated the debate by creating a shadow minister for Arts *and* Media.

The concept of the cultural industries has, in this sense, been instrumental in broadening the definition of art – while stopping well

short of any more general concepts of 'culture'. The exclusion of 'non-technological' sectors such as the theatre industry from discussions about the cultural industries can be partly seen in this context. Because the popular technological cultural industries are normally excluded from traditional arts funding, they are highlighted for polemical reasons. While the cultural industries could easily incorporate industries such as theatre, they were neglected in order to *shift the emphasis* of discussions about culture.

The cultural industries have been ignored by arts funding bodies for two reasons. The dominant aesthetic ideology discounts them not so much because they are not seen as 'art', but because they are deemed to have little or no artistic *value*. They are too popular. High levels of cultural competence are not necessary to appreciate them. The other argument for ignoring them is that, since they are already sustained by the free market, they do not *need* public subsidy.

I have already examined these points in some detail (chapter 2). In this chapter I shall look at the cultural/artistic values that have been abandoned by leaving the free market in control, and at the potential for public investment.

TELEVISION

It is hard to overemphasize the cultural importance of television. It dominates our leisure time. The 98 per cent of us with a TV set spend an average of around 30 hours a week watching it. It occupies a place in most people's lives unrivalled by any other form of cultural production.

The growth of television was both rapid and profound. The BBC began the world's first public television service from Alexandra Palace in 1936. The first and only major setback to TV's rise towards ubiquity was the outbreak of war three years later, causing the service to be immediately shut down. Nine months after its relaunch in 1946, it had an audience of under 15,000. Five years later this figure had grown forty-fold to 600,000, and in ten years the audience had expanded 400 times to reach 6,000,000. By the mid-sixties, 20 years on, nearly every household in Britain had a TV set.

Even using the most conservative definition the broadcasting companies spend a great deal on 'the arts'. A House of Commons Select Committee suggested that, in 1981/2, 'the arts' received nearly three times more from broadcasting than from the Arts Council. As the literature on the cultural industries makes very clear, an arts or

cultural strategy that does not involve broadcasting is a nonsense. And yet, in Britain, this is precisely what happens: broadcasting is, in fact, the responsibility of the Home Office.

There is not a great deal most public sector agencies can do about television. Even a regional initiative such as the North East Media Development Council, an EEC and local government funded initiative designed to assist and shape the development of television and film production in the region, is still competing against a dominant national framework. The key decisions about television – its legal framework, who broadcasts, and so on – are taken at a national or international level.

British governments have effectively shaped the form of television today. We have a particular mix of public corporations (BBC) and protected independent companies – protected, at the moment at least, by the lack of any comparable legal competition. There are rules and regulations determining both the funding and the content of British broadcasting, ensuring, for example, that certain amounts of home-produced programming are broadcast, or that the four main channels do not all aim for the same market (as do the three networks in the USA). These have invariably been informed by cultural and artistic considerations, such as the importance of plurality, diversity, and innovation – even if these decisions have come, in recent years, from such an unlikely source as the Home Office, a Ministry more familiar with matters of policing than TV programmes.

British television today is a mishmash of 'public service broadcasting' and comfortable commercialism. The regulations that commit channels to a certain amount and range of production are easy to enforce because there is no 'free market' in TV. The limited amount of television space available to advertisers – ITV and Channel 4 – keeps the costs fairly high and the TV companies fairly rich. They can *afford* to be regulated. They could, indeed, afford to be regulated more than they are. The competitive ethos – the 'battle' for audiences – the channels are obliged to adopt (ITV and Channel 4 to increase their audience to attract advertisers and the BBC to justify politically the level of the licence fee) decreases the inclination to innovate or to diversify. Both channels will tend, for example, to 'play safe' in the peak-time viewing slots, and put out material they already know will be popular. Both BBC and ITV will decrease viewer choice by scheduling similar kinds of programme to clash with one another.

Any analysis of television today is inevitably haunted by the spectres of cable and satellite. The prospect of more channels to

choose from would appear to increase diversity and choice. Left to the freedom of the market place, it usually achieves precisely the opposite. Giuseppe Richeri has demonstrated that, while the intrusion of the free market into broadcast television in several European countries has produced *more hours* of broadcasting, it has led to 'a general homogenisation of programming'.

> In many European countries it can be observed that when one single public can receive programmes transmitted simultaneously by several stations operating independently (whether they are from networks or from single stations) and when all or part of these stations rely on advertising as a determining or exclusive source of finance, a competitive process is set in motion based on the maximisation of the viewing figures and therefore on programming; an effect which normally produces several unambiguous results...

> The quality of programmes tends to move towards the minimum common denominator of public taste, especially during the hours in which viewing is potentially high; while the programmes with a cultural, informative or educational content, where they exist, or the programmes which deviate from the average taste, are diverted towards secondary viewing hours.
> (P. Drummond and R. Paterson (eds), *Television in Transition*, 1985)

The Italian experience has been particularly instructive. The effect of free market competition has created an unstable cultural economy in which only the biggest and blandest – personified by TV mogul Silvio Berlusconi – have survived. This has forced public stations (RAI) and other private stations to modify their programming to suit the dominant taste.

A report by Logica Consultancy into the future of broadcasting in Europe suggests that, come the mid-1990s, cable and satellite will become increasingly significant purveyors of programmes. In this scenario:

> the position for Public Service Broadcasters (PSBs) becomes increasingly problematic after 1995. As the audience for new terrestrial and satellite channels grows, all national broadcasting is faced with some drops in audience share. But PSBs are especially threatened with losing licence fee credibility.
> (Anthony d'Abreu, *Broadcast*, 14 August 1987)

The unregulated introduction of cable and satellite channels in Britain initiates a downward spiral towards the lowest common denominator. The ITV companies and Channel 4 would have their income sliced by a fall in the cost of TV advertising space (there would, after all, be so much more of it). They would need to cut back on the cost and quality of their programme production, and jettison their 'minority' programming as uneconomic. BBC1 and BBC2, faced with this competition, would find the licence fee increasingly difficult to justify unless they too abandoned any commitment to diversity and joined the race for low-cost mainstream programming.

A broadcasting strategy needs urgently to review this threat, and explore ways of regulating what can and cannot be broadcast. The international broadcasting system heralded by satellite makes this process both more complex and more urgent. As Mulgan and Worpole put it:

> The conflict is not a simple one between freedom and state control. It is a question rather of how public safeguards and accountability can be used to guarantee freedoms, both to broadcast different voices and for viewers to experience real choice.... Regulation could be used to guarantee diversity and a wide range of ownership amongst programme providers.
> (*Saturday Night or Sunday Morning*, 1986)

Deregulation, on the other hand, has potentially alarming consequences, as Alan Plater graphically suggests:

> deregulation ... roughly summarised, means cabling the nation from here to hell and back, sticking satellites on every street corner, advertising on the BBC, scrapping all the chapters and regulations, kicking balance into touch, and leaving the entire business, radio and television, national, regional and local to the market forces. It's a fine philosophy, if you believe in the market forces: if you don't, it's the biggest crap game in town.
> (B. Baker and N. Harvey (eds), *Publishing for People*, 1985)

A cultural policy should, Mulgan and Worpole argue, involve increasing the diversity and range of British television by careful regulatory mechanisms, ensuring a wide range of programme production. They are in favour of the expansion of independent production *within this framework*, coupled with the democratization of the broadcasting institutions themselves. Such a strategy may well

require a review of the sources of finance of British TV. This would mean examining various myths about costs to the consumer – something that the Peacock inquiry (*Report of the Committee on the Financing of the BBC*, July 1986) failed to do. Advertising, it is usually assumed, allows us to watch ITV and Channel 4 for nothing. The economists Ehrenberg and Barwise have suggested that, on the contrary, the costs companies pay for TV advertising are passed directly on to the consumer by increasing the price of goods. TV advertising is largely defensive – it protects rather than increases a product's share of the market. It therefore does little to lower the costs of goods through economies of scale (*Television and its Audience*, 1984 and A. Ehrenberg, *New Society*, 14 February 1985).

Using their analysis, ITV costs the consumer *more* than the BBC – we just pay for it in the supermarket rather than through the licence fee. The licence fee itself may no longer be able to absorb the rising costs of TV production. Moreover, the pressure governments can put on the BBC when the time comes around for negotiating an increase in the licence fee also suggests that it does little to guarantee the BBC's independence from government.

No funding mechanism is perfect, but funding parts of the broadcasting system through general taxation – via an independent body like the Arts Council – would, perhaps, equip it more adequately for the future. This public subsidy is not necessarily best spent on a corporation like the BBC. The mix of advertising revenue and public revenue could, for example, be allocated to *types* of programme rather than whole institutions.

This is, of course, a highly complex matter. What is clear is that if our most important cultural form is to embrace cultural values, such as diversity and innovation, it needs both commercial and public investment within a carefully regulated framework. There is, within these guidelines, a great deal of scope for change. What comes first is not particular broadcasting institutions but a system of cultural value. The institutions are merely the means to those ends.

Intervention to develop our broadcasting culture is needed sooner rather than later. Time is running out. The commercial forces behind cable and satellite networks will not hang around now they have been allowed space on the screen. The regulatory problems are far more difficult than hitherto: regulations governing who is allowed to make programmes in Britain does not affect international companies beaming in programmes from other countries. The attempts by Filipe Gonzalez's government to introduce carefully regulated private

channels into Spain's public broadcasting system were partly undermined by Canal 10, a 'Spanish' satellite channel beamed in from British Telecom International's Greenwich ground station. The Spanish parliament's jurisdiction over a production company based in Soho is very limited.

If these issues cannot be settled with European agreements, it may be necessary to introduce national measures to discourage such interference. This could involve heavy taxation on hardware, such as satellite dishes, or restrictions on the rights of companies to advertise on satellite channels. The shape of our popular culture, no less, is at stake.

VIDEO
The cultural potential

The video cassette recorder (VCR) has been a sudden addition to the average household's supply of cultural hardware. The percentage of households with a VCR has risen dramatically from 7 per cent in 1981 to 51 per cent in 1986 (source: British Videogramme Association). If the 1950s and 1960s saw the TV set shift from marginality to universality, then the 1980s has been the decade of the video.

The potential of the video is enormous. The development of low-cost production equipment, such as VHS or the newer Video 8, means that far more people are able to get involved in programme production. This means that people have, in theory, access to a diverse range of programme material.

The reality, at the moment, is rather different. Commercial cultural forces have been able to exploit this new-found freedom in fairly limited ways. The most significant development has been the growth of a distribution network of video libraries, enabling the VCR owner to choose and borrow a video of his or her choice. The stock of these video libraries is usually restricted to feature films: there were, in 1986, 350 million rentals of feature films. This is a significant development for the film industry – particularly the US film industry, with companies such as RCA/Columbia and Warner Brothers dominating the video market. The Broadcasting Research Unit estimated that, in 1986, nearly *15 times* more people in Britain watched a rented film on video than went to the cinema. The British Videogramme Association calculated that the value of video sales and rentals that year came to £435,000,000.

The main use of VCRs is, none the less, much more simple. Most

people use them not as an *alternative* to television, but as a way of *watching more* of it. The evidence suggests (see, for example, D. Docherty *et al.*, *The Last Picture Show*, 1987) that most people use their VCRs to record TV programmes they might otherwise miss. The video may have given the television viewer more choice, but it has hardly broken the mould of television culture. It has, broadly speaking, given people access to more of the same. Without strategic public investment, it will remain so.

The Sheffield TV Group, in a feasibility report into cable television in 1983, argued that while the economics and commercial limitations of cable television made it a source of cultural stagnation, the possibilities of public investment in video could be of real cultural value (*Cable and Community Programming*, 1983). It laid particular stress on the growing network of social and community venues with VCRs: youth centres, social clubs, community centres, educational institutions, workplaces, and so on, have all tended to acquire a VCR in recent years. Here, they suggested, was a network of public viewing centres for a whole set of new and diverse programmes. What was needed was public investment in video production and distribution.

In some areas this has occurred, albeit in an ad hoc and piecemeal way. The growth of 'independent' and 'community' video, stimulated by investment from local authorities, Channel 4, Regional Arts Associations, and the BFI, has, unfortunately, been characterized more by its failures than its successes.

The public sector – close to the edge

An increasing number of workshops (some franchised by the specially designed ACTT Workshop Agreement which sanctioned more realistic rates of pay for workshops) and video groups have received public support in the 1980s – there were over fifty grant-aided groups in London in 1986/7, for example (N. Power and J. Lewis, *Twenty Years On*, 1987). They have, however, made very little impact on most people's lives. The *Videoactive Report* (J. Dungey and J. Dovy, 1985) discovered that in the independent sector 'the average number of copies (of video tapes) sold was only 14 per year, and 80 per cent of the titles sold 5 copies or less'. Mulgan and Worpole write that 'radical broadcasting is thriving on the edge of the mainstream': this is, perhaps, a little too close to the edge!

The fact that some public investment in video has been made, albeit without much effect, is still instructive. It paves the way for larger-

scale investment based on a realistic assessment of its cultural value
and the problems that are likely to occur. It is worth beginning by
restating the question – what cultural value could be accrued by
investment in video?

The general aims of the public investment in video have been rather
confused. The *1985 BFI Yearbook* talks about the 'original and often
radical' work of the publicly subsidized sector, reflecting a dominant
strain of thought that saw the sector as an alternative to the main-
stream, both in ways of working and in the product itself ('integrated
practice'). Investment in such production, it was thought, led to a
diverse audio-visual culture. The problem with this approach is that
it asserts the values of cultural diversity and innovation for their own
sake, rather than putting them in the cultural context of most people's
lives.

This places most of the work of the 'independent' or 'workshop'
sector much closer to the cultural values of the art establishment: an
'alternative' culture created and viewed by the educated middle class.
Who, after all, watches *The Eleventh Hour* slot (the TV showcase for
independent productions) on Channel 4? Who actually goes to most
of the video screenings held up and down the country? The same
people, who, on the whole, have the cultural competence to enjoy
contemporary art, theatre, and the other various pleasures of the art
world. This is, in the end, about as 'alternative' as the Cambridge
University Footlights Review.

Much of this may seem unfair. Nevertheless, it is clear that even
where the intention has been to produce work for a range of audi-
ences, a number of mistakes have been made:

1. Apart from the small number of tapes broadcast on Channel 4,
there are two types of audiences for video. There is the existing
audience that watches videos at home, and there is the potential
audience that sees them at public venues, social centres and insti-
tutions. With a few exceptions, video groups and workshops have
restricted themselves not only to the second, but to small sections
within it. The *Videoactive Report* pointed out that:

> Expectations existed that we would be able to suggest to the
> sector what it had to do to get its work into people's homes, on
> the living room shelf between 'Conan The Destroyer' and 'The
> Evil That Men Do'. However, we have observed that domestic
> VCR use is overwhelmingly purely recreational, whereas most
> of the sector's output is educational, campaigning or agi-

tational. These two audiences, though they may overlap, are very different.

Part of the problem here is lack of investment. It certainly cannot be said, however, that video groups have gone for the main chance. The unwillingness of groups to work within the main forms of distribution and consumption – principally through video libraries – is symptomatic of a number of other problems.

2. The focal point of these problems is the lack of a marketing and distribution strategy. Any serious attempt to create a new form of cultural consumption – in this case watching videos in youth clubs, educational institutions, social centres, etc. – that does not begin with a well planned and well resourced marketing and distribution plan is doomed from the outset. Yet, far from having a marketing and distribution strategy, the sector ignores such considerations at almost every stage. The few distribution agencies that do exist – such as Albany or Concord – complain of the number of tapes made with no clear audience in mind. Where tapes are to have a target audience, the needs and interests of that audience (in matters such as form, style, and tape length) are usually ignored. Audience research is almost never done. Groups invariably fail to include resources for marketing and distribution in their budgeting. Apart from the small increases in the consumption of tapes that the distribution agencies have been able to achieve, almost no serious attempts have been made to establish new networks of viewing centres. The distribution groups are, for commercial reasons, forced to concentrate on the educational and institutional outlets that are already geared up to the use of video. No agency exists to sell the *idea* of video to potential viewing centres ('generic marketing'). It is hardly surprising that the sector has failed to make an impact!

This is more the fault of funding agencies than of the individual video groups. They have funded production and training without any attempt to create a cultural environment for that work. If groups were funded within a marketing and distribution infrastructure, their work would inevitably become more accessible, more entertaining, and more relevant.

3. Groups are often funded to provide a 'resource' to the community. The intention is to 'demystify the process of production' and to enable groups to express their ideas through a mainstream cultural form. For some community video groups (such as Real Time in Reading) this has worked well as a local educational process in

itself. The 'resource' function is, however, usually more ambitious than this: groups 'within the community' are supposed to be able to produce tapes not for the sake of it but for an audience. This usually does not work. When Albany Video reviewed this aspect of their work, they found that they spent a great deal of time and energy managing this resource, only to find that:

a) it did not significantly broaden access to programme making, since most of the groups who came forward were middle-class and highly articulate, rather than from those sections of the population traditionally excluded from production;
b) the tapes they produced were usually unwatchable, made without any clear view of who might watch them and what people might be interested in seeing.

Albany Video have subsequently dropped this side of their work completely. They are moving towards a system used by the Media Arts Lab in Swindon. Rather than simply loan out equipment, they treat their equipment as a resource, which people may or may not be awarded in a form of small-scale grant aid. Priority is then given to particular groups, and to those with clear distribution strategies.

4. Another major element of the subsidized sector's work is *training*: the idea being to train people who would normally be denied access to video production skills. This, again, can work on a purely educative level, teaching people general skills of communication and confidence. Unfortunately, however, much of it is coupled with rather vague but more ambitious objectives. People are trained to produce work for an 'alternative' video infrastructure that does not yet exist, or to work in a television industry which does not recognize such training.

A public investment strategy

The gulf that exists between the commercial video culture and the public sector is at the root of the failure of public investment in video. Here, in many ways, is an example of how *not* to invest in a commercial cultural industry. The aim of such investment should be to instil cultural value *into* that culture – value that investment for profit is unlikely to provide.

There are already clues to how this might be done. A small group in the East End of London, Island Arts Video, co-ordinates the local production of a regular video magazine programme about the area –

A Dog's Life. The group receives a small grant to distribute the tape free of charge through local video hire shops and newsagents, to be borrowed in its own right or to accompany a James Bond movie or *Star Wars*. Simply by plugging into the existing commercial distribution network, *A Dog's Life* has been able to reach a substantial local audience. Although a few other groups, such as Valley in Vale in South Wales, have used this approach, they remain very much the exception. With more resources for production and publicity, their success could be extended much further.

Another group to develop an effective local distribution network is 5hcv in Port Glasgow. 5hcv is one of the many MSC schemes in Inverclyde (Inverclyde District Council Leisure Services alone have 700 people on MSC schemes!). They produce a fortnightly two-hour magazine programme for people in local hospitals, old people in sheltered housing and long stay institutions. The tapes cover local people and events – 'anything and everything' – and reach a regular audience of about 1,000 people. Their physical involvement in the distribution of the tapes means they get constant feedback. They are almost unique amongst independent video groups of this kind in having changed the style of their programmes in response to their own audience research.

A very different example is Trilith Video, a small rural video group based in Bourton in Dorset. Trilith make video tapes 'for and about country people', looking at rural life and rural issues. They are beginning to develop rural distribution networks nationally. A 25-minute tape called, appropriately, *About Village Halls*, offers advice on how to use, administer, manage or establish a village hall. The tape was targeted at rural community councils (RCCs) all over the country (there is one in every county), who will organize regular loans and hires to, say, parish councils or other village organizations. Through this network the tape has reached thousands of people.

It is no coincidence that it is those groups who are most advanced in their awareness of marketing and distribution that tend to produce the most watchable material. As Trevor Bailey of Trilith puts it: 'It's got to be entertaining and it's got to have people that the audience can identify with.' Albany Video has now become a 'distribution led production group'. Their work distributing material for the sector has made them target their production work more successfully. Tony Dowmunt of Albany Video puts it simply: 'It enables us to know what is marketable and what people want that isn't already there.'

This sounds very much like a straightforward commercial imperative. In the case of groups such as Trilith or Albany Video who need to generate income from sales to survive, this is certainly true. What is important about Albany, 5hcv, Island Arts Video or Trilith is their ability to use the mechanisms of marketing and distribution to create something new and different to carefully targeted audiences. Their work, regrettably, only represents a drop in the ocean. How can public investment make a bigger splash?

The key to a video strategy is that it needs to be distribution led rather than production led. This applies both to the existing network of video hire shops (for domestic consumption) and the potential networks of public viewing centres. While both are probably easier to develop on a local or regional rather than a national basis, there are a number of national agreements or initiatives that might act as a catalyst. This might involve agreements with commercial distributors, or the creation of a public marketing and distribution service to channel appropriate productions into High Street hire shops. The first job of a national agency would be to conduct a sophisticated market research project to find out how patterns of domestic video hire might be extended and stretched.

In terms of a public viewing network, there are several agencies who might form partnerships to extend distribution and exhibition. The bid by Telejector – a company making large video projection screens – in the early 1980s to remove televised football from the airwaves in order to sell it around pubs and clubs on an expanded video distribution network, was almost certainly a publicity stunt. It nevertheless highlighted the potential of negotiating agreements with breweries and national entertainment and leisure organizations. The list of *public* agencies who might be incorporated into a distribution strategy is enormous – health, education, leisure, arts, and social services have a vast range of public spaces under their jurisdiction. A little imagination would go a long way.

Agreement with many of these organizations is most likely to come to fruition at local and regional levels. This requires the establishment of local and regional public video distribution and marketing agencies. This would need to be at the forefront of investment in video rather than simply an extra tagged on to production funding. The first stage to be tackled, particularly in the creation of new audiences through new public viewing outlets, is generic marketing. This means selling the *idea* of video – both buying it and hiring it – to a variety of institutions. You need to sell the idea of using video

regularly to teachers and youthworkers, for example, before you can expect them to buy or hire particular tapes.

Although this work needs to be carried out in conjunction with production groups, it is the distribution and marketing agencies that should guide and channel what gets produced rather than vice versa. Part of this process is simply to educate and train production groups to understand the needs of their target audiences. The recently produced *Off The Shelf* (K. Arora and J. Lewis, 1987) marketing guide for video groups is one such initiative. It is only once such a distribution and marketing infrastructure is in place that groups should be encouraged to innovate and experiment.

The video culture that might emerge from this type of public investment has the potential to be creative and exciting. The long-term effects on our visual culture could be quite dramatic. In 1985 the Birmingham Film and Video Workshop worked with a group of young unemployed working-class people from Telford to produce a video called *Giro*. The video was so lively, creative, and *watchable* that it was broadcast on Channel 4 to an enthusiastic response. The group have, since then, gone on to form Dead Honest Soul Searchers (DHSS), and continue, in their own words, to make lively and original programmes 'from a young, working-class point of view, and enable other young people to do what we've done'. Amber Films in the north-east have made a series of soap operas based upon their headquarters – a pub in North Shields. The pub is used as a set and a community base, providing the raw material for the series (*Shields Stories*). The existence of such groups, and their breakthrough onto our TV screens could become the rule rather than the exception. Our pop music industry has owed its diversity and originality to a flurry of activity at the grass roots. The lessons here for our television and video industry are pretty clear: it is a choice between cultural stagnation or cultural vibrancy.

RADIO

The same old song

The importance of radio as a cultural medium is frequently overlooked. The days of cosy evenings spent listening to shows on the wireless were rudely interrupted by television. The radio has, none the less, adapted to this intrusion, and continues to play an important

role in most people's lives. Ninety-eight per cent of households have not only one radio but usually several – an average of 2.7 sets per household. These come in all shapes and sizes: transistor radios, tuners, clock radios, radio cassettes – the old-fashioned radiogram has given way to a variety of portable and adaptable gadgets. JICRAR's audience figures suggest that more than 85 per cent of the adult population in the UK listen in for an average of 20 hours per week.

There are more radio stations on the air than there are television channels – most people will be able to receive at least six legal stations (seven in London) plus a shifting array of on- and off-shore pirate stations. The range of subjects and interests covered is, despite this, far narrower. Although drama, discussion programmes, soap opera, story-telling, educational programmes, specialist subject and specialist music programmes are available, radio output is dominated by chart based pop music, interspersed with chat shows, phone-ins, news and magazine programmes.

The reasons for this lack of diversity or choice are partly economic and partly cultural. Although radio and television in Britain have a similar economic structure – a mix of 'public' stations funded by licence fee and independents funded by advertising – the financial position of radio is far less secure. BBC radio stations are, after all, incidental to a licence fee which is based upon the ownership of TV sets – they are automatically in a weak position to make budgetary demands. Similarly, Independent Local Radio (ILR) stations do not receive the patronage of advertisers that their TV counterparts enjoy. Radio advertising is seen by advertising agencies to be not so much ineffective as lacking in glamour. Either way the radio industry in Britain accounts for only 2.5 per cent of total media expenditure by advertisers.

This economic climate forces most radio stations constantly to maximize the size of their audience – they can scarcely afford to do otherwise. If this means using a standard formula of popular music, news, and chat, then so be it.

Their reluctance to diversify their programming mix is a response to the cultural role radio plays in people's lives. When we listen to the radio we tend to choose stations rather than individual programmes. David Vick, reviewing research on the use of radio (*Independent Broadcasting*, October 1982) points out that two-thirds of radio listeners 'listen to the same station for all or most of the time'. Surveys

in Birmingham and Sheffield, for example, showed that 85 per cent of those who listen to a given radio station at breakfast time will listen to the same station at the same time the following day.

Combined with this station loyalty is radio's role as a *secondary* form of entertainment. Basically, people tend to listen to the radio while they're doing something else – driving, at work, or in the home. In a study of radio listening habits, the Research Bureau found that only 26 per cent of people claim to pay 'a lot' of attention when listening to the radio – compared with 56 per cent who pay 'a little' and 19 per cent who attend 'hardly at all'. This not only makes popular mainstream music and incidental news and chat the most marketable commodity, stations feel obliged to pump it out all the time to avoid upsetting their audience's expectations (T. Twyman *et al., The Psychology of Radio Listening*, 1984).

The deviations from this norm, chiefly BBC Radios 3 and 4 – are part of a very different kind of cultural tradition. These stations – particularly Radio 3 – are firmly within the Reithian mould of 'highbrow' broadcasting. This is, effectively, public subsidy to forms of art and culture that, on the whole, require certain levels of cultural competence, appealing – as audience figures show – to educated middle-class tastes. In this respect, the BBC and the Arts Council work to the same set of cultural values.

The strength of these values can be measured by their apparent immunity from a free-market philosophy. The Peacock Committee contained many advocates of the benefits of market forces – yet their subsequent report made no suggestion of 'privatizing' Radios 3 and 4, which absorb relatively high levels of subsidy. Rather, it proposed exposing the less expensive and more popular Radios 1 and 2 to the rigours of advertising revenue and the market place. Economically this proposal made very little sense. The audiences for Radios 1 and 2 match those for the ILR network – they would be competing for the same advertising revenue in an already shaky economic climate. Such competition would send many ILR stations into economic oblivion.

Radios 3 and 4, on the other hand, have distinct, middle-class audiences on high incomes. They are the radio equivalent of the 'quality' press. They offer very attractive opportunities for a whole new range of advertisers. These services – albeit 'streamlined' for greater economic efficiency – could be sold off with far less risk to the commercial radio sector as a whole.

It doesn't have to be this way

How might the radio network in Britain be revitalized? What role might the medium play in a more dynamic and democratic culture? Clearly, the delicate economic climate and conservative radio listening habits represent serious restrictions. Within these limitations there are, nevertheless, a number of possibilities. There is a great deal of evidence to indicate a general demand for a greater variety of radio services. These fall, broadly speaking, into two categories – 'specialist' or 'community of interest' stations and local or neighbourhood stations.

The success of the pirate radio stations in the mid-1980s – the 'second wave' of pirate broadcasting – identified an enthusiasm for specialist music stations, such as Solar or JFM, and black and ethnic minority stations such as the Dread Broadcasting Corporation or London Greek Radio. An NOP survey in early 1985 suggested 21 per cent of Londoners listened to pirate stations – almost twice as many as those tuning into BBC Radio London. The same survey also detected high levels of interest amongst Londoners for both 'community of interest' and neighbourhood stations (J. Lewis, *The Audience for Community Radio*, 1985). Interest in such stations was most pronounced amongst working-class people and black and ethnic minorities. This came out of a range of desires: for 'community spirit' in the area, for information about 'what's going on', for entertainment, and for the chance to get involved in broadcasting.

The desire for local or neighbourhood stations goes beyond the fare offered by ILR and BBC Local Radio. This is particularly the case in larger metropolitan areas such as Manchester or London. (*Nothing Local About It* by Local Radio Workshop suggested that these stations were not really 'local' at all.) Research by MORI in London (*Attitudes to Radio Listening in London*, 1982), and by the BBC's Special Projects team, suggest a keen interest in things local – whether people, events, music, entertainment, or information.

This would seem to indicate the need for wide-scale franchising of community radio. There is certainly enough space on the airwaves to accommodate several additions to the services on offer (a fact demonstrated by the pirates and acknowledged by the government).

The cultural case for 'community of interest' stations is indisputable. The economic climate for them is, however, a fragile one. Many of them would inevitably compete with ILR stations for advertising revenue, upsetting an already delicate system. In terms of

public subsidy, on the other hand, these stations offer a far more convincing example of cultural diversity and value than Radios 3 and 4.

The wide-scale franchising of local or neighbourhood stations – a thousand flowers blooming? – on the other hand, is a little more premature. It is worth looking at the cultural potential of the existing local radio network before rushing into the creation of a 'third tier'. There are two major cultural shortcomings inscribed within our present system. Most areas receive a public (BBC) and an independent (ILR) local radio service. The political pressure on the former and the commercial pressure on the latter push them towards the bland programming necessary to maximize audiences. They actually provide the listener with very little choice at all.

The other problem with these stations is their distance from their audience. Despite their 'localness', they draw very little upon the localities they serve. There are exceptions to this, and much can be learnt from them.

The Ariel Trust is a radio training project for young people in Liverpool. The Trust was set up in 1982, following the publication of reports that suggested (to no one's great surprise) that although young people spent a great deal of time listening to the radio, they had little access to it and no idea how it worked. Unusually, a small group of people decided to do something about this. Grant aid was sought, and the deputy news editor at BBC Radio Merseyside, Phil Pinnington, left his job to take over the running of the project.

The Ariel Trust's 10–12 week courses are free, and are designed for a wide variety of young people who, for various reasons, as Phil Pinnington puts it, 'would not normally have got anywhere near a radio station'. They have forged links with local schools and voluntary organizations, and their courses are always full. In the five years since the project began, 1,500 local young people have been through the Trust.

The aims of the project are to teach radio literacy – a skill that goes beyond the ability to put a radio programme together. They teach what Phil Pinnington calls 'the ability to say what I want to say in the way I want to say it' – in other words, the fundamental skills of *self-expression* – 'you start with sound, because it is the purest form of communication'.

The project's success stories are many and varied. Three young black former students from Liverpool 8 are now presenting a regular programme on Radio Merseyside, and many other former students have gone on to make radio programmes for the local station. This is,

of course, both gratifying and important, but some of the project's achievements are rather less glamorous. There is the story of the disabled girl, who despite not doing very well at school, was able to prove herself at oral skills, and gain the confidence and experience to become the first disabled person to get a job with Royal Insurance (one of Liverpool's major employers). Or there was Phil Pinnington's description of the tough group from a local inner city school: 'after four weeks I almost gave up, until I spoke to their teacher, and found out that this was the only time during the week when they all bothered to turn up'.

The project has always had close links with the local BBC Radio Merseyside – the station manager is Chair of their Management Committee. This has proved invaluable over the years, giving the Trust access to their studio space when they've needed it, and acting as a broadcasting outlet for some of the programmes made by the students.

These links could be taken much further. The potential of projects such as the Ariel Trust in the development of local radio is enormous. Radio could begin to realize the vision outlined by Bertolt Brecht over fifty years ago.

> Radio must be transformed from a medium of distribution into one of communication. Radio could be the most tremendous means of communication in public life. A vast channelling system – or rather this is what it could be if it could not only broadcast but receive, not only get its audience to listen but get them to speak, not to isolate its members, but put them in contact with one another.
>
> (Quoted in Peter Sketchley, *Fast Forward or Pause?*, 1985)

Or, as Phil Pinnington puts it: 'the goal is to have, eventually, an Ariel Trust in every town and city, and to see sound recording as part of every school curriculum.'

It is this kind of training that will provide the bedrock for a fruitful development of local or community radio. Without it, the role a local or community station can play in the cultural development of our nation is limited. With it, radio could become the focal point of a local galaxy of culture – through music, drama, poetry, local history, news, or any other ways of interpreting the world.

This can only happen, of course, with public subsidy and careful regulation. The Community Radio Association has, for example, a code of practice to ensure that a station works as a source of

expression rather than profit. Simply 'freeing the airwaves' to all and sundry, or offering franchises to the highest bidder, will thwart rather than develop the potential of radio.

The dangers of a free-market approach can be seen by the recent experience of the French. The Socialist Party was elected on a programme to license the many pirate stations in France, to 'open up the airwaves'. This they did. Several years later their failure to think through a coherent radio strategy has created little more than a network of commercial stations playing Anglo-American pop music. Commercial pressures, without regulation or public subsidy, have driven the more innovative or diverse stations to bankruptcy.

It is curious that the possibilities of the radio medium in Britain have never been explored, let alone realized. The answer lies, perhaps, in Phil Pinnington's ominous assertion that 'people in positions of power in this country are terrified of an articulate public'.

CINEMA

The decline of the cinema as a cultural venue has been an unremitting feature of postwar Britain. In 1946 there were 1,640 million attendances in British cinemas, and three-quarters of the population had been to the cinema in the previous year. Thirty-eight years later, in 1984, attendances had dropped to 53 million, and only a quarter of the population had been during the previous year. It is worth asking: is the cinema becoming an obsolete part of British culture?

The portents are certainly gloomy enough to suggest this. Simon Blanchard, writing in 1983, offered a prophecy of doom:

> This extended downward trend in the number of cinemas, the numbers employed in them, size of box office takings etc., has now reached the stage in which the process of steady but stately decline which has been the sector's fate since the early 1960s looks set to accelerate into more or less complete collapse.

> There now exists a distinct possibility that one or more of the main circuits could decide to cease operations altogether, or at least very drastically reduce its activities down to a core of prime city centre sites.
> (*Film and Video Distribution and Exhibition in London*, 1983)

Disaster has, in fact, been staved off. In 1985 audiences rose by 18 per cent, by another 3 per cent in 1986, rising to around 70 million in

1987. Whether this is simply a temporary stop on the inexorable road to oblivion – precipitated by the development of 'multiplex' cinemas and the promotional push of 'British Film Year' in 1985 – it is difficult to say. At the very least, it gives us a little breathing space to consider the future of British cinema.

Why have most people stopped going to the movies? The usual scapegoat is television, whose rise coincided with cinema's decline. Docherty, Morrison, and Tracey provide a slightly more sophisticated explanation:

> Rather than asserting a causal connection between cinema and television it is more accurate to say that the rise in television was caused by the *same* process underlying the decline in cinema attendance. Just as the conditions for the cinema emerged during one phase of industrial capitalism, which created a working class concentrated in large industrial conglomerations, with increased leisure time and a financial surplus; so the conditions for television were created by the rise in real wages, comfortable homes and the emergence of the nuclear family, which was concurrent with the sense that the working-class extended family was breaking up.
>
> (*The Last Picture Show*, 1987)

The rise of television, they suggest, was part of the development of a home-based consumer culture. Quite simply, people increasingly spent their leisure time and money indoors. This is a problem in the general sense that the value of *social* pleasure and public interaction is likely to wither away and die if everybody stays at home. A culture based on privacy may be cosy but it will never be dynamic.

Is it, in the case of cinema, anything more than that? If we were to subsidize cinemas (and, in the select cases of Regional Film Theatres, we already do), would this be anything more than an attempt to halt the drift towards private rather than social consumerism? The commonplace answer to this is that cinema is a qualitatively *better* place to watch a film than on TV or video. John Ellis emphasizes the difference between the cinema and TV as experiences thus:

> The cinematic image is large and high definition, and it is watched in conditions of relatively intense and sustained attention. This produces a concentration upon the activities of looking.... These hold the spectator in a process of pleasurable anxiety, wanting to know, being provided with information,

71

but not all the information in the correct form until the end of the film.

With television, on the other hand, the 'spectator glances rather than gazes at the screen; attention is sporadic rather than sustained' (*Visible Fictions*, 1982). The cinema, in other words, has a power to hold our attention in a way that TV, as normally viewed, generally does not (see, for example, D. Morley, *Family Television*, 1986). We are, according to this argument, more likely to be drawn into the enigmas and resolutions – what Roland Barthes has called the *hermeneutic code* of narrative (*S/Z*, 1974) – of a film if we watch it in the cinema rather than at home on TV.

The authors of the BRU study argue, on the other hand, that: 'Just because cinema was the original home of film, it does not make it the best place to see film anymore than a football ground is the best place to watch soccer.' Most people, according to their survey, would seem to agree: only 31 per cent thought cinema the best place to watch a film, compared with 64 per cent preferring TV or the video.

The truth is, of course, that the two experiences are different: the cinema adds a new dimension to the televisual experience. The value of the cinematic experience is both social – it is a 'night out' – and aesthetic – a medium with a particular power and immediacy.

It is, moreover, an experience with which most people feel comfortable. The cinema has an accessibility that most other 'arts' venues do not share. The commodity on show is, after all, universally consumed on TV and video. The cinema audience in Britain reflects this, being drawn from a wide class and educational mix (D. Docherty *et al.*, *The Last Picture Show*, 1987). This remains true even though working-class attendance has declined more rapidly in the postwar years than the rest of the cinema audience.

The fall in working-class attendance is not altogether surprising. The cost of going to the cinema has risen in Britain more rapidly than in other western European countries or the United States. Since 1955, the price of admissions has increased over two and a half times in *real terms*. It is also more difficult to go to the cinema because there are, quite simply, fewer of them around. In the last thirty years around 3,000 cinemas have closed. This has invariably hit the 'local cinema' hardest, restricting most cinemas to urban centres. Going to the cinema has therefore become more costly both to get *there* and to get *in*, while transport problems inevitably favour car owners.

The decline of the 'local cinema' has hit working-class audiences particularly hard. The BRU survey suggests that the local cinema is viewed much more favourably by working-class cinema-goers than by middle-class ones, and that 'the working class in fact claim that they would attend more if the cinema were closer to them whereas the majority of middle-class respondents claim the location of the cinema would make little difference'. There is also evidence to suggest that the decline in audiences is accelerated by cinema closure. As the BRU study points out: 'in the early 1950s . . . every time a cinema closed 75% of the attendances at that cinema were lost. . . . In other words, the location of the cinema in the local neighbourhood was vital in the formation and maintenance of the cinema going habit.' Thus, when a local cinema closed, only 25 per cent of its patrons would travel further afield to continue their cinema-going.

People are not just put off going to the cinema because their local one is now a bingo hall. Many local cinemas have responded to falling profits by cutting back on maintenance and refurbishment. The local cinema becomes the local 'fleapit' – not a place to go for a night out. Research in Islington on the local Holloway Road Odeon clearly demonstrates this. Despite its high profile site and local people's keen interest in films, people stay away because 'it really is a dive . . . if they did up the Odeon, I think a lot more people would go a lot more . . .' (*A Survey of Arts and Leisure Activities in Islington*, 1987).

How might public subsidy maintain and develop the cultural practice of cinema-going as part of British cultural life? The current policy, as usual, does almost the opposite, by segregating and supporting an exclusively middle-class cinema culture – and a narrowly based one at that. It does so through the funding by the British Film Institute (and, in some cases, by the local authority) of Regional Film Theatres. The audience for these 'art movie' cinemas is overwhelmingly middle class and highly educated (as both the BRU study and *Art – Who Needs It?* discovered, to no one's great surprise).

Investment in British film production – meagre as it is – is also aimed at this new cinema culture. BFI supported productions 'outside the artistic orthodoxies of the film and TV industries' (*1985 BFI Film and Television Yearbook*), producing often inaccessible 'arty' films such as Peter Greenaway's *Zed and Two Noughts*. Funding the experimental and 'unorthodox' in a thriving and dynamic culture is fine – funding it in a dying one is like capping the last two teeth in someone's mouth. The 'diversity' in the cinematic culture that the

BFI is 'supporting' is devalued by its distance from a more popular and accessible film culture.

The problem is not only one of lack of investment but of the style of that investment. Certainly more money needs to be spent to revitalize our cinema culture. In 1986/7 the net yield from VAT on cinema tickets alone was £19 million, while British technical and film production skills made over £230 million in overseas earnings in the same year. The government reinvested a fraction of this back into the industry – around £13 million – through the BFI, British Screen Finance Ltd, the National Film Development Agency, and the Arts Council. In 1985, British Film Year, 151 feature films were made in France, 89 in Italy, 64 in West Germany, 77 in Spain and just 31 in Great Britain. Even Greece, with one-sixth of our population, produced more films (P. Shaw, *National Campaign for the Arts News*, 1987/8).

The problem is not, however, simply one of under-investment. It is difficult to see how public subsidy for film and cinema *in its current form* would help matters. Rather, it would push cinema further towards the position now occupied by the theatre – another bastion of middle-class culture, another temple for the culturally competent.

Investment needs to begin by attracting people back to the cinema. This means public subsidy *not* for Regional Film Theatres but for local cinemas. Money for re-opening them, for refurbishing them, for marketing them. Only then will working-class audiences return to the cinema.

A more comprehensive cultural strategy will build upon this investment by investing in *appropriate* film production for general release. This could work in a number of ways. It might involve productions sponsored by television companies – in the way that Channel 4 does now. It might involve public subsidy accompanied by regulation – a quota system for the percentage of British productions shown on general release, for example.

This may be a complete shift in direction, but if we believe in the cultural value of the cinema, it is a necessary one. One possible model for the future is the Rio cinema in Dalston, a predominantly working-class part of north-east London with a large Afro-Caribbean population. The Rio, with the help of small injections of local authority grant aid (from the GLC and Hackney Borough Council), is beginning to establish itself as a 'community cinema'. Their main problem has been to free themselves from the 'art-house' image which has defined their audience in recent years. They have set about

attracting a mixed local audience in a number of ways: they run a popular programme, mixing commercial and independent films; they have prioritized the refurbishment of the building to improve comfort and atmosphere and they have run other cultural events – such as discos – alongside their film programme in order to attract new audiences into the building.

Such a strategy will involve intervention at both a national and local level. Around half the screens in Britain are owned by two companies: Cannon and Rank. Negotiations for public and private investment in a local cinema programme should begin at a national level. This would allow basic guidelines to be adopted for local and regional investment in cinema. If the audience for cinema begins to grow, the economic climate for investment in British film will grow with it.

READING AND WRITING

The world of printing and publishing embraces a multitude of sins – so widespread that we can scarcely avoid them: national newspapers, local newspapers, free sheets, coffee table magazines, specialist magazines, listings magazines, books about romance, books about what to eat and where to eat it, books with facts in them, books with poems in them, books about books. In terms of what is produced, it is difficult to complain that this is a cultural world without diversity. We can, in theory, choose between the *Sun* and *Socialist Worker*, between Virago and Mills and Boon, between *Marxism Today* and *Woman's Own*.

Most readers, unfortunately, experience only tiny and particular parts of this world. While most people read newspapers, the majority read tabloids such as the *Sun* and the *Star* whose cultural range is limited to celebrities, sex scandals, sport, and a smattering of bigotry. Most people do not read books – and those who do are more likely to go for a Jeffrey Archer than a Jane Austen. Access to this world is determined by two things: distribution and literacy.

The distribution of books, magazines, or newspapers is a costly business. It requires heavy investment in marketing and access to national and regional distribution infrastructures – such as W. H. Smith (which has nearly 50 per cent of the book market in the UK). Substantial financial resources are required to achieve this. This means that the control of the sector's cultural output is concentrated in a small number of large businesses. So, for example,

While there are over 400 publishing firms, 62% of the total market is concentrated with the top 11 firms and 95% of the paperback market with the top nine firms, themselves only a small part of the large communications conglomerates with interest in newspapers, video, television, films, bingo, package holidays and the leisure industry.

(Greater London Enterprise Board, *Altered Images*)

This concentration will obviously shape what gets written and what gets read. It is, nevertheless, quite possible to capture specific and well defined markets for books or magazines. The success of Virago, the Women's Press, *Marxism Today* or *City Limits* in culti-vating a healthy readership shows that in publishing the market place is rather more colourful and bustling than in many other cultural industries. This success is, however, based upon the ability of these publications to exploit fairly small middle-class markets on a profit-able basis. The notion of 'cultural competence' is fairly straight-forward when it comes to reading. Levels of literacy will determine what a reader can and cannot read, whether it's the *Beano* or *The Waste Land*. Writing consists of the nuts and bolts of grammar and vocabulary. These need to be learned and understood before that writing makes any sense. Although grammar and vocabulary operate according to a number of linguistic laws, they are also *referential* – they refer to a complex and turbulent set of cultures – or as Roland Barthes puts it: 'the text is a tissue of quotations from innumerable centres of culture'. This is a process he explores, for example, in *Mythologies*, where he looks at the 'second order system of signifi-cation', the world of 'myth' which enables us to understand (or not) the cultural context of, say, an advertisement.

It is not only complex literary works such as *The Waste Land* or *Finnegans Wake* that require constant reference to other cultural sources to understand them. An accessible novel, for example *Catch 22*, requires enough knowledge of the novel form in order to compre-hend its shifting use of chronology. Magazines and papers such as *City Limits* or the *Independent* require knowledge of a range of cultural and political worlds before they have any meaning.

The world of print and publishing assumes levels of literacy. Access to that world is, therefore, determined not only by what is available but how it is written and what is written about. As Sue Gardiner and Jane Mace make clear, 'literacy is class linked' (B. Baker and N. Harvey (eds), *Publishing for People*, 1985). Being middle class

with a formal education is like having a plane ticket; it gives us access to many different parts of the print world.

These problems are so closely linked to our education system that it is difficult to see how public investment (in print and publishing) would change very much. Certainly the main Arts Council input conforms closely to the aesthetics of cultural competence: their subsidy supports work at the most inaccessible end of publishing, within the great literary traditions of prose and poetry. It is not surprising that a report on Writers and the Arts Council (ACGB, 1981) discovered that 63 per cent of the writers receiving Arts Council awards had been to the universities of Oxford or Cambridge. This is cultural elitism at its most straightforward and, to paraphrase a well known saying, 'it takes one to read one'.

In the last ten years or so, other, more imaginative investment strategies have been tried – usually with very small amounts of public money. The most ambitious of these was the launch, following years of feasibility studies and prevarication, of the *News on Sunday* – a tabloid newspaper offering an alternative to the other popular papers at that end of the market, covering different stories and offering different perspectives. The venture was doomed by a lack of long-term investment and a confusing editorial policy that changed on an almost weekly basis. *News on Sunday* was caught between the desire to compete with its popular competitors and a style and approach that were much closer to papers at the 'upper end' of the market.

Once bitten, twice shy. The failure of the *News on Sunday* will probably prevent any similarly ambitious ideas getting off the ground. This is a pity. In the popular tabloid newspaper sector, more than any other, market forces have operated to suppress almost anything of cultural value. The economic resources required to compete successfully in the industry, and the rampant success of the 'lowest common denominator' approach have created a bland uniformity that represents one of the most powerful forces for cultural stagnation in Britain.

Part of the problem facing any new paper with a different set of messages is the loose regulatory climate in which it operates. The tendency towards monopoly is alarming and unsanctioned – News International, for example, owns 30 per cent of our national daily press (the *Sun*, *Today* and *The Times*) as well as the *Sunday Times* – these being but a small part of an international media empire. A regulation restricting companies or conglomerates to one title would be unpopular amongst media magnates, but, from a cultural perspective

would be difficult to argue against. (Apart from the spurious idea that this might mean fewer papers and, therefore, less choice, it is difficult to see how, in the current climate, there *could* be less choice!) Other regulations, such as the 'Right of Reply' that the Campaign for Press and Broadcasting Freedom has tirelessly lobbied for, or, even better, the regulations governing balance and diversity that control broadcasting, must also be considered. It will, of course, take a bold government to regulate seriously such a politically powerful monster, despite the long-term cultural benefits.

Most investment strategies have concentrated on areas where the investment required is much much smaller. Many of these have revolved around independent publishing and distribution. In some cases this has meant support for magazines such as *Women's Review*, although more strategic investment has concentrated on publishers such as Bladestock (serving writers from the 'Third World and metropolitan minorities') or Bloodaxe (publishing 'accessible' and 'socially relevant' poetry and photography), or on 'independent' bookshops (such as the Sheffield Independent Bookshop) or distributors such as Turnaround Distribution.

While these investments have, as Ken Worpole puts it, 'established new forms of writing, discovered new writers and new networks of readers' (*Reading By Numbers*, 1984), they have, in most cases conformed to traditional notions of literacy and literature. *Women's Review*, for example, promoted women's work within a fairly traditional set of cultural and literary values, while the books published by Bloodaxe, distributed by Turnaround or sold by the Sheffield Independent Bookshop are consumed, on the whole, by a well educated middle-class audience. As Keith Armstrong, veteran of worker/writer groups in the north-east rather disparagingly put it, they 'are pitched towards the world of *The Times Literary Supplement*'.

In many cases, this is due to 'circumstances beyond their control', while amongst the more successful ventures, the level of public investment is very low indeed. Bloodaxe Books, for example, have used successful and popular marketing strategies to keep their level of public subsidy down to 25 per cent. Their director, Neil Astley, has translated their 'philosophy of publishing not just for writers but for *readers*' by, for example, investing in a glossy and popular style of presentation – 'very much against the ivory tower academic approach'. The higher costs of production are offset by an increase in sales.

Turnaround distributes a diverse variety of published material that will not usually be handled by mainstream publishers, material that they feel is socially useful or of cultural value. They distribute for 136 publishers (although the eight largest account for 60 per cent of their turnover) to around 900 outlets (mostly bookshops, although they are trying to widen the range of outlets). Their strategic role is key to the prosperity (or survival) of the diverse and usually small-scale publishers that use them. Despite the 'non-commercial' nature of some of the material they work with, they operate at a low level of subsidy – 2 per cent of total turnover, 14 per cent of the turnover after payment back to their publishers. This is a small strategic investment to sustain a high level of cultural activity.

Sheffield Independent Bookshop is a self-financing 'radical' bookshop. They, like Turnaround, carry a variety of material, and are looking to cater for new markets – particularly Afro-Caribbean and Asian book-buyers in Sheffield. Their financial stability has been advanced by assistance from the local authority. Sheffield City Council enabled them to move to a city centre site by letting them have a building (allocated to the Library Department) at a peppercorn rent, and guaranteeing their bank loan of £100,000 for refurbishment costs. Since moving to the new site, they have benefited from access to passing trade – very important in book buying. A GLEB report on *The Book Industry* (1983) revealed that '50% of book purchases are by impulse. Moreover it has been estimated that these impulse buying decisions are taken within ten seconds of sighting a title'. To prove the point, the move to the city centre has doubled their trade. They have also benefited from the patronage of Sheffield City libraries, who have negotiated a book supply deal with them.

While these investments are cheap ways of generating cultural activity they will, as those involved acknowledge, do little to extend the range of readership. The most exciting cultural developments in this respect are the worker/writer/community publishing groups and the adult literacy publishing projects.

There are now around thirty groups who belong to the Federation of Worker/Writer and Community Publishers, founded at Centerprise Bookshop in Hackney in 1986. These groups have, between them, achieved sales of well over half a million for their publications (see Roger Mill's article in B. Baker and N. Harvey (eds), *Publishing for People*, 1985).

An excellent model of such a group is Bristol Broadsides. Based around ten 'Worker/Writer' groups in and around Bristol, Bristol

Broadsides publishes their work and organizes its local distribution. The writing groups (most were set up by Bristol Broadsides) are based mainly on council estates and in old working-class areas. They are run by a variety of people – the local Workers Educational Association supplies some money for co-ordinators – and bring together working-class people without formal educational qualifications who are, or have been encouraged to become, interested in writing. The groups build up people's self-confidence and develop their work.

Bristol Broadsides then selects work produced by people within the groups (either collectively or individually) and publishes it. Although Turnaround will handle their material for national distribution, most of their sales are local (reflecting the subject matter). Because the publications, through poetry, prose, oral history, autobiography, and fiction, are expressions of working-class people within a local working-class culture, they appeal to a whole new readership. The books are sold, for example, in newsagents on housing estates, as well as being marketed and sold by group members within their own social networks. Phil Smith, the groups' co-ordinator, is aware of the need to market the work to generate audience interest. 'We've won the argument that working-class people on housing estates can write. It's no longer a novelty, so there's got to be a newsworthy quality in the writing.' This means, for example, getting the publications reviewed in the *Bristol Evening Post* – books such as *Bristol As We Remember It*, an oral history project (6,000 sold locally), *Sh ... Mum's Writing*, a book of poetry by women on a council estate (3,000 sold locally) and *Tales of the Rails* by a local railway worker (3,000 sold locally).

Because much of their work is developmental, and in order to maximize sales by keeping prices down, Bristol Broadsides operates on a level of about 50:50 of public subsidy and self-generated income.

Queenspark in Brighton developed a local readership network by selling its working-class autobiography and fiction door-to-door in the local area. The selling system involves area contacts and a network of individual street sellers. Their first book (Albert Paul's *Poverty, Hardship but Happiness*) sold 1,000 copies in a month through this network. Since then, they have been able to sell 2,000 to 3,000 copies of books in one working-class district of Brighton.

Bloodaxe has also developed distribution networks around Newcastle and the north-east, particularly for their more 'local' material – such as local photographer Jimmy Forsyth's book *Scotswood Road*,

or *Bossy Parrot*, an anthology of poems by children from the region. Their local network includes W. H. Smith station bookshops, and newsagents (they have negotiated distribution with the wholesalers who supply them), as well as fifteen local bookshops supplied on an almost daily basis. They have used local publicity networks – particularly press and TV – to the full. The launching of *Bossy Parrot* was a masterpiece of local marketing. The book's material was drawn from the children's poetry competition held over the previous four years in the *Newcastle Evening Chronicle*. This guaranteed local press coverage. Bloodaxe then persuaded the local bus, metro, and ferry companies to display posters in the buses, trains, and ferries, featuring selections from the book (a little like 'Poems on the Underground' on the London Tube, only much larger, more widespread and far more accessible). The launch of this scheme (on a ferry boat) earned them national TV coverage on *John Craven's Newsround*. Local sales have, not surprisingly, benefited from this publicity.

Another area that has established new audiences and new traditions in publishing is adult literacy. The Gatehouse project in Manchester is a community publishing project working mainly with adult literacy classes in the area. This work has broadened out to involve elderly people (residents in sheltered housing blocks) and disabled people.

Gatehouse's publications fill a gap in the whole adult literacy process. Few books are actually written for adult literacy students themselves. The project has set about filling this gap by working with students to produce work by and for them. Like Bloodaxe, with both these and their other 'community' publications they retain, as Stella Fitzpatrick put it: 'an eye to the marketability of something'. Like other successful worker/writer and community publishing projects they have extended the range of writers *and* readers.

Interventions in the world of publishing, whether by regulating the national press to raise standards and increase the range of what is offered, or by subsidizing community publishing and distribution projects, is a difficult process. The realm of literacy is so dependent upon our education system, that battles for increasing cultural value will always take place in the margins (to use an appropriate metaphor). It is this knowledge, above all, that needs to guide public intervention and public subsidy.

POP MUSIC

Many aspects of cultural life in Britain may appear mundane or dull compared with our European neighbours, such as France or Italy. There is one area, however, in which the British undoubtedly excel, and that is pop music. Our pop music culture is rich in every respect. There are tens of thousands of bands up and down the country, playing reggae, African styles, soca, soul, latin, jazz, rap, rock, folk, country and western, blues, rhythm 'n' blues, rock 'n' roll, punk, heavy metal, gospel, bhangra, or just plain old pop music. They perform in the many thousands of venues, large and small, in every town and city.

This wealth of cultural activity is significant in itself. But it has also created the conditions for a successful and highly profitable industry. In 1985, the British pop music industry earned nearly half a billion dollars in overseas royalty earnings. Between a quarter and a third of the world's hit records are British – an extraordinary level of cultural domination. Not surprisingly, many of Britain's wealthiest people are pop stars – Paul McCartney, Mark Knopfler, David Bowie, and Elton John are all multi-millionaires.

There would appear to be no need to intervene in such a successful cultural climate. The free market seems to be doing very nicely. The case for public investment has, nevertheless, been convincingly argued by Mulgan and Worpole, following their experience at the Greater London Enterprise Board (GLEB) related in *Saturday Night or Sunday Morning*. They point out that the state is *already* involved in pop music. It subsidizes thousands of bands through the Department of Health and Social Security, and indirectly controls and promotes sales of records through the BBC – notably Radio 1 and *Top of the Pops*. It simply neither recognizes this involvement nor has a policy to develop it.

The vitality and, in turn, the success of the pop music industry is a product of the large number of non-profit-making and self-exploiting bands, venues, and independent record labels. In the late 1970s the punk and new wave movements had, in their early stages, nothing to do with the major record companies. These movements spawned a whole generation of musicians and styles that the majors were able to exploit, buy and sell, keeping the British music industry one step ahead of its rivals worldwide. In terms of sales, the independents comprise a fairly small part of the sector (around 5 per cent). However, despite their small size, they play an important strategic

role in the sector's development. Culturally, as Mulgan and Worpole point out, they 'act as the Research and Development departments of the major record companies'.

Because they take risks and promote innovative artists, they will discover talent and even test out their popularity. The major record companies can then move in and promote them on a larger scale, without taking any commercial risks at all. If the last two decades have witnessed the rise of British pop music it is easy to anticipate its fall. We have already had a premonition of this in the mid-1970s – a period when the stranglehold of the major record companies threatened to suffocate the industry. A shortage of new bands (apart from those manufactured and marketed by the majors) and new styles created a cultural climate where young people began to feel more and more isolated from the pop music world. The advent of 'punk' rock was, of course, a straightforward rebellion against this commercial elitism. Above all, by asserting that 'anyone can play', it gave young people the confidence to create and perform themselves. The rejuvenating effect on pop music – from top to bottom – was profound.

The record industry cannot rely on these cultural explosions to shake it up. The complex set of social, cultural, and economic forces that generate them do not occur 'naturally' every ten years or so. Indeed, the current state of the industry looks decidedly unhealthy – much as it did in the mid-seventies. Jon Savage, writing about the industry's award ceremony (the BPI awards) in 1988 summed up the malaise:

> The investment required to guarantee worldwide success is huge and only available to a few. Worldwide promotion follows domestic success.
>
> The result is to iron out any individuality: like fellow awards winners Wet Wet Wet, (Terence Trent) D'Arby now offers the 'rock, pop and soul' mix that is the current pop esperanto. The problem with the BPI Awards is that they dominate the landscape to the exclusion of 'minority' or dissenting voices. This landscape is harshly overlit: a seamless flow of leather jackets, Levis, soft drinks and pop nostalgia triggers that loop into one gigantic advert.
>
> Its control of the interlocking media industries means that pop is now not a democratic forum but a club which only the lucky few can join. Here is one reason for pop's failure to reflect

our society or, even, to offer convincing myths of transformation.

<div align="right">(Observer, 14 February 1988)</div>

The guarantee of cultural energy, diversity, and originality (and, in the long term, the commercial success of the industry) lies in public investment. When Mulgan and Worpole argue in *Saturday Night or Sunday Morning* that: 'Without intervention, the opportunities for black musicians, regional musics and minority musics will be dependent on the ebbs and flows of the business, and how far the A & R men [*sic*] see commercial opportunities', they are *not* advocating the subsidy of an autonomous independent culture. Investment in the 'grass roots' of pop music culture will create an energy that will work its way up into the industry's mainstream.

Investment can take a number of forms. At its most sophisticated it can involve strategic strengthening of the non-profitable risk-taking independent sector. The investment by GLEB in Rough Trade and the Cartel in the mid-eighties was an attempt to develop the distribution and marketing of records on independent labels. The nurturing of musical grass roots will usually be small scale and local or regional. Investment can take three main forms:

a) Support for local production by investing in studio facilities that impoverished local bands (and most of them are) can afford. This might range from basic 4-track production, like Contagious Tapes in South London or Red Tape studios in Sheffield, to 16-track (Studio 64 in Middlesbrough) and 24-track (Firehouse in North London or the 24-track studio in the Sheffield Audio-Visual Enterprise Centre). The 4-track studios will be sufficient for making 'demo' tapes, to help bands on their way, while the 24-track studios will be of a professional recording standard.

b) Support for local bands by providing rehearsal space. This can be done through Arts Centres, such as the Dovecote Arts Centre in Stockton or as an extension of studio facilities (all the studio projects mentioned above have rehearsal space).

c) Support for local venues such as the Riverside in Newcastle, the Leadmill in Sheffield, or the Zap Club in Brighton. The key factor here is the support of local magistrates in granting late licences for entertainment and alcohol. The financial problems experienced by Riverside would be solved overnight if they were granted a bar extension – the commercial success of the Leadmill and the Zap Club

is built upon bar profits and the fact they are places to go after the pubs close.

One way of meeting all these needs is by supporting music collectives. These are 'self-help' organizations composed of local bands, musicians, and interested people coming together in order to develop their local infrastructure. A good example is the Middlesbrough Music Collective (MMC), one of the many collectives in the north-east of England. MMC began as a group of 12–15 people meeting in a pub in 1983, and have since grown to a membership of 120. Their aims were to set up a local venue, and to solve the chronic shortage of rehearsal space. After approaching local funding organizations (the local RAA, county and borough councils) and gaining some financial support, they have achieved and surpassed these aims. They now organize and promote gigs every week, and they have set up Studio 64, a recording and rehearsal facility that is fully booked up all year round. The studios are used not only by local bands but by other arts and community groups (such as theatre groups or groups making a video). Although the studio brings in revenue (around £4,000 a year), rates are heavily subsidized to allow maximum possible access – most of its users are, after all, on the dole.

In the future MMC and Studio 64 hope to develop local production by negotiating deals with local cutting plants. As co-ordinator Martin Harvey points out, such negotiations are possible because 'we've got more weight than any individual band could carry, because we're likely to come back'. Another project in the north-east, in the old steel town of Consett, has worked in a similar way. Consett Music has brought people in the town together to promote the performance and production of folk and popular music. The closure of the steelworks in 1981 had a devastating effect on the local economy, which, in turn, meant the closure of the network of workers clubs and the wide-ranging musical culture that they supported. Consett Music has set about retaining and revitalizing this local culture with great success, putting on small and large musical events, and producing and distributing a number of records. John Kierney, one of the driving forces behind the project put it fairly simply: 'After the de-industrialization of the region, we wanted to have a role in determining our own future.'

The breadth of appeal of music amongst young people (and others besides) makes it one of our most egalitarian cultural forms. This is confirmed by the experience of community arts organizations such as

SADOL in Liverpool or Cultural Partnerships in Hackney – you don't *need* to generate an interest in music, you just need to harness and develop it. The health of the music industry as a whole moreover, depends upon support for activity at the grass roots – whether by providing rehearsal space, supporting small venues or small 4- to 16-track studios. It is at this level that new forms – from new wave to bhangra – will develop and permeate upwards.

5

THE SUBSIDIZED CULTURE

THE POLITICS OF ARTS FUNDING

In the opening chapters of this book I analysed the aesthetics that have characterized the public funding of art and culture. While this ideology was conceived as apolitical, its social consequences are elitist and profoundly non-egalitarian.

The political consequences of this are by no means straightforward. For many years, these aesthetics have sustained a curious alliance of political support. For the Labour Party, the principle of public subsidy for something 'worthwhile' came fairly naturally. Art should be subsidized so that everyone can have access to it. When Jennie Lee published her paper *A Policy for the Arts* in the mid-1960s, calling for the definition of the arts to be broadened to embrace the principle of universal access, she gently rocked the boat rather than setting it on a new course. The principle of universal provision was strengthened, even if the practice remained largely the same.

The Conservative Party and other sectors of the establishment were equally happy to endorse a policy that ensured the survival of our great national institutions – chiefly the theatre – and our cultural heritage. Indeed, if the aesthetics that have characterized postwar arts funding have their political home anywhere, it is with the paternalistic conservatism of the 1950s and 1960s.

This political consensus was more the product of prejudice and muddled thinking than anything else. Aesthetic values that simultaneously promote elitism and universal accessibility are, needless to say, full of contradictions. The political instability of this consensus has opened it to attack from both right and left. From a right-wing point of view, expressed by a free-market think tank such as the Adam Smith Institute, public support for 'lame ducks', for example

parts of the theatre industry, is no more justifiable than using public money to prop up the steel industry. The 'people' have, through their preferences in the market place, rejected both. If the market can only sustain a scaled down theatre or steel industry then it is pointless to pretend otherwise.

From a socialist perspective, it is possible to argue that arts funding has been controlled by aesthetic values that benefit neither those in need nor even the majority, but the privileged. This means that the most subsidized art forms have become products of a middle-class culture to be consumed by that culture, or, as Alan Tomkins puts it,

> while it is often very difficult to match a particular cultural form with a particular class or 'taste', it is possible to judge that certain forms such as opera, fine art, painting, etc., have been extensively colonised by a dominant class group.
>
> (GLC, *Campaign for a Popular Culture*, 1986)

How can we promote a popular culture with aesthetic forms that have devalued the popular? Both the socialist and free-market criticisms are, in their own political terms, difficult to refute. Although arguments do not always become political realities simply because they are good ones, it is worth asking: why have they failed to dislodge the hegemony of the dominant aesthetic values?

There are three principal reasons. The first is the power inscribed within the 'arts lobby'. The 'arts' are a *cause célèbre* in a very literal sense. No other cause has such a range of celebrities to speak on its behalf, people whose access to the news media is shared by few other professions. Many actors, even if they earn their living from films or television, will be well disposed to expressing outrage at the closure of a provincial theatre. The charge levelled by the arts lobby at their opponents is predictable but unnerving: anyone who attacks 'the arts', in any shape or form, is to be branded a philistine. Since few people like to be called 'philistine', this is an intimidating accusation. Those of us who seek to redefine culture and cultural value are suddenly lumped together with those who oppose any form of public cultural funding. Since the amounts of money involved are not usually large, politicians are not surprisingly loath to run this particular gauntlet.

Like other forms of hegemony, the dominant aesthetic values also retain their power by absorbing critical elements. Thus, for example, some of the critical voices in the 'community arts' movement were 'bought off' with small grants or assimilated into mainstream activity.

This curious contradiction, whereby critics of the dominant aesthetics became part (albeit a rather small part) of the system they condemned, was only made possible because the propositions offered by many of those critics (from Jennie Lee onwards) tended to be vague and incoherent.

A third more serious defence of the arts is the assertion that money spent on the arts actually creates wealth, partly by stimulating tourism. Surveys have suggested that Britain's art and culture is a major factor in attracting tourists from abroad. Since the Treasury gains hundreds of millions of pounds from tourists through VAT-rated goods and services, the arts can claim to have earned a proportion of this. This is a complex argument, and I shall examine it in more detail in chapter 7. Suffice to say that it is slightly disingenuous (perhaps deliberately so) to argue that arts funding is informed by a considered economic rationale. This implies that most arts subsidy is based upon tourism and the cultural industries – ideas which, at the moment, are still incidental to the values of cultural subsidy.

While this mixture of power, pragmatism, and persuasion keeps the dominant aesthetic in place, it does little to justify it. The art forms protected by subsidy are characterized by their inaccessibility. As a member of one group discussion put it (quoted in chapter 2), they're for 'posh people', and, since posh people can either afford it anyway or else afford to do without it, why not give up the subsidized art forms as so many cultural dinosaurs?

Unless the subsidized art forms can demonstrate a capacity for universal accessibility, and prove their relevance to our everyday cultural life, this question will become increasingly difficult to answer. In this chapter I shall be looking at the potential of the subsidized sectors to broaden their appeal, and at the recent experience of the more innovative and popular groups and venues working in Britain.

THE PERFORMING ARTS

The rise and fall of popular theatre

The popular theatre of Elizabethan and Jacobean England, where players performed to the gentry and the peasantry in the same theatre, did not die because of complex economic, social, or cultural trends. It died because, under a puritanical law in 1642, it was made illegal. When it was restored eighteen years later, it was forced by legal constraints to perform in small theatres to metropolitan high society.

The popularity of the theatre made it difficult to suppress, and by

the end of the eighteenth century 'almost every town of more than about 750 inhabitants had its theatre, and more than half the population must have gone two or three times a year to see some kind of theatrical performance' (John Pick, *The Theatre Industry*, 1985). The nineteenth century saw the theatre shift with the population towards the larger towns and cities. Legal constraints were relaxed, and the Victorian period saw the rise of the second great age of the popular theatre. By the last quarter of the century there were over sixty theatres open in London with capacities of 1,000 or more, playing to largely working-class and lower-middle-class audiences. Charles Dickens described a typical audience upon a visit to The Britannia:

> Among our dresses there were most kinds of shabby and greasy wear, and much fustian and corduroy that was neither sound nor fragrant.... Besides prowlers and idlers we were mechanics, clock-labourers, costermongers, petty tradesmen, small clerks, milliners, stay-makers, shoe-binders, shop workers, poor workers in a hundred highways and byeways. Many of us – on the whole, the majority – were not at all clean, and not at all choice in our lives or conversation. But we had come together in a place where our convenience was well consulted, and where we were well looked after, to enjoy an evening's entertainment in common.

Towards the end of the century, theatre managers realized that there was more money to be made by playing to smaller high-income audiences paying high prices than large audiences paying cheap prices. Middle- and upper-class audiences were encouraged by sophisticated marketing, dress restrictions, seat booking systems and the more genteel plays on offer. The 'pit' gave way to the stalls.

The rise of the cinema in the twentieth century completed the transition away from popular theatre. Working- and lower-middle-class audiences drifted from the stage to the screen. Audiences for the theatre, from that point on, grew smaller and more socially exclusive.

The history of theatre subsidy is an interesting one. Theatre and performance during the second world war was subsidized by two government-led organizations: the Entertainment and National Services Association (ENSA), substantially the largest, an organization bringing a variety of performing arts to the troops and to wartime workers, and the Committee (later the Council) for the Encouragement of Music and the Arts (CEMA).

CEMA began as an organization to help amateur companies, but

soon developed a concern for 'high quality' art, in response to what was perceived as the populist fare provided by ENSA. CEMA proceeded to define itself in terms of a division between 'art' – which they provided – and 'entertainment', which ENSA provided. What constituted 'art' in this respect had very little to do with any desire to promote live or dynamic performances. CEMA's subsidy went, not to new plays and new work, but to tours of classical productions or to established theatre companies playing classical work.

Once war was over, it was, nevertheless, CEMA that survived to become the Arts Council of Great Britain. As time went on, the link between theatre and subsidy became stronger and stronger. The ideology of state subsidy for art and culture was developed along the way. John Pick, accordingly, writes about the *'symbolic* value of state subsidy – it proved you were serious worthwhile art'. The dominant aesthetic values were in place, controlling the purse strings and consigning theatre to a classical culture, where playwrights were not only revered but, in most cases, long since dead.

The Arts Council is now hoist with its own petard. Decades of support for 'art' at the expense of entertainment have made the theatre an expression of middle-class tastes. The majority of people are now alienated by what was, hitherto, the most popular cultural form. Steadily declining audiences have, at the same time, increased the need for subsidy in a downward spiral towards economic and cultural obscurity.

In spite of the history of the theatre, we need to remind ourselves that this is not an inevitable state of affairs. There is nothing intrinsically bourgeois about the theatre. After all, dramas of various kinds are watched every day by millions of people on TV, while a wide cross-section of people floods back into theatres over Christmas to see pantomimes, Christmas, or other live shows. The work of Joan Littlewood and the Theatre Workshop in the East End of London should also be highlighted as one of the most successful initiatives to revitalize the popular tradition of working-class theatre. This tradition has, some would argue, stronger roots in some regional cultures than others. Christine Hamilton, Arts Officer with the Scottish Trade Union Congress (the first of her kind) argues that making links between the labour movement and the performing arts is easier in Scotland because 'there's always been a tradition of involvement in the arts in the Labour Movement up here, and a tradition of working class theatre'.

While it is difficult to justify most Arts Council or local authority

funding for theatre on anything other than elitist cultural or historical grounds, this does not mean theatre and drama is not worth funding at all. A radical and strategic shift in direction might, just might, rescue it from the cultural margins.

Popular theatre revisited?

There are many theatres and theatre groups performing in Britain today. Some are well subsidized and a few are commercially viable, but most survive on a shoestring – carried along by the enthusiasm of actors and directors for performance. This enthusiasm tends to be for the art form rather than any serious attempt to popularize it. There are, nevertheless, a few theatres or companies that *have* tried to break out of the rarefied world of the theatre with some success. Their experience is invaluable.

There has been no shortage of 'committed' theatre groups in the last decade, working in opposition to what is seen as mainstream theatre. A few, such as Bedside Manners or Age Exchange, have successfully targeted and cultivated specific audiences (in these cases, hospital patients and the elderly). The majority have ended up playing in arts centres, small theatres, or community theatres to small audiences of young middle-class people interested in 'fringe' theatre. They have, on the whole, failed to reach beyond this limited audience. There are a number of reasons for this failure. The first, and perhaps most awkward, problem is the image of theatre itself. The funding practices of CEMA and the Arts Council have helped to create a rarefied middle-class ambience around the whole idea of 'theatre'. This is, nevertheless, not insurmountable. A popular or targeted marketing strategy can overcome some of these inhibitions. Unfortunately, most theatre or drama is marketed, consciously or unconsciously, to educated middle-class audiences. The type of publicity (usually 'arty' leaflets or posters with high word counts, demanding a high level of literacy), and the distribution of that publicity (listings magazines with middle-class readerships and mailing lists of 'theatregoers' or attenders of other cultural venues), reinforces the image and the existing social make-up of audiences. A marketing strategy, of course, will only work with the right kind of product. Classical plays, plays about 'issues', plays about plays, or plays about various forms of middle-class angst are likely to put most people off. Their content has social and cultural connotations that most non-theatregoers will not identify with.

Two theatre companies that have attempted to reintroduce popu-
lar theatre are Hull Truck and Tic Toc (Theatre in Coventry, Theatre
of Coventry). Both seek to appeal to non-theatregoing audiences by
presenting popular lively material that 'people can identify with'.
Rod Wilkinson of Tic Toc describes the danger of being 'yet another
lefty theatre group ... we want our plays to be popular rather than
trendy'. Barry Nettleton of Hull Truck outlines a similar approach:
'we've never been a political company *as such*, we never do plays
about "issues" or "agit prop" ... our plays depict ordinary working
class people sympathetically, in a style that aligns us with a popular
audience.' Plays such as Tic Toc's *Meat* or *Hooligans* are aimed very
clearly at a young working-class audience. Other material such as
The Cheeky Chappies World Tour, about two music hall entertainers
in Coventry, are designed much more for older audiences. Hull
Truck's approach is similar, and includes a sophisticated built-in
marketing strategy. Two of their most successful productions have
taken areas of popular culture and used them to attract large cross-
over audiences. *Up and Under* is a story about Rugby League foot-
ballers, a sport dear to the heart of the local population, while
Bouncers is a tale based upon the pain and pleasure of the local disco.
Apart from being intrinsically popular subjects, they have used their
subject matter to market them to Rugby League supporters and
disco-goers, using, for example, ticket deals promoting the play with
a disco.

A similar approach has been developed by groups such as the
Remould theatre company. Two of their most recent plays have been
based upon oral history projects with deep sea trawlermen on Hum-
berside (*The Northern Trawl*) and the working life of nurses (*Close to
the Bone*). The relevance of the subject matter to local audiences has
enabled Remould to attract to local venues and village halls in the
region large numbers of people who would not normally be theatre-
goers (a fact confirmed by their audience research which shows large
numbers of non-theatregoers turning up to their plays).

Marketing involves more than simply producing the right product
at the right price. It involves establishing a high local, regional, or
national profile, using the media effectively and producing good
publicity material designed for a target audience. Both Tic Toc and
Hull Truck are very conscious of these demands. Hull Truck's Barry
Nettleton suggested that they are 'always willing to overspend on
publicity, more than any other area' while Tic Toc are always keen to
'make sure our name is in the local paper at least once a week'. This

awareness means making sure venues have a publicity pack to promote the play, as well as exploring new or more imaginative 'crossover' marketing ploys. Hull Truck, for example, promote their Christmas shows in conjunction with local restaurant bookings for office parties, offering a joint 'night out' package.

They have also linked up with local sports personalities in publicity ventures, and instead of concentrating on traditional audience groups they have targeted their publicity at housing estates. While they have only, as they admit, 'scratched the surface' in their attempts to re-establish theatre as a popular form, they have adopted a new set of standards in reviewing their success. It is not enough to play to capacity audiences, as both companies appear to, unless that genuinely reflects their broad, popular appeal.

Once theatres begin to re-establish credibility with audiences, a key secondary marketing device comes into play – word of mouth. The Theatre Royal, Stratford East has cultivated a local Afro-Caribbean audience by promoting black performers and productions. The Theatre Royal staff emphasize the importance of marketing and developing that audience through word-of-mouth networks (a view confirmed by their own audience research).

Both the Theatre Royal and the Spring Street Theatre in Hull, home of Hull Truck, have tried to make their theatres as welcoming and comfortable as possible. Both have well equipped spacious bars and, the Theatre Royal in particular, have managed to create a 'pub' atmosphere, the bar attracting customers in its own right. Both Hull Truck and Tic Toc also work on the principle that in order to get people back into the theatre, you need to perform outside it. This involves performing in village halls, youth clubs, old people's homes, and community centres. They must be willing and able to perform in a variety of inappropriate surroundings with adaptable sets. As Barry Nettleton puts it: 'we're not precious about what we do. All our shows can be done in the worst possible conditions. Other companies aspire to expand in scale. We don't, because it's important to play small scale venues. For most people, they're a first step towards coming into a theatre.'

Part of Christine Hamilton's role as Arts Officer for the Scottish Trade Union Congress involves trying to extend this principle by encouraging performers to take 'tasters' of forthcoming events into workplaces. Her job is (amongst other things) to provide a link between the Scottish Labour Movement and the performing arts, whether by encouraging trade union sponsorship or by rebuilding

the popular tradition of theatregoing by marketing and direct work-place involvement. This may mean developing what already exists. She is, for example, currently attempting to establish a touring network around trade union clubs, in order to offer audiences something more than 'the racist sexist stuff that normally goes round'.

Tic Toc has been particularly successful at establishing a network of youth and community venues in the Midlands and the North – audiences for which their material is particularly well suited. Their success in building up a reputation in these venues reveals not only the vitality of their work, but the potential of theatre. Who, after all, contributes more to a new dynamic culture – Tic Toc performing a new play to a lively capacity audience in a working-class youth club in Liverpool, or a production of Ibsen playing to a graduate audience in a provincial theatre? If the answer to this question isn't obvious, it is perhaps appropriate to recall Dickens's description of Joe Whelks, the 'average' working-class theatregoer: 'Those who would live to please Mr Whelks must please Mr Whelks to live. It is not the manager's province to hold the mirror up to nature, but to Mr Whelks.'

The rise of theatre, if it is possible, will only take place with careful tending at the grass roots. The work of Theatre in Education projects (TIE), community plays, projects such as Second Wave in Deptford (a drama training and performance group for young local women) or the Bubble Theatre (a touring workshop and performance company who work in areas and with people that the theatre does not normally touch) are all a very necessary part of this process. Their role will be considered later, in the section on participation (chapter 6).

In marketing terms, it is also useful to look at the commercial theatre industry, which usually emphasizes 'entertainment' rather than 'art'. While there are some general lessons to be learnt from the commercially successful theatres, concentrated in the West End of London, their cultural significance should not be overstated. They usually survive on a diet of fairly bland or traditional material in the centres of large metropolitan areas. The economic conditions that guarantee their survival (large and concentrated audience catchment areas, a healthy tourist trade, and an established tradition of being a place to see shows) apply to few areas outside London's West End. We are not going to revitalize popular theatre by putting on *Run For Your Wife* in every town and city.

Dance

Dance is, on the whole, more about participation than performance. Nikki Crane of the South Humberside Dance Project puts it simply: 'It's much easier to get people to do it than to get them to watch it.' How many people have not danced in public at one time or another, whether at a tea dance, in a ballroom, at a disco, or even at a party? Going to watch *other* people dancing is quite another matter. Watching dance can often be difficult and demanding. If a narrative is present in a performance, it is usually too tenuous or basic to capture the imagination of those uninitiated in the language of dance. This is not a problem if, like a pop video, it only lasts three minutes. Since most performances last considerably longer than this, most people will find it incomprehensible or boring. It is the abstract art of the performance world. Like many other subsidized forms, the 'state of the art', modern, and contemporary dance is performance at its most inaccessible. This, with ballet, is where most of the Arts Council subsidy is directed. Audiences are invariably small and distinctly middle-class, an example of culture at its most rarefied. When it comes to participation in the variety of popular dance forms on the other hand, dance, as Nikki Crane says 'is the easiest thing in the world to sell'.

This experience is common amongst the network of dance 'animateurs' across the country, many of whom are involved both in stimulating participation and promoting performances. The South Humberside Dance Project, for example, following some skilful outreach and marketing, has encouraged, on average, 200 people a week to take part in dance workshops and courses in Scunthorpe. The participants tend to be women from a diverse set of backgrounds. The Hull Dance Project has also worked at what animateur Helen Wragg calls 'street level', using working-class youth dance cultures, such as hip hop, to attract and develop activity.

Dance City, a venue in Newcastle, pulls in around 300 to 400 people a week, to do anything from contemporary dance and ballet to jazz dance, tap, mime, aerobics, or even flamenco. A group such as the Hip Hop Alliance in Brixton is in the very forefront of popular culture, adapting and developing a fusion of visual (graffiti art) and performance (new black dance styles) culture. Sheila Whiteley, education adviser at the Midlands Art Centre, suggests that in terms of courses attracting a broad social range: 'dance has been the main success, especially when street dance took off – once the word

spread we would have 300–400 kids turning up over a weekend.'

This is not always the case, of course. These projects have a popular appeal because they have targeted a wide range of social groups using appropriate dance forms and styles. Creating a wide-ranging *audience* for dance is rather more difficult. Groups such as the Phoenix Dance Company or the English Dance Theatre have attempted to do this by playing at 'non-dance' venues such as community centres and schools. Mark Curtis of English Dance Theatre, referring to the inaccessibility of most modern dance, suggests that 'we're unconventional in the dance establishment because we're conventional'. While this (combined with a 'reassuring' marketing strategy) increases their appeal, their audiences are nevertheless quite different from the range of people who come to their base at Dance City for classes and workshops. As Mark Curtis says, 'the people who do it are different from the people who view it – there's very little crossover'.

One way of achieving crossover audiences is by encouraging practitioners to perform. The South Humberside Dance Project attempts this by putting on 'showcases', events with up to 200 local dancers performing in what Nikki Crane calls 'an explosion of dance, with budding ballerinas to local housewives getting involved'. Showcases involve extraordinary mixtures of people and dance styles, with ballet to breakdancing, juggling to jive. Like community plays, the sheer numbers of people involved guarantee its popularity, even if it's only because of the performers' families and friends!

In our culture it has become the nature of dance to be a participative art form. While dance can be incorporated into a popular narrative form by musical and dance dramas such as *West Side Story*, *Fame*, or the films of Fred Astaire and Ginger Rogers, the expressive pleasure of dance on its own is easier to experience than witness. This may change of course. If the cultural codes informing dance change to incorporate different notions of performance, involving other narrative forms or forms of participation, then anything is possible.

THE VISUAL ARTS

Here's looking at you

Visual art manifests itself in all sorts of ways. It refers to art galleries and exhibitions, photography, art in public places, art and architecture, art in the environment, and the whole world of craft and design. Visual cultures surround us in the clothes we wear, advertising

hoardings, the furniture we sit on, the packages our food comes in and even the plates we eat it off. We design our own environments when we choose which wallpaper to use or which colour to paint the walls, according to our own aesthetic criteria.

A free-market economy cannot always afford to promote purely functional commodities. In a world of competing choices, products need to differentiate themselves from one another. They need to look both distinctive and attractive. They are carefully designed and packaged. In the film *Repo Man*, this idea is parodied when the hero eats food out of a can simply labelled 'food' and drinks out of cans labelled 'drink'. In a free market, this functional simplicity seems absurd: competition means commodities need to be differentiated by the way they look, by their 'image' – whether they're beer cans or curtains.

The free market will, of course, only provide commercial artistry if it gives a product an advantage in the market place. This will often be the case, for example, for goods that are sold in shops. In other cases, where perhaps the relation between consumer choice and the product is a little less direct, the cost of commercial artistry will be kept to a minimum. The houses and streets we live in, for example, or the city centres we shop, work, or go out in are usually designed cheaply and functionally, using a tired and tested formula.

The world of subsidized visual art can generally be defined by its non-functional nature. Whether it's in a gallery, in a park, or on a wall, its existence is primarily aesthetic. It is there to be looked at. The relationship between this world and commercial art is informal and incidental. Ideas occasionally float between the two worlds, so that coke cans end up on canvas (via Andy Warhol) and Mondrian's style of abstraction becomes cushion covers.

Although the world of subsidized art is on public display, most people will only experience it when the commercial world uses it to sell something. Most publicly supported art is in art galleries. Most art galleries are visited by tourists and the middle classes. This is hardly surprising. The codes required to understand and enjoy non-representational art are not only complex but intimidating, which is why it is studied at universities and colleges.

Making the visual arts more accessible is a matter of education, context, and form. I shall look briefly at some attempts to do this: in art galleries, in public places, and through the medium of photography. It would be a pity, after all, if most people only had access to visual art through advertising agencies and commercial designers.

Art galleries

Since the era of social reform and the great exhibitions of the 1850s, museums and galleries have been subsidized as free services available to the public. The ideology of 'universal provision' that justifies this subsidy is, in Britain, very strong. For a local authority to charge admission to its art galleries is seen as socially unjust and an abrogation of civic responsibility. Unfortunately, as we have seen, educational and class barriers make the public provision of art in galleries far from universal. In an era in which the provision for housing, education, social services, and health-care is invariably being subject to cutbacks, it is hard to justify free provision of a service generally used by the economically and educationally advantaged.

The situation is not improved by the failure to recognize the problem. Many galleries are either uninterested in integrating themselves more with the cultures of their town or city, or else are denied the resources to do anything about it. Unlike other arts venues (the theatre, for example), art galleries cannot be accused of failing in their attempts to popularize themselves, when such attempts are scarcely ever even made.

There are some notable exceptions to this, and much can be learnt from them. One of Britain's galleries that takes its civic responsibility most seriously is in Southampton. Several years of education and outreach work have made Southampton Art Gallery a more relevant and vibrant part of the city's cultural life. The education and outreach programme is central rather than additional to the gallery's work. Their philosophy is expressed by their education officer, Sue Sangway: 'We're trying to link with what's going on in the city, and to break down the barriers people have about coming into the place.' Or, as outreach worker Isabella Oulton put it: 'We want people who live and work in Southampton to feel that the gallery is *relevant* to them.'

The number of education and outreach staff has gradually increased over the years, not because of additional resources, but because the gallery has shifted its budgetary priorities in that direction. That means, for example, that the education and outreach team has a major input into the exhibitions programme. It also means that they are not shunted off to a particular education room: as Sue Sangway put it, 'We don't have an education space and we don't *want* an education space – our work goes on in the gallery.'

The education programme began by bringing primary and secondary

classes into the building. They would do quizzes, practical work, and workshops based on the permanent collection. These are designed to develop their visual language skills and to make them visually aware, *not* to teach them facts about the history of art and artists. The collection is laid out accordingly, on thematic rather than chronological grounds. The success of this approach is suggested by the enthusiasm of the response: large numbers of the school kids return to the gallery at the weekends after their workshops.

One group of sixty eight-year-olds from local schools was brought back to the gallery five years on. They had, in the early 1980s, worked on a project and an exhibition looking at difficult contemporary art. The education team claimed that, even five years later, 'the experience had completely changed their attitude to art ... they had a real appreciation of modern and abstract work ... it was incredible how much they'd retained. An understanding of contemporary art had obviously been instilled in them.'

The success of this programme led to a demand from parents for similar courses. These began in 1982 – 'Afternoon Art' – and quickly expanded to five adult classes/workshops a week. The network touched by the children's workshops spread to their parents – encouraged by the staff they were now attended by a wide range of people, many of whom had found an art gallery unfamiliar territory. These workshops are now in such great demand that the gallery no longer advertises them. The 'word of mouth' network, particularly amongst parents, even though the courses are not free (charges cover the cost of tutors and materials), guarantees that they are always fully booked up.

The outreach programme was set up in 1986 to build upon this work, and to expand further the number and range of the gallery's users. The principle behind the programme is to establish a link between local people and the gallery. This usually means setting up workshops outside, and bringing them in at a later stage to put work together for, say, an exhibition. The first pilot project involved a mother and toddler group on a 'problem' housing estate (one of the most isolated sections of the population in terms of cultural provision). The success of the project led to its expansion to twelve groups all over the city. Their approach, based upon confidence building and visual awareness, has proved more productive with working-class than middle-class groups. The outreach programme now encompasses a broad range of groups, from people in sheltered housing to Asian women to partially sighted people. Close links have

been established with community development workers and with a variety of other appropriate council employees. They are now coping with the demand they have created for visual arts workshops.

Another gallery to have adopted an education and outreach strategy is the Cartwright Hall in Bradford. The staff try to treat the gallery as a public space rather than a place simply to store art. This means putting on musical or dramatic events in conjunction with exhibitions and seeking the maximum input from the local community when it comes to choosing and contributing to an exhibition. They are particularly keen to involve the large numbers of Asian people who live nearby.

They have set about implementing this strategy in a number of ways. Like Southampton Art Gallery they have an imaginative education programme with local schools. Their Education Officer, Tom Wood, stresses 'the need to talk about the works of art in a way that tunes in to the children's interest . . . to tell them the stories behind it . . . and then teach them to be analytical'. This means, for example, using storytelling as well as creative and analytical work. Like other venues with egalitarian cultural values, the staff emphasize that the benefits of an education programme are not limited to schoolchildren, but are an excellent way of involving their parents. In order to extend this strategy they set up a residency (in this case a printmaker) at a school and community centre next to a large council estate nearby. The printmaker was able to establish links with the local community, not only to encourage them to visit and get involved in the gallery, but to act as, in Tom Wood's words, 'a *host* for those people . . . if people feel there's a friend there they'll feel a little less intimidated about coming along'. These links are exploited by their exhibitions policy. Their exhibition of Islamic calligraphy involved outreach work in Asian shops, community centres, language centres, and other meeting places in both the assembly and promotion of the exhibition. Such an approach involves an open-minded rather than a traditional approach to aesthetic value. Cartwright Hall has, for example, put on an exhibition about pubs: doing the gallery up in a pub style, using the wealth of material from Bradford's many old Victorian pubs, and selling beer mats to the visitors. Another exhibition borrowed from a rather different aspect of popular culture, featuring a display of posters from Indian films. Both exhibitions were not just popular, they succeeded in drawing in a new kind of audience – such as local people interested in either pubs or Indian films.

The gallery's endeavours have enabled them to build up a computerized mailing list of people and groups from the social and ethnic groups they are targeting – as Tom Wood puts it, 'we've no problems getting the white middle classes along to our events'. The staff recognize that they are only just beginning to realize their philosophy of accessibility. Overcoming the cultural connotations that have made galleries a middle-class preserve means, after all, overturning a whole cultural history.

Part of the problem art galleries face is the municipal aura of the buildings themselves – obstacles that media centres such as the Watershed in Bristol and the Cornerhouse in Manchester have found it easier to avoid by building galleries around popular bar and catering facilities. Both the Watershed and the Cornerhouse look more like cafés than art galleries. A further extension of this, of course, is to take visual art out of galleries altogether, and put it into public spaces.

Art in public places

Taking art out of galleries and into the public domain is not necessarily straightforward. It can involve a variety of public places: shopping centres, parks, housing estates, libraries, banks, hospitals – anywhere where people live, work, or take their leisure. It can mean small sculptures, big sculptures, murals, pictures on walls, or features of architectural design. It can take place in collaboration with architects, with local communities, or with public or private patrons. It can be whacky and startling, unobtrusive and mellow, or simply impressive.

The merits of public art are fairly clear. It has the power to add to the visual culture of our surroundings; to stimulate, arouse, or please us, the public. This is all the more necessary in what is, for most of us, sometimes a fairly dreary and functional environment. Beyond this, there are few general rules – except to say that there is not enough public art, and what there is is often half-hearted or inappropriate.

Examples of poor public art are too numerous to mention. John Willett writes about a familiar sight, 'the kind of modern sculpture that gets pinned on to a building as a decorative afterthought or placed off-handedly in a courtyard – what has graphically been called "the turd in the plaza" – all this now tends to be passed with averted eyes by the average member of the public, so that it really represents a dreary waste of talent and money' (P. Townsend (ed.), *Art Within Reach*, 1984). Or there is the ubiquitous tacky mural on a wall

of a council estate, less a thing of beauty than what Alistair McCallum of the Cranhill Arts Project in Glasgow calls 'a badge of deprivation'.

Debates about murals and muralism are echoed in other areas of public art. Murals have been seen as a public art form in its purest sense. Holger Cahill of the Federal Arts Project (in Roosevelt's USA of the 'New Deal') wrote in 1936:

> Mural painting is not a studio art; by its very nature it is social. In its great periods it has always been associated with the expression of social meanings, the experience, history, ideas and beliefs of a community.
>
> (Quoted in *Murals*, 1986)

This philosophy has made murals a common form of public art – they are also cheap on materials and require only a blank wall for a canvas. Although murals are only a small aspect of public art, the 'social role' of the mural has also made it the focus for a debate about consultation – a debate that has implications for public art in general.

Michael Miles, introducing a directory of murals in 1986, wrote that:

> The critical debate is becoming more intense and incisive. Less often now are artists 'parachuted' into a community to do a mural and run. Less often is rotten urban planning covered up by murals. The growth of community art has helped inform mural art and spotlight the need to relate, to bring the community into the planning, design and execution of murals.
>
> (*Murals*, 1986)

Public art is, in this form, both for the public and by the public. The debate about consultation is, unfortunately, not this straightforward. Owen Kelly has written about the way in which murals can 'simply oppress people. They are ideological advertisements. They demand attention from the passer-by in a way which brooks no argument, and they shout at a volume which makes reception compulsory to all but the blind' (*Community, Art and the State*, 1984). An ugly mural does not become a thing of beauty because a few local people have been asked about it or taken part in its execution. A mural may simply be an inappropriate addition to the aesthetics of, say, a council estate. It may look cheap. It is a messy rather than a clean artistic form. In the end, a mural in this context may inevitably appear to be only a more sophisticated version of crude vandalistic graffiti.

There are two points here. Firstly, if consultation is merely an opportunity to have a say about *how* the walls on your local estate are covered in paint, then it is little better than being asked about how your area should be vandalized. Secondly, one of the abiding features of public art is that it takes place in an enormous range of environmental contexts. What is appropriate in one context may look ugly or silly in another. A mural on a council estate may reinforce the prevailing untidy imagery disliked by the tenants. In the glossy uniformity of a city-centre shopping complex, it might be seen as adding a touch of spontaneous life and self-expression.

Consultation is a complex process. It needs to be educational, to develop people's imaginations and *extend* public taste, and it should be open-minded about the artistic options available. This means not only presenting people with options, but providing the time and the resources to think them through. Consultation is, needless to say, not always possible, or even appropriate. How on earth would such a process be carried out for a city-centre development for example? A superficial consultation exercise at this level might simply create a preference for the lowest common denominator.

Investing in the visual environment

There are a number of ways of instituting a public arts policy. The chief requirements, in the first instance, are public regulation and public money. At the regulative level, demands have revolved around the '1 per cent' quota for the arts, the idea that the budget for any public building should include 1 per cent for artistic content. Some local authorities, such as Sheffield, have recently adopted this principle. While this puts public art onto the planning agenda, it does beg a number of questions. These regulations may be easily enforced at the public level, but this will not affect most public building, which in Britain is carried out by the private sector. The regulations can only be enforced as part of a 'planning gain' by local councils, whose leeway is severely limited by the financial attractions of a site and the number of competitors for it. A government committed to removing regulative and legislative barriers in a free-market system makes matters considerably worse. If local authorities are to implement the '1 per cent', they need the legislative authority to do so.

A second problem with the '1 per cent' is that it is difficult to define exactly what it means. Henry Lydiate comments that 'since the

notions of "works of art" and "architecture" have lost their traditional meaning, the principle of integration or synthesis of the arts – inherited from the 1930s – needs to be thought out afresh' (P. Townsend (ed.), *Art Within Reach*, 1984). Art and architecture can be either fused together or separated in a planning process, 'art' can be an approach to design, or concrete 'works of art' attached to or within a building. Work carried out over the last few years on refurbishing and cleaning buildings in Glasgow city centre, for example, has considerably improved the aesthetics of the environment, without requiring a great deal of 'artistic' input. Trees have been planted and small open spaces created to show off the cleaned-up Victorian buildings at their best.

A third question, related to the first two, is one of implementation. There are a number of models of percentage schemes in Europe and the United States, which have operated with varying degrees of success. One of the more progressive schemes was set up in Canada, the '1 per cent to the people' scheme introduced in 1964. This combined members of the local community and the 'art community' to initiate recommendations, thereby providing a 'built-in' level of consultation and artistic input. Two of the main obstacles to successful implementation have been: weak legislative frameworks, allowing tokenistic arts provision of the 'turd in the plaza' variety; and over-bureaucratic structures of control (as in France) which have slowed and watered down plans.

It is worth mentioning some examples of good practice in this area. Newcastle Arts Centre, for example, is not so much an arts centre as a small 'arts development area'. The arts centre is part of a complex of listed buildings near the city centre. These have been developed to provide the arts centre with an economic base, generating income through rental (incorporating flats, shops occupied by groups such as the National Trust, restaurants, and studio/workshop space) and directly through related retail outlets, including an art materials shop, a pottery and ceramics shop, and a picture-framing business. Part of the scheme's development has been the on-site location of various craft workshops/studios, including ceramics, woodwork, glass-making, and silversmiths. This has enabled the direct involvement of a series of artists and craftspeople in the refurbishment and design of the buildings at every stage.

The objectives are twofold: to improve the buildings themselves, and to provide a future base for craftspeople to develop autonomous businesses. Both objectives are well on the way to achievement: the

interiors of the building are exceptional, while the ceramics and the glass workshops are becoming successful in their own right.

While the intimacy and scale of artistic involvement demonstrated in the Newcastle Arts Centre would not be practical or possible in every instance, the principle of constant artistic involvement in the development of public space is a useful one. One of its most sophisticated manifestations has been in the Hospital Arts movement. This is not to be confused with art therapy, which is a healing practice in its own right. It promotes what Linda Moss calls 'the contention . . . that there is an important role for the arts in the hospital environment but outside the context of formal treatment, and that this role can contribute to the healing process' (*Art for Health's Sake*, 1987).

Improving the physical environment in hospitals is more than simply a morale boost for patients. Hospitals are working environments for large numbers of people – nurses, doctors, cleaners, caterers, porters, and so on. Arts projects can turn them from clinical, inhospitable environments to visually stimulating public places. At the new St Mary's Hospital in Newport on the Isle of Wight, artists have been involved in the planning and design of the building itself, although most projects, not surprisingly, have been set up to improve existing interiors. One such is Southampton Hospital Arts, based at Southampton General Hospital, Southampton's second largest employer, dealing with 126,000 patients per year.

The project works in a number of ways. It makes permanent additions to the interior by commissioning artists to do murals or sculptures (such as the 'Rainbow Room' or the 'Disney Room', where pictures of rainbows or Walt Disney characters adorn walls near the children's wards). These are done in close consultation with the staff. This is, as Julie Seddon Jones (the projects worker between 1986 and 1987) points out, 'incredibly important. Everybody likes to feel involved . . . people hate it when something just "appears".' The hospital also now provides space for exhibiting work, whether by well known photographers, by staff and patients, or by local artists, and takes on education work with long-stay patients.

The general issue here is more than simply the provision of public art. It is, firstly, about people having control over the aesthetics of their own environment, and, secondly, it is about incorporating artistic considerations at every stage in the planning, design, and development of public space. This requires not only a shift in consciousness on the part of national and local government, but a shift in resources.

Photography

Photography is part of two quite different cultures. It has, on the one hand, been absorbed by the 'high' culture of the visual arts, with a similarly complex set of aesthetics. It is, on the other, part of a popular form of representation used to celebrate people or events – from the holiday snap to newspapers and magazines. This mixture of cultural connotations has made photography a popular form with community arts groups who have seen it, in Alan Tomkins's words, as 'fundamentally a collective form, it is endlessly reproducible, it becomes increasingly available every day. Photography has become one of the most powerful forms of contemporary communication, and literacy' (GLC, *Campaign for a Popular Culture*, 1986).

While most of us have a camera of some sort, the history of photography as a subsidized art form, within both the mainstream and the community arts, has been characterized by its inaccessibility. The comparative cheapness of photographic equipment and the reproducibility of the image do not, after all, distinguish it from many other visual art forms. Most objects, such as prints or sculptures, can be reproduced or manufactured. The aspects of the photograph that make it a popular form of representation have usually been ignored by the arts world, in favour of the more traditional visual arts culture. The culture of the gallery has ignored the culture of the holiday snap.

Much of this has to do with marketing, style, and distribution. The photographic image is, even at the more avant-garde end of the market, a relatively accessible form with popular reference points in newspapers, television, advertising, and family albums. Attempts to advance the creative development of photography need to recognize and develop that popular platform. The Side in Newcastle, while being based at their own gallery, have tried to develop popular local distribution networks for their work (and the photographers they work with). They will have around six photographic exhibitions out at any one time, travelling around networks of schools, libraries, unemployment centres, and other public spaces. One of their most imaginative ventures involved the production of 900 copies of a large 'book' of photographs of the North Shields Fishing Industry. The 'book' consisted of separate panels that could be displayed on walls – a cross between a calendar and a portable exhibition – and was distributed to shops, pubs, launderettes, schools, and cafés all over the region. Here, at last, was a way of transforming a photographic exhibition into a popular context. The East Cleveland Photography

Project has used a similar strategy to develop a network of exhibition sites in mining villages in the county. These are, again, based in places where people live and work, so that, at any time of the year you can see an exhibition in a village in East Cleveland.

A rather different celebration of photographic images is displayed at the Museum of Photography, Film, and Television in Bradford. The museum's style is to present exhibits in a popular and often dramatic display. The audience are constantly asked to press buttons, ask questions, or make interpretative decisions about photographic and televisual images. This interactive approach to exhibition makes dry or difficult subjects such as the history of photographic lenses or the nature of photography as a form of representation appear lively and intriguing. The people who visit the museum are, as the head of marketing Jean Hunter describes, 'not a traditional museum audience', a fact supported by the museum's extensive audience research. The large number of visitors (around 700,000 a year) spans a comparatively broad cross-section in terms of class, education, and other socio-demographic categories.

The museum's philosophy of 'making it as accessible as possible to as wide an audience as possible' (as Jean Hunter put it) is not unusual. What distinguishes them is their method of display, 'structuring displays so that they're relevant to people' (by the use of interactive technology, where people can, for example 'edit' shots from different TV cameras), and an overall marketing strategy that is geared to this philosophy. The evidence suggests that photography, of all the visual arts, lends itself particularly well to this approach. The success of groups such as the Cranhill Arts Project in the East End of Glasgow, the East Cleveland Photography Project, Building Sights in Balsall Heath in Birmingham, and the Mount Pleasant Photography Workshop in Southampton vindicates this. All four are based in working-class districts with little other cultural provision: Balsall Heath and Mount Pleasant are also multi-racial areas with substantial Asian populations; Cranhill is a housing estate next door to Glasgow's Easterhouse estate, and East Cleveland is a network of old mining villages. These projects have built and developed the photographic skills of local people, created an interest and an understanding of photography, and spread their work through their own local magazines, newsletters, or exhibitions in the locality and beyond.

Judy Harrison has spent ten years developing the Mount Pleasant Photography Workshop. The cultural 'reach' of the project throughout the local community is impressive, and while it owes a great deal

to Judy's hard work and outreach skills, the photographic medium has made it work. 'If you start with what is familiar, you automatically engage people's interest ... and photography is an ideal way of doing that', she says, with the benefit of experience. People *like* looking at pictures of people and places they know. The universality of photographic language also makes it an accessible and multi-cultural art form. The lessons here are very clear. Photography can either be built upon a popular tradition or an 'arts' tradition. The first has the potential to influence our visual culture, the second leads only to obscurity.

6

FROM MASS PRODUCTION
TO POPULAR PRODUCTION

CULTURAL CONSUMPTION AND THE
COMMUNITY ARTS

I have, in the preceding chapters, argued that there are currently two principal approaches to cultural production: the commercial culture governed by the free market, and the subsidized culture governed by an elitist aesthetic. Neither, I have suggested, are conducive to a number of cultural values. They suppress, in their very different ways, diversity and innovation in any popular cultural sense and they are only marginally concerned with creating a more harmonious or stimulating visual environment. I have tried to propose various strategies for changing this unhealthy state of affairs, in order to promote a range of cultural values in the context of British society today.

This argument has, so far, been written substantially and deliberately from the point of view of the cultural consumer. How, I have asked, can we create a more dynamic, rich, and diverse popular culture for audiences, viewers, listeners, and readers? I have used the consumer as a focal point partly because it is as consumers that most of us experience culture, and partly to shift discussion away from the producer or artist. Discussions about art and culture have, hitherto, seen the producer/artist as the source of culture rather than a stage in a process.

The consumer does not, of course, exist in isolation from the cultural process either. Strategies for a popular culture are not just about the technicalities of marketing, distribution, and exhibition – important though these things are. They rely upon the quantity and quality of the cultural products, and, by implication, upon the organization of production. It is for this reason that I have suggested specific investment strategies in the cultural sectors in order to stimu-

late production that, from the consumers' point of view, enhances the cultural values I have been advocating. I have tried to locate particular sites where investment or regulation in production would be most effective. This is not a simple or a straightforward exercise. Much of the well intentioned investment that I have examined (in, for example, the video sector or in arts centres) has failed because it has not been geared to the complexities of cultural consumption (see chapter 4). There has, nevertheless, been a recurrent theme throughout. A successful investment strategy will usually involve, at some stage, investment at the level of popular or grass roots production.

The case for promoting greater involvement in cultural production is based upon the notion of self-development. The benefits for people's lives, in terms of self-expression, personal fulfilment, and quality of life, are fairly clear. The value of such activity is not, however, restricted to those involved. The cultural effects spread from the bottom upwards. From one perspective, it would add an enormous 'research and development' wing to the cultural industries, making them more innovative, diverse, and popular. From another, it would create a cultural democracy, a 'society in which people are free to come together to produce, distribute and receive the cultures they choose' (Shelton Trust, *1986 Culture and Democracy Manifesto*, 1986).

The principle of popular participation in cultural production has been one of the abiding concerns of the community arts movement. It is no coincidence, then, that some of the groups and organizations to which I have referred would be designated (if not by themselves, by funding agencies) as community arts projects. The focus upon participation by community artists or advocates of 'cultural democracy' is, for Owen Kelly, based on the notion that: 'The acts of production and consumption are ... two complementary classes of activity, neither of which is inherently right or wrong, but either of which, performed in isolation from, or ignorance of the other, is on its own incomplete' (*Community, Art and the State*, 1984). Cultural consumption is 'admittedly interesting, illuminating and sometimes important', but it is downgraded as an experience in relation to the 'primary activity' of 'direct participation in the production of a living culture'.

While popular participation in cultural production is of benefit to the individuals concerned and, ultimately, to culture itself, this emphasis upon participation is not without its problems. Most cultural production, if it is worth doing, is worth consuming. Videos, films,

plays, and performances are made to be watched, music is made to be listened to, books are written to be read. It is, moreover, the consumption of culture that gives it its social meaning and significance. Cultural activity, by its very nature, usually involves more consumers than producers. There are exceptions to this on the more intimate or local level, but in an age of broadcasting and mass technological reproduction (from the printing press to the VCR) this is necessarily so. Even if we were all involved in some form of cultural production, we would inevitably spend more time consuming than producing.

The tendency of community artists to treat production and consumption like an enormous disco, where the minority (the producers or the dancers) have all the fun and the consumers are relegated to the status of wallflowers, looking on, has led to a number of problems. The failure of an arts project to appreciate or understand cultural consumption has, all too often, decreased the value of the cultural activity it has generated. It has led to art that either no one wants to consume (because the needs and interests of audiences have never been considered), or that no one is able to consume because it has not been properly marketed, distributed, or exhibited. Community art has, in this way, marginalized itself.

It is partly for this reason that many community artists, and others, have become uncomfortable with the very term 'community arts'. Alistair McCallum of the Cranhill Arts Project in Glasgow is particularly dismissive: 'We're not a "community arts" project – "community arts" sounds so amateurish ... we don't want to be a branch of social work.' This is a view that is reflected by many of the more successful erstwhile 'community arts' projects. As the authors of the *Campaign for a Popular Culture* observed, 'the word "community" suggests simplistic, low budget, and low technology production – an approach which can seem, on occasion, to imply a lowering of expectation and standards' (GLC, 1986). These feelings of unease are the product of a cultural practice that has sacrificed cultural consumption to the god of participation.

This is not to belittle the value of popular participation in production. Broadening the base of cultural production is, as I have suggested, a necessary part of a process of cultural regeneration. How this is achieved is not a simple matter, as the generally unhappy history of investment in the community arts would seem to indicate (see chapter 3). My concern in this chapter is to propose more effective strategies for increasing access to cultural production, based upon the experience of some of the projects which have been most successful in

promoting popular participation. I shall begin with a more general look at the 'community arts' and their problems.

THE COMMUNITY ARTS GHETTO

The community arts movement developed in the 1960s and 1970s from a number of related cultural strands. It brought together in a rather muddled form a number of practices: bringing art *to* the community, promoting art *in* and *by* communities, and *representing* communities ignored by the dominant culture. It incorporated a range of 'radical' or 'alternative' approaches. It was not, as Owen Kelly has demonstrated, a theoretically homogeneous movement with well defined objectives. It defined itself in a negative sense, in opposition to a dominant elitist culture, adopting the slogan 'let a million flowers bloom'. The Association of Community Artists was formed at the beginning of the 1970s, and although they successfully lobbied the Arts Council to fund a number of community arts projects, the main concerns of public funding, both economically and culturally, lay elsewhere. Responsibility for the community arts was passed on to Regional Arts Associations (RAAs) following devolution from the Arts Council in 1982. The RAAs were, as more 'local' organizations, more sympathetic to the community arts, and the 1980s have seen local authorities and the Manpower Services Commission show increasing interest in community arts activity. It is seen as cheap, requiring little capital investment, and being generally socially worthwhile.

Despite some notable exceptions, the community arts movement has, unfortunately, failed to achieve, or even look like achieving, its broad objectives. It has failed to make art and culture more accessible to most people. Far from challenging or storming the citadels, it has remained a harmless and irrelevant skirmishing on the sidelines. There are a number of explanations for this.

Perhaps most importantly, the community arts movement has let the elitist aesthetics of the dominant subsidized culture off the hook. Most community artists were opposed to this cultural elitism, and yet, by forming a separate entity, 'the community arts', they allowed themselves to be appropriated by it. The public funding agencies could defuse criticism by funding the community arts as an *additional* (and rather small) category. This kept the dominant cultural aesthetic entirely in place. In some ways, it even strengthened it – arts

113

funders could divert critics by pointing at the smattering of community arts groups carrying out socially useful deeds on their behalf.

While some remained unhappy with such an outcome, others were all too ready to accept a role as *complementary* to the funding of the prestigious arts. The history of the GLC administration of 1981 to 1986 is an example of this. The Arts and Recreation Committee originally planned to fund a substantial community arts programme by *diverting* funds from its existing budget, which included the English National Opera, the London Festival Ballet, the Royal Opera House, and the London Orchestral Concert Board. In the event, faced with the opposition of the more powerful sections of the arts lobby and a hostile press, they capitulated. Tony Banks, the committee chair, succeeded in persuading his colleagues to increase the overall arts budget to allow for the new development at no cost to the old.

The ties between the old and the new also numbed the popular impact of the community arts. The audience research carried out by Comedia to find out who had benefited from the several millions of pounds spent by the GLC's Community Arts Sub-Committee was not encouraging. The audience for (and users of) the community arts was, on the whole, no less middle-class and had as many educational qualifications as traditional arts audiences. They were simply more left wing (J. Lewis *et al.*, *Art – Who Needs It?*, 1987).

There were many reasons for this. Some derived, as I have suggested, from an emphasis upon participation in production at the expense of cultural consumption. Because of this, projects usually had little idea about their target audience or how to reach them. Marketing was usually counterproductive (appealing to middle-class tastes) or non-existent, while distribution and exhibition strategies were either 'tagged on' to a production or ignored.

Another problem was that in the rush to embrace the 'new politics', the community arts neglected some of its founding principles. The politics of anti-racism and anti-sexism, of support for disadvantaged or oppressed groups such as people with disabilities or lesbians and gay men, *displaced* rather than developed class politics. In the subsidized arts, where class and education are the key variables separating who benefits and who does not, such a shift was often one step forward and two steps back. Most working-class people were as alienated by the community arts as they were by the traditional. It is symptomatic that, in a survey of the GLC's community arts groups, less than 1 per cent worked on housing estates where many working-

class communities are based (GLC, *Campaign for a Popular Culture*, 1986). This sometimes meant that groups took what Alistair McCallum describes as 'the middle class view that the working class is restricted to problem groups, like smackheads and people that like stabbing other people'.

It is hardly surprising that some of the more effective 'community arts' groups feel inclined to drop the phrase altogether. A campaign for a popular culture this was not.

The history is not entirely gloomy. A number of groups up and down the country have evolved from the community arts movement to begin to promote popular participation. Their experience tells us a great deal about the value of this level of cultural activity. They focus not upon making the right gestures but upon effective working practices. As the Real Time video group put it, 'It's no good *looking* accountable ... having a "representative" management committee or whatever ... it's the way you work that matters.'

Before outlining strategies for increasing access to cultural production, it is worth emphasizing the status of such an endeavour. Popular participation should be part of, not incidental to, an overall cultural strategy. It is only an additional or separate category of arts activity in so far as it focuses upon access to cultural production. While some of this activity will legitimately ignore the quality or nature of the product in order to concentrate on training or on the benefits of the creative *process*, most of it will be geared towards forms of cultural consumption.

PROMOTING PARTICIPATION
Gaining credibility and confidence

Encouraging people who do not, traditionally, get involved in artistic or cultural production to become involved requires a proactive approach. As Sylvia King of Jubilee Community Arts puts it: 'It's no good just putting a sign on the door saying what you are doing.' A proactive approach means, first of all, locating activities in accessible places for your target groups – on a housing estate for example. It also means going out into a locality and marketing yourself, otherwise known as outreach work. The more experienced groups in the field emphasize two broad principles for successful outreach work; establishing *credibility* and giving people *confidence*.

Building up credibility and trust can take time. Projects such as Valley and Vale in South Wales, the Mount Pleasant Photography

Workshop in Southampton, and Jubilee Community Arts in the West Midlands have spent many years building up formal and informal relationships with local people. Noname Community Arts, who work on housing estates in or around Norwich, began by doing 'lots of face to face work just to build relationships with people'. They will 'begin by visiting everybody, and laying on social events that don't necessarily involve "arts" at all'. When Nikki Crane of the South Humberside Dance Project wanted to set up dance workshops with women on a housing estate in Scunthorpe, she began by putting on coffee mornings. She was then able to overcome people's lack of confidence, and persuade them to give it a go. The group that she brought together have since become a lively dance workshop, and despite initial qualms ('you've got to be joking!') have gone on to perform at local events. There is, of course, psychology behind successful participation. Ann Consadine of Second Wave, a young women's drama group in Deptford, is aware of 'the need to understand people's hidden interests'. Many of these revolve around the desire for social contact – such as being with friends or making new friends. 'From the moment that people meet together, you have to create social and emotional links between them.'

Real Time, a community video group in Reading, have spent some time perfecting their own workshop technique. 'It's important to give space to people's embarrassment, so we've spent some time developing the way we work, to give people confidence, and make sure it's not just the pushy people that get to do things. We also use various games and exercises to develop people's confidence in front of the camera.'

It helps, of course, if you have an accessible base in the locality from which to work. Amber Films in the north-east have taken the innovative and imaginative step of buying and running a pub in North Shields, in order to provide a community base for their work there. The pub has not only allowed them to extend the range and depth of their local contacts, but provides them with a venue and a film set for their series of soap operas (*Shields Stories*). Jubilee Community Arts went for a similar approach by setting up a photography project in a local pub, with the agreement of the landlord. They began by simply taking pictures themselves and showing them, and by encouraging people to bring their own photos in.

Gaining people's confidence not only involves using 'non-arts' or social activities as starting points. It means using the right kinds of arts activities in the right way. The recent survey of potential arts

involvement on housing estates in the London Borough of Ealing (LSPU, *No Business Like Show Business*, 1987) made this point very clearly:

> It was a striking feature of the interviews that if we began by asking people what they did in their free time and told them about some of the more 'arty' activities that community arts had to offer, we were frequently met with blank disinterest or puzzlement. It was only when we began to discuss other aspects of their lives, like children, homes, schools, etc. and developed the idea of community arts from those starting points, to illustrate its relevance to them, that they responded positively. Once they could talk about community arts as something which could fit into and improve their lives without giant leaps of change and disruption, their confidence and enthusiasm grew. They became much more open about what they wanted to do and more imaginative in their own proposals for activities.

A good example of an activity that a number of groups have found successful in involving a cross-section of local people is the fireshow – an event that encourages a number of different kinds of participation. This will involve building a bonfire which will be, in itself, a work of art. It may be constructed as a building such as a castle, a creature, or a person (preferably an unpopular one). It might involve a performance, a play, music, dancing, processions, or elaborate costumes in the lead up to or during the bonfire itself. The potential range of artistic activities is both wide and variable. As rural arts specialist Dof Pollard points out, 'it allows lots of different groups to get involved in lots of different ways', whether building the bonfire, making the costumes, or taking part in the procession. It is also an exciting and entertaining event to witness. One of Dof Pollard's ventures at the village of Skinningrove in the north-east attracted 3,500 people, in a village with just 400 homes.

Other groups such as Cultural Partnerships and Noname Community Arts have also used fireshows with great success. At Moxley in the West Midlands, Cultural Partnerships set up a fireshow based upon people's frustration with local bureaucracies. The 'Castle of False Promises' was duly built, and a show performed involving a group going to the castle with a peaceful petition, only to be reduced to a zombie-like state and thrown out. Once the audience is won

over, the castle is stormed and, in the moment of triumph, burnt down. The event was, not surprisingly, enormously popular both with the participants and the residents of Moxley.

While much of the most imaginative work is, like the Moxley fireshow, relevant in both form and content to local people, the politics are implicit and experienced, rather than displayed. Ann Consadine emphasizes the dangers of political sloganizing: 'young women feel safe about Second Wave because it doesn't have a separatist feminist image'. Since, as she says, the group 'want to talk about feminism to *everybody*', it is important to remain accessible rather than off-putting. It is all too easy for community arts groups to fall into the trap of assuming the universality of various left-wing political discourses and to ignore their intimidating cultural connotations.

When Valley and Vale worked with a group of young people in a mining village following the closure of the mine, the politics of the video they produced were based directly upon their own experience. 'Staying for the sake of the valley' was a personal and moving response to a future without any obvious means of employment, a commitment that had meaning for everybody in the area. This statement developed, needless to say, from Valley and Vale's use of cultural forms that were immediately attractive to the young people in the area: video and music. George McKane of the Sons and Daughters of Liverpool has also found music the most powerful attraction for getting young people involved in cultural production. George has used this enthusiasm to offer a wider range of options, from drama to poetry – art forms that might have been ridiculed had they been introduced from the outset.

Finding out people's interests necessarily involves a certain amount of research – something that is done all too rarely. There are, of course, very different approaches that can, if used skilfully, generate interest in quite different ways. 'You might', suggests Sylvia King, 'begin with something gimmicky and very up front, like a video box or a self-portrait photo booth.' This then provides a starting point for all kinds of other activities, depending on people's ideas. Sylvia recalls 'one group of girls who giggled while they were having their photos taken, who we discovered were interested in drama'. The group have, with encouragement, gone on to, quite literally, act upon this interest.

Joining the professionals

The process of achieving credibility is, only rarely, about being 'just the same' as the people with whom you are working. Most of the more successful experienced groups adopt a very professional approach. Keith Armstrong, a 'literary animateur' in the north-east will begin by introducing himself in these terms: 'I'm a professional writer with certain skills – do you want those skills?' Or, as Judy Harrison of the Mount Pleasant Photography Workshop puts it: 'I don't see myself as a community arts worker. I'm a photographer that works with the community.'

It is, perhaps, more common for groups of this kind to use an informal, easy-going, amateur approach, in the belief that this will be 'less intimidating'. As *Art – Who Needs It?* clearly suggested, this is a mistake. All the available evidence confirms Phil Cope's (of Valley and Vale) view that 'working-class people are used to things being done properly and professionally'. Professionalism works at a number of levels. Simply at the level of appearances, if something *looks* amateur, it is likely to be treated as such. If people are going to devote time and possibly money to something, it needs to be seen to be of value, something worth doing. A knockabout workshop in a tatty community centre will simply confirm most people's cynicism about the quality of services they are invariably offered. Alistair McCallum's view that 'a community centre should look like an airport lounge', with its comfortable and professional ambience, is a much more effective way of negotiating this cynicism.

Sue Sangway's education unit in Southampton Art Gallery describes a revealing illustration of this: 'the audiences for our weekend courses were beginning to tail off, until we quadrupled the price from £2.00 to £8.00. The response was tremendous. After we raised the price we could fill the courses three times over . . . people said "if it's only £2.00, it can't be worth giving up a whole weekend for".' While such price rises will not always be appropriate for people with comparatively little disposable income, the point is clear enough. If it looks cheap, it will be treated as such.

The courses in sound broadcasting run by the Ariel Trust in Liverpool may cost nothing, but the young people 'who wouldn't normally get anywhere near a radio station' who take them respond to the professionalism with which they're run. As Dof Pollard says, 'you turn up when you say you're going to turn up'. Alternatively the Cranhill Arts Project have 'deliberately offered things that people

119

here could get jobs with ... the skills that people have learnt here can be turned into job skills'. In an area of high unemployment, this is a serious issue. This is not to propose a series of Youth Training Schemes – quite the opposite. While the Youth Training Scheme has an image of training young people in dull, useless, or menial skills, these projects begin by offering skills people enjoy and desire.

The key word here is motivation. The workers at Cultural Partnerships 'emphasize the importance of quality products ... of always working towards something rather than presenting a series of aimless workshops'. People will, in other words, respond to the incentive of producing something concrete – whether it's a performance, a video, a photographic exhibition, or a T-shirt with their own design printed on it. Moreover, as Judy Harrison points out, 'People demand a high standard in order to gain self-esteem.' Keith Armstrong, similarly, talks about 'the application of professional standards to community arts', an outlook he has, like others in the field, arrived at through experience:

> I'm much more interventionist and directive than I was. . . . I used to be much more woolly and laid back. I think it's good to focus on an issue and be product based, otherwise you end up doing interminable workshops which are often just an ego trip for those involved. I'm now interested in getting a high standard product out of what I do.

Alistair McCallum also recognizes that 'one of our mistakes in the past was that there was nothing to aim at'. Cranhill Arts now sees the importance of people seeing their work exhibited, whether in a photography exhibition or on a T-Shirt. This orientation does more than increase the motivation to participate. If the product is well produced, it is more likely to be consumed. This increases the cultural value of the activity for all concerned.

Marketing, distribution, and exhibition

A number of projects promoting participation are not concerned with the final product. This has been a contentious issue in the past, with groups adopting positions somewhere along the continuum of the 'process versus product' debate. Groups such as Swindon Media Arts Lab have tried to move away from the confines of this argument, discovering that the most interesting things happen when, as co-ordinator Martin Parry says, 'you marry process and product'. A

concern for the quality of the final product is, in other words, part of the process of participation.

There are, nevertheless, groups such as Real Time community video, for whom the educative process itself is paramount. Like the Ariel Trust in Liverpool, Real Time use technology to teach the fundamental skills of self-expression. They are *training* projects in the best sense, using professional techniques to develop ability and awareness. Too many groups, unfortunately, offer the worst of both worlds, combining poor training with aimless cultural activity. The poverty of the product is excused by the 'value' of the process of producing it, while the training is constrained by the confines of the production process.

It is, however, not enough to be concerned with the cultural value of what you are producing. 'You need', argues Sylvia King of Jubilee, 'to build a distribution and marketing plan into every product'. If the product is worth seeing or listening to, its value depends upon it being seen and heard. Many groups, particularly those in the community arts, are extraordinarily resistant or incompetent when it comes to marketing and distribution. The authors of *What a Way to Run a Railroad* (J. Landry *et al.*, 1985) have traced the history of this failure, unearthing its roots in misguided notions of ideological purity.

The degree to which this failure remains unrecognized by community or radical arts groups is staggering. It accounts, more than anything else, for the marginality of this kind of cultural activity. Those groups who refuse to accept such a peripheral role tend to share Phil Cope's view that 'It's all about marketing. If capitalism can sell people pink toothpaste and convince them that they need it, then we can sell them something that's relevant, useful and entertaining.' Valley and Vale accordingly make sure that their work is well publicized and well distributed.

Like Island Arts Video, they distribute their videos through local video shops with publicity posters to accompany them. This gives them the confidence to 'think big': to put on, for example, international festivals like La Lucha, mixing the familiar male voice choirs, with the new, such as the Bristol School of Samba. The publicity campaign for La Lucha pulled out all the stops – 'We created an atmosphere by the publicity that was almost bigger than the event itself.' This is not hype. It is simply effective marketing.

Distribution and marketing do not *have* to take place on an elaborate scale, as long as the target audience is built in to the production

process. Swindon Media Arts Lab gives out small grants to local groups who want to produce a video or photographic work. They will, first of all, encourage groups to think professionally about the process: 'We've learnt to be very careful about what we're offering. We will, for example, make the cost of the equipment here part of the grant, to make clear its cost and value.' This induces a professional attitude amongst people who use the equipment in a way that simply operating as a 'resource', as Albany Video have found, does not. Martin Parry, the Media Arts Lab's co-ordinator, goes on to stress that a professional production attitude is not enough: 'We will try to encourage an applicant to think carefully about their audience, and how they're going to organize a distribution strategy in order to make sure that they see it.' The Swindon project is then able to transmit its more watchable material to 12,000 homes on a local cable network.

Albany Video adopted this approach in the production of the *Downham Tape*. The tape was part of an oral history project organized by a social worker with elderly people on a housing estate in south-east London. The fifty copies sold locally are used both informally (people borrowing it from one another) and at regular local screenings. The tape was successful because it was geared to a specific target audience.

Just because a project is 'community' orientated doesn't mean it cannot have a significant cultural impact. Projects such as Bristol Broadsides, Queenspark Books in Brighton, the Side in Newcastle, the Mount Pleasant Photography Workshop (with their locally produced news magazine *Step Forward*) have all developed effective local marketing and distribution strategies.

Marketing does not need to be limited to promoting the product – it can also stimulate participation. A good example of this approach was developed during the 'Lincoln Community Play'. The play, performed in Lincoln to large audiences in the summer of 1987, was planned and conceived a year and a half in advance in order to attract maximum participation. People were encouraged to get involved not only in the play itself (with 120 local people performing), but in the oral history research behind it, in planning and administration, making costumes and sets, and in a variety of subsidiary publicity and fundraising activities. The core team began by promoting participation with an ambitious outreach campaign, visiting schools, corner shops, launderettes, pubs, and clubs to get people involved. Enthusiasm was maintained and developed by a regular newsletter (delivered

round the housing estates by a team of local kids, named by adminis-
trator Dawn Williams the 'BMX Bandits') and a whole series of
events and marketing devices. Competitions were held; badges and
T-shirts sold; jumble sales, socials, and fun runs were organized; two
large murals were painted on the main streets through the town
centre; rock benefits and other musical events were put on; they even
managed to get other plays produced and performed in community
centres and various local venues. The greater the activity, the greater
the momentum.

The success of the play can be measured not just by the numbers
involved in the actual performance, but by those involved in the
build-up to it. Some of the groups which were set up to take on
subsidiary cultural activities have continued to work together and
develop long after the play finished.

In rural areas the task is sometimes more difficult – particularly
where a project requires building-based resources. Rural projects
have a natural tendency to become itinerant, travelling from one
village to the next. Some projects have overcome the problems of
providing access to resources by putting them on wheels. North
Cornwall Arts has converted a bus into a mobile arts studio, with
facilities for screenings and a variety of arts workshops. The Travel-
ling Centre (also known as 'Elsa') can base itself at whichever village
hall or rural meeting place it likes. A similar approach is used by the
East Cleveland Photography Project, whose mobile darkroom
travels around the old mining villages in the county.

Arts development – the DNA of cultural activity

Arts development work should involve a constantly evolving popu-
lation. An active group or organization will aim to work with new
people as often as practicable, in order to promote the widest possible
participation. The 'bums on seats' measure of cultural impact,
whereby groups were judged for the purposes of grant applications
partly by the *number* of people they touched, as audiences or partici-
pants, has long been derided. 'It is the quality of involvement that
matters, not the quantity', has become a familiar complaint. Ad-
vocates of the 'qualitative' approach have, unfortunately, thrown the
baby (or, more accurately, the baby's bum) out with the bathwater.
While smaller numbers may mean a more sophisticated level of
involvement, how many people you reach *does* matter.

The emphasis on quality of involvement is no more or less important

than the need to extend that involvement as far as possible. One of the most effective ways of achieving this is to equip people with the skills and knowledge to establish themselves as an autonomous group – what Martin Parry of Swindon Media Arts Lab calls 'transferable skills'. Groups such as Valley and Vale, Jubilee, and Noname Community Arts are committed to this way of working. They operate as cultural catalysts – first stimulating and encouraging people's involvement, then teaching and developing skills with the objective of providing the wherewithal necessary for their autonomy.

While this development work revolves around cultural activity, it is dependent upon a whole range of subsidiary skills. An arts development agency needs to be able, like DNA, to reproduce itself. This means that the ability to make a successful grant application, financial acumen, understanding of marketing, publicity and distribution, administrative and even developmental skills need to be passed on. Noname contrast this approach with what they call 'hit and run' community arts: 'You need to leave people with the confidence and the ability to do things themselves. That means involving people in the processes *around* activities, like booking rooms or producing leaflets.'

Valley and Vale will try 'to set up autonomous groups, right from the word go'. The original grant application, along with other subsidiary activities, will be done in partnership with the potential group from the outset. This does not mean abandoning groups to the big wide world before they can cope. Even after new groups have shown they are able to work on their own, Valley and Vale will regularly visit them to see how they are getting along, and help out with any problems they might be having. It is partly for this reason that Phil Cope describes Valley and Vale in terms of community development rather than community arts. Sylvia King, similarly, describes Jubilee 'not as a community arts project, but a multi-media development agency'. The name you give it is, ultimately, not that important. What matters is the dynamic cultural activity it generates.

Grabbing them young

There are, as I have already described, a whole range of existing channels to go through to reach people who would not normally get involved in cultural activity. They may be institutional, like social services departments, youth and community workers, or educational establishments. It may involve working with tenants' groups, social

clubs, or voluntary organizations. It may simply mean going to places where people meet, such as pubs, launderettes, or cafés. Despite the many options, there is perhaps one method of encouraging participation that groups have used more successfully than any other. It is by working with children.

Whether through playgroups, schools, youth clubs, or on the street, involving children and young people in cultural activity, if it is done well (unfortunately, this is usually a big 'if'), can be enormously profitable. Barry Nettleton of the Spring Street Theatre in Hull describes their work with schools as presenting the opportunity to 'grab 'em young – if you can get them to come into a theatre just once...'. The long-term effect of cultural activity can be profound, as Southampton Art Gallery and the Mount Pleasant Photography Workshop have discovered. They have experienced children's ability to retain artistic skills and perceptions and use them, as they grow up, in their own self-development (see chapter 5).

Cultural activity is often used as an educational dustbin. It is seen as a way of occupying kids who do badly at school, a way of making school a little more entertaining. While this may not be the best of motivations, it is understandable. The survey into arts provision on housing estates in Ealing (LSPU, *No Business Like Show Business*, 1987) discovered that:

> The overwhelming response of interviewees was concern about the lack of provision available for young people. This was the case whether they were parents or not. Even people with no apparent interest in our enquiries would say 'do something for the kids', as they closed the door. Concern was expressed for three reasons. Firstly, there was the anxiety of parents for their children.... Secondly, interviewees were disturbed by the groups of young people 'hanging around' the estate with nothing to do. Perceptions of the problems of the estates were focused on young people.... Thirdly, parents wanted relief from the demands their children's boredom made on them....

Cultural activity is seen as a way of safely occupying children and young people, in order to increase the freedom of parents and the security of people in general. The anxiety generated by groups of young people 'hanging around' cannot be underestimated.

Surveys have consistently revealed that this fear is very real and very powerful – particularly on housing estates. People, especially women, will not join in cultural activities, simply because they are

afraid to go out. If young people were engaged in less threatening activities, this sense of unease would diminish. Why do arts and cultural activities seem appropriate here when education in general does not? The answer is fairly simple. Presented in the right way, participation in music, video, or other forms of cultural production seems interesting, accessible, and relevant. The success of projects which have targeted just those groups of young people 'hanging around' confirms this. The music and video project initiated by Cultural Partnerships on the Clapton Park estate in Hackney, and the work of the Sons and Daughters of Liverpool in Merseyside, where nobody over the age of 19 on the management committee is allowed to vote, are both good examples. They have used popular cultural forms, such as music and video, to involve young 'non-arty' people in cultural activity. The courses in sound broadcasting by the Ariel Trust would often be the only time some of the kids would turn up in school time (see chapter 4).

The opportunity to participate in popular culture is one young people are unlikely to resist. Such opportunities are, unfortunately, only rarely presented. The chance to channel energy and enthusiasm into productive and creative activity is being wasted. The familiar complaint – 'there's nothing to do round here' – is an indictment of the cultural poverty of arts provision. Working with younger age groups, through groups or play schemes, also goes beyond the direct beneficiaries. It is not only a way of freeing the parents from the burdens of child-care, it is a way of involving parents themselves. A number of arts development workers have discovered that parents, particularly women, who would not have the confidence to get involved in cultural activity, will join in if their children are involved. Jubilee Community Arts regularly do play schemes partly for this reason – as Sylvia King says, 'play schemes are very often a way of getting adults involved'. Noname Community Arts also describe activities with kids as 'a means to an end'.

One of the best examples of this approach is the Mount Pleasant Photography Workshop in Southampton. It began as a multiracial photography and language project at Mount Pleasant School in 1977. It has, since then, developed to encompass not only the whole school but the local community. There are now workshops not only for the schoolchildren but for young people and for adults. The school itself encourages parental involvement with provision for the many parents speaking Asian languages, so it is not an unfamiliar place for them to come. In this context, as the project co-ordinator Judy

Harrison puts it, 'the school is an ideal place for community involvement'.

Judy has, over the years, managed to build up contacts with parents, with the Asian temples, and with other community projects in the area, both through the project and through her work as a photographer, taking photographs of weddings and other cultural events. Many of the project's first pupils have since grown up, to produce a generation of young people in the community with interests and skills in photography. The project has, through the school, managed to involve and touch people throughout the locality. The project's magazine, *Step Forward*, produced by local people for local people, is distributed through the school. Every child will take a copy home when a new edition comes out.

Many other projects, from education and outreach teams at the Southampton and Bradford art galleries to the 'Lincoln Community Play', have gained a foothold in the community by working with children and with schools. Them Wifies, a women's project in the north-east, began as a mobile children's workshop, but as time progressed they became more interested in working with the mothers. They now work mainly with young women in inner-city areas – work that often depends upon provision for children through crèches or play schemes.

The potential of work with children and young people is, on the basis of these experiences, considerable. Its benefits can be felt both by the children and by the communities in which they live. Such provision is currently seen as marginal, both in terms of arts provision and education provision. If a cultural policy is generally to broade the basis of participation and production, it needs to become central.

7

MONEY MONEY MONEY

ARTS FUNDING: THE ECONOMIC DEFENCE

It is, in social or cultural terms, difficult to justify most present public spending on the arts. This much I have already argued. This is not an argument against spending public money on art and culture – far from it. I have tried to suggest strategies for public investment that *would* create a climate for the cultural regeneration of Britain. The clear implication of this argument, in financial terms, is that we should use the £563 million (the 1987/8 figure) spent by local and central government on arts and museums in a very different way.

I shall, in the next and final chapter, briefly consider the organizational and financial consequences of the strategies I have outlined. I cannot do this, however, without considering the most powerful defence of current spending policy. This argument is not social or cultural, but economic. Deiter Helm, an economist, has outlined the economic case for 'the arts' (i.e. the arts as we presently fund them) fairly succinctly, considering and rejecting both the free market and the 'distributionalist' critiques of current spending patterns. Of the latter, he writes:

> The most telling criticism of arts expenditure comes from the left rather than the right. Distributionally it is hard to escape the observation that the sorts of art supported in Britain are those which appeal to the rich rather than the poor. Unemployed people, people living below the poverty line, don't tend to go to the theatre, galleries and exhibitions. And they certainly don't go to the opera.

> (*New Society*, 20 February 1987)

It is worth noting that the distributional imbalance does not only

128

exclude the 'underclass' that Helm refers to, as I have demonstrated in chapter 2, but the majority of the population. The barriers that prevent most people attending arts activities are, as I have already argued, cultural rather than economic.

One of the problems with this 'distributionalist' criticism, Helm argues, is that it fails to take into account the *economic* importance of current spending policies. The current subsidy for the arts, the argument runs, is nothing like as costly as it appears, for three reasons. The arts are, first of all, seen as a major attraction for overseas tourists. The National Campaign for the Arts argues that British Tourist Authority surveys show that four out of ten overseas visitors nominate the arts and museums as their main reason for coming to Britain. The estimated £250 million per annum they spend not only creates employment in sectors such as tourism and catering but, since tourists spend most of their money on VAT-rated goods, much of it goes straight into the coffers of the Treasury.

A second argument concerns the real cost of subsidy. The subsidized arts will pay large amounts of money back to the government; again, through VAT (which is levied at the full rate on many arts activities), and through national insurance and income tax paid by those working within it. Subsidy will also allow higher employment levels in the arts, thereby taking some people off the dole and lessening the state's financial burden of unemployment – thereby reducing the real cost of jobs in the arts.

Thirdly, the subsidized arts will contribute to the prosperity of the commercial cultural industries. The National Campaign for the Arts estimates that the arts industries have an annual turnover of £1.3 billion a year (estimates of this figure tend to vary a great deal, since there are a number of cultural sectors, like graphic design, that may or may not be included). Subsidy will contribute to this prosperity, by, for example, helping the film and television industries with the provision of actors partly trained in the subsidized sector.

These are persuasive arguments – even if they tend to be rather vague on economic detail. They suggest that, weighed against these economic benefits, the real cost of the arts is so small that cutting levels of subsidy would have negligible economic benefits and could, at worst, be economically counterproductive.

The problem with this case is that it usually rests upon a syllogism that doesn't work. The argument, in other words, runs thus: the arts accrue considerable benefits to the economy in terms of tourism, the cultural industries, and various tax yields; the arts rely, in part, upon

subsidy; the economic benefits of the arts therefore depend upon the subsidy they receive. Like most syllogisms, the partial truth that it contains disguises a weakness in the logic. The fact that arts and museums are an attraction for overseas tourists would only economically justify the subsidy to arts and museums if tourists stopped coming in direct proportion to the withdrawal of subsidy. The truth is that, first of all, while some would stay at home, many of the tourists attracted by British arts and museums would probably still come even if subsidy were entirely removed. The commercial cultural sectors (like West End theatre) and Britain's cultural life and heritage would retain their appeal. Secondly, the subsidized arts that tourists find most appealing comprise a very small percentage of the total arts subsidy. They will be concentrated upon the prestigious arts and museums in central London. Even if tourists actually visit a wide range of subsidized cultural venues and events once they are here, they would doubtless find other ways of spending their money if these did not exist. Thirdly, if the premier arts attractions were forced to become more commercially viable by imposing or increasing charges, this would be unlikely to deter the *overseas* visitor who wanted to visit them.

The same point applies to the other economic benefits of the arts. Much of the arts economy would survive without subsidy, while the economically beneficial elements of subsidy are located in very specific areas. If we wanted an arts funding strategy based upon economic benefit, we would *not* spend the money in the way we do now. The arts are funded according to particular aesthetic judgements, not on the basis of tourism or an industrial strategy. If we fund the Royal Shakespeare Company because we accept their arguments that the wealth they create, principally through tourism, is greater than the cost of the subsidy, then so be it. We would need to recognize, however, that we were funding them for that reason. If we fund them as part of a programme of cultural subsidy, then we must justify it in social and cultural terms. How else are we able to construct a coherent cultural programme?

This does not mean ignoring the economic effects of cultural subsidy – far from it. A cultural strategy should consider economic effects in the same way that an economic strategy should consider cultural effects. The most developed thinking in this area, moreover, comes not from the traditional arts, but from still developing work on the cultural industries, based in a few local authorities (mainly in employment and economic development units) up and down the

country. The cultural industries perspective, in a general sense, forms a substantial part of the cultural programme I have already outlined. There is, nevertheless, a danger in embracing too uncritically the policies developed in its name. I have, for this reason, tried to be fairly specific in analysing the cultural industries, both in terms of cultural sectors and in delineating cultural and economic objectives. In order to evaluate subsidy in cultural *and* economic terms, it is necessary to reconsider the cultural industries, or, more specifically, the role of investment in art and culture as a local economic strategy.

CULTURE AND THE LOCAL ECONOMY

A number of cities in Britain have begun to use the arts and cultural industries as a form of economic regeneration. The objectives are threefold: to raise the profile of the city and attract tourists; to use cultural facilities to make the city an attractive place for businesses to move to; and to create employment by investing in and developing local cultural industries. The strategy has, in theory, the added bonus of making the cities better places for the inhabitants to live in – principally by the rejuvenation of city centres.

The first British city to use art and culture as part of a co-ordinated promotion and tourist strategy was Glasgow. The strategy contained a number of elements. The best known is the promotional 'Glasgow's Miles Better' campaign, launched with the help of the Struthers Advertising Agency in 1983, and backed by public and private sector agencies (by 1987, public and private agencies had contributed around £700,000). The campaign was based upon the realization that, despite the beauty of its Victorian buildings and its many cultural attractions, the dominant image of Glasgow was negative. Glasgow's history as the 'model' nineteenth-century metropolitan city was long forgotten, replaced by images of grime, social deprivation, and fighting in the street. The campaign's slogan, with its many ambiguities (Glasgow's miles better than you think, Glasgow's miles better than it was, Glasgow Smiles Better) attempted to change these perceptions.

The strategy had a precedent in the highly successful 'I love New York' campaign. Like New York, its success was dependent upon having something to sell. The local authority accordingly invested in stone-cleaning, tree-planting, and refurbishment in order to show off the city centre's impressive architecture. The increase in both domestic and tourist users of the city centre has encouraged private sector

investment in catering, shopping, and entertainment, alongside public investment in prestigious arts organizations.

The local authority has, in recent years, doubled its grants to the four 'principal' Scottish companies: the Scottish Ballet, the Scottish Chamber Orchestra and Chorus, Scottish Opera, and the Scottish National Orchestra. The opening of the Burrell Collection (an extensive art collection given to the city), and investment in arts centres, theatres, and cultural venues has established Glasgow as Scotland's cultural capital. As a result of the work done in recent years, the decision of the EEC's twelve ministers of culture in 1986 to declare Glasgow 'European City of Culture' for 1990 (ranking it with Athens, Amsterdam, Berlin, and Paris) was almost a formality. Eight other British cities (Edinburgh, Liverpool, Leeds, Bristol, Cardiff, Bath, Swansea, and Cambridge) competed for the title, but none of them was as geared up for a successful submission.

The promotion of Glasgow had a number of objectives. It was designed to benefit the local population, and to win them over to the idea that 'Glasgow's Miles Better'. This tapped Glaswegians' affection and loyalty towards their city, and built upon it. The campaign also had two clear economic objectives: to encourage tourism and to attract investment.

While it is difficult to make an assessment about increases in investment in the city, the campaign has undoubtedly had an effect upon perceptions of Glasgow amongst the key target group – social classes A, B and C1. Advertising for the national campaign concentrated on national magazines or newspapers with appropriate ABC1 adult readership, such as the *Observer* magazine, the *Sunday Times* magazine, the *Reader's Digest* and *Punch*, and in London on taxis, buses, and underground poster sites.

The Struthers Advertising and Marketing Agency, who initiated and carried out the campaign, also recorded its effect with a survey of the ABC1 sector of the population. This measured 'before' and 'after' perceptions of Glasgow amongst people in England and Wales.

Perceptions of Glasgow before the campaign were, among this group, extremely negative. Respondents were asked to list Glasgow, along with five other cities (Aberdeen, Birmingham, Edinburgh, Liverpool, and Newcastle), in terms of lists of negative and positive perceptions. The negative perceptions were clearly *the* dominant image of Glasgow. As many as 89 per cent associated the city with unemployment, 83 per cent with drunkenness, 73 per cent with bad housing and 72 per cent with violence. These scores were higher than

those registered against any of the five other cities, apart from Liverpool, which scored as highly on the image of 'unemployment'. Overall Glasgow was seen as the worst place to live or visit.

Not surprisingly, only small percentages of respondents associated Glasgow with positive characteristics. It was considered the least friendly, the least safe, and the worst place to work. Comparisons with Edinburgh, Glasgow's main rival for tourism and investment, were particularly unfavourable. Edinburgh's image as a cultural and tourist centre (based upon the famous Edinburgh Festival) made it a far more appealing place in terms of every positive or negative category. The role of culture in this image-making process appears, on the evidence of the survey, to be fairly important. More than five times as many people considered Edinburgh a 'tourist centre', more than seven times as many saw it as a 'cultural centre', and seven times as many associated it with 'art and music'. Accordingly, four times as many people saw Edinburgh as a 'nice place to work'.

After the campaign these perceptions undoubtedly changed. An image of the city as a centre for culture and tourism had taken root. Approximately twice as many people began to associate it with 'culture', 'entertainment', 'art and music', and 'tourism'. It was also seen as a friendlier and generally more attractive place to live or visit. These perceptions had real economic effects. The National Survey of Scottish Tourism demonstrated that the volume of domestic tourist traffic through Glasgow increased fairly dramatically, catching up with Edinburgh. Between 1982 and 1984, tourist numbers tripled, from 700,000 to 2 million. The economic benefits of this are not just felt by the cultural and tourist industries, but by subsidiary industries such as catering and retailing (since tourists will want places to eat and places to shop).

A more recent initiative, based upon the Glasgow model, has been embarked upon by Bradford City Council. The objectives were similar: *pride* (of local people in the city), *image* (for tourists), and *investment* (by outside companies). The initiative was a response to local economic problems, with companies pulling out of the area and unemployment subsequently rising. Like Glasgow, the campaign focuses upon an advertising campaign with a central theme – in this case 'Bradford's Bouncing Back'. Instead of Glasgow's 'Mr Happy', the campaign team chose the 'Bradford Bears'; cartoon bears, which decorate their campaign logo. The campaign was initially funded by the local council (which seconded Tom Clinton, now the campaign's director, to run the campaign with a small budget) and the local

media. This seed money was used to attract private business sponsor-ship, the first 'launch' to 300 local business people attracting enough financial support to get the campaign firmly under way.

As an advertising campaign it has been highly successful. The team of 'bears' (students dress up in bear costumes) administered by the 'bear co-ordinator' are a constant and much demanded presence in the area, having been involved in 400 events in their first year. Tom Clinton estimates that the campaign has successfully created around £1 million worth of publicity in that period.

Bradford, of course, has less to 'sell' to tourists or investors than Glasgow. The surrounding countryside and the nearby Yorkshire Dales help, but the city itself is hardly famous for its beauty or its culture. The local authority has, in order to change this perception, adopted a cultural strategy. Their success in attracting the National Museum of Photography, Film, and Television (a branch of the Science Museum) helped provide the inspiration for the campaign. Their own capital investment of £1.8 million in the building has been boosted by money from the EEC and central government, which pays the Museum's revenue costs. Since opening in 1983, the Museum has attracted visitors in steadily increasing numbers (now around 700,000 annually), a third of whom are local, a third regional, and a third national or international.

The city has built upon the Museum's success, investing in the Alhambra Theatre, and giving the London Festival Ballet a sub-stantial grant to launch a 'world premiere' there. Their presence helps put Bradford on the cultural map. From the point of view of Brad-ford and Glasgow, these strategies have been successful. They have succeeded in changing people's perceptions and attracting tourists, as well as, it is widely claimed, increasing local people's pride in their own city.

Other cities have, to a greater or lesser extent, begun to initiate similar promotional strategies, based on cultural or other leisure facilities. Some areas have started to pursue a more directly inter-ventionist cultural industries approach. This has involved investment in the local cultural economy, in order to create jobs and increase local prosperity. This investment is based on the principles of local public sector economic strategies where public sector agencies (usually the local authority) invest public money in order to protect and develop industry and employment.

The work of the Cultural Industries Unit at the Greater London Enterprise Board in the mid-1980s (now, following GLC abolition,

Greater London Enterprise) is perhaps the best known in this field. They were able to demonstrate the importance of culture *as an industry*, to show that far from being ephemeral and marginal to the economic world, 'what is available for cultural consumption and what opportunities there are for development are clearly determined by economics' (GLC, *The London Industrial Strategy*, 1985). The cultural industries are an important part of the British economy, employing around half a million people (although estimates vary widely depending upon what and who is included – the graphic design industry, for example, not always being included in estimates). It would also appear to be a growth area. The Henley Centre estimates that consumer spending on leisure, for example, more than doubled between 1980 and 1986 (11.7 per cent to 24.7 per cent of total consumer spending), a growth they forecast would continue into the 1990s (*Leisure Management*, January 1986). The Cultural Industries Unit's contribution to the development of cultural sectors concentrated on 'independent' cultural production, and they made a number of strategic investments – particularly in the area of distribution.

The decline of other economic sectors, such as manufacturing, has meant that investment in the cultural industries has been taken increasingly seriously. As Mulgan and Worpole put it:

> What was once thought of as the ideological superstructure has now become a significant part of the economic base. To buy a Style Council or Kiri Te Kanawa record, a new book by Fay Weldon or Alice Walker, to watch a Victoria Wood programme or a Channel 4 film on television, involves standing at the end of a massive line of producers and printers, tape operators, scriptwriters and sleeve designers, printers, engineers, camera crews, promoters, record pressers, distributors, lawyers, accountants, musicians and editors, not to mention the people who designed and made the hardware on which the music, film or book was recorded, printed or watched.
>
> (*Saturday Night or Sunday Morning*, 1986)

This thinking has influenced a number of local authorities. Cardiff with over 4,500 people working in the media industry, has begun to promote and develop itself as 'Cardiff – the media city'. Birmingham City Council has looked at a number of investment strategies in the media and audio-visual sectors, commissioning a detailed report (by Comedia) into the potential for economic development. Sheffield City Council has, with the help of other local initiatives, developed

the idea of a 'cultural industries quarter' in an industrial improvement area near the city centre. These investments are attempts to counter the talent drain (of, say, media companies or successful pop bands) and the work drain (the use of, for example, recording studios or video facilities) to the capital city.

Sheffield's interest in the cultural industries began in 1983, when it worked with the GLC to co-sponsor a series of public hearings and commission reports on cable television. The commercial success of the Leadmill Arts Centre, the growth of the local independent video sector and the concentration of musical talent in the area (bands such as ABC, Heaven 17, the Human League, the Comsat Angels, and Cabaret Voltaire) has encouraged the city council to promote the economic development of its own cultural industries. The cultural industries quarter, based on sites adjoining the Leadmill, is centred on the Audio-Visual Enterprise Centre, a complex of commercial 24-track sound recording studios, film and video studios, photographic exhibition space and darkrooms. The centre has been developed using Department of the Environment Urban Programme Industrial Improvement Area and Managed Workspace funds, and provides a base for bands and local businesses such as the Human League, the Comsat Angels, FON Records, Sheffield Independent Film and the Untitled Photographic Gallery.

The aim of this investment is to provide a focus for the cultural industries in Sheffield, link up businesses to allow for mutual support, co-operation, and development, and to help develop the city as a nationally recognized base for cultural production. The 24-track studio in the centre is more advanced than the city's other commercial studios, and is designed to move Sheffield's recording sector into the international market.

A more specific local initiative is the North East Media Development Council (NEMDC) in Newcastle which was set up in 1984, with money from the European Social Fund and the local authorities. The initiative was built upon the strength of the independent film and video sector in the region – the five organizations setting it up already employed around sixty people, and had a combined turnover of between £1–1½ million a year. The NEMDC has two broadcast standard studios and a development team.

The NEMDC is part of a regional media strategy, based upon training, development, and video distribution and which aims at the development of a media industry in the north-east. It will build on the work and material provided by existing groups such as Amber,

Trade, and Swingbridge, and try to establish the region as a centre for training in the film and television industry.

Reasons to be cautious

These local initiatives are, in different ways, innovative and imaginative forms of economic regeneration based, initially at least, upon public sector support. Although it is still too early to make a serious evaluation of them on either cultural or economic grounds, there are, I would suggest, a number of general problems with either tourist based or sector development strategies.

The most profound shortcoming cannot be laid at the door of the local agencies involved; it concerns an absence at the centre. Attempts to boost the local economy necessarily involve competing with other local economies. If tourists (whether they come from London, New York, or Paris) go to Glasgow or Bradford they are likely to do so at the expense of a visit somewhere else. Similarly, if businesses or clients move to Sheffield or Cardiff because they provide an attractive home for cultural sector enterprises, they will be taking business from elsewhere. This means that one city's economic development is likely to be another's economic decline.

This problem is difficult for local authorities, on their own, to overcome. The only way that their initiatives can contribute to any overall, national economic development is by central co-ordination. A national agency needs to co-ordinate local developments so that they add up to an *overall increase* in economic activity. This means attracting *more* tourists from overseas to a greater variety of British destinations. It means building up new local, national, and international markets rather than simply shifting the benefits of existing levels of demand. There is little evidence that local initiatives can achieve this on anything other than a small scale. While they may be effective agencies for generating and shaping demand within the local economy, they require national investment and organization to reach much beyond this.

A national economic development agency would be able to organize local economic activity more effectively, ensuring local agencies complement one another, making sure they work together to create new national and international markets and setting up a national and international distribution and marketing infrastructure to assist and stimulate development. Such an agency would also be able to promote a more equitable geographical distribution of production

centres, channelling employment opportunities into the areas that most needed them. It would be able to promote and develop *regional specialization* in various cultural industries and sectors – for example, Sheffield for music recording, Newcastle for media training, etc.

This is not to say that, without national organization and infrastructure, local initiatives are pointless. They are in a position to influence the local private sector and to sow the seeds of economic regeneration. What is important is that those initiatives are aimed at *new* rather than existing markets. Using cultural facilities to attract tourists, businesses, or other kinds of economic activity may make sense only at a parochial level. If the overall amount of money spent on production or consumption is simply regionally redistributed by such a strategy, it is, on a national level, a waste of time and money.

The other main problem with many culture-led initiatives is cultural rather than economic – although it has economic consequences. The 'cultural industries' approach has been developed, on the whole, by progressive agencies inclined towards popular and egalitarian cultural policies. Part of the driving force behind the cultural industries, indeed, was a critique of the public funding of art and culture. The cultural industries are, it is argued, popular and ubiquitous, as opposed to the secluded elitism of the subsidized arts. The use of culture to promote economic activity is, however, a dangerous weapon. Using cultural facilities to promote tourism and attract businesses usually means promoting just the sort of prestigious culture aimed at high-income groups that the subsidized arts promote now. The economic rationale behind Glasgow's support for opera, ballet, classical and chamber music, and theatre, and Bradford's support for a national ballet company, is based upon the people they attract. These art forms appeal to people on high disposable incomes, people who run businesses, and who make the most lucrative tourists. This may be fine as an economic strategy, but as a cultural policy it is regressive and socially limited.

The commercial culture, I have already argued, represses cultural values such as access, diversity, and innovation. A cultural industries strategy runs the risk of doing just the same. An effective economic strategy may be forced to run counter to an egalitarian cultural policy. The principle behind much of the original thought on the cultural industries approach should not be forgotten: namely, that the basis for public investment in cultural sectors should be to guarantee social and cultural values that the free market cannot. If a

cultural industries strategy is reduced to a method of generating employment and economic activity, this principle vanishes.

Here lies the heart of the ambiguity of the cultural industries approach. The 'cultural industries' has become a symbol for two very different objectives: economic regeneration and cultural regeneration. Investing in cultural sectors to create wealth and employment does not necessarily have progressive cultural consequences. Investing in the world of commercial culture to guarantee its diversity, creativity, or its relevance to groups regardless of income and education does not, on the other hand, necessarily have lucrative economic or employment consequences. A democratic, diverse and innovative broadcasting industry certainly costs more than one that is undemocratic, safe, and unimaginative.

This does not mean that both economic and cultural goals cannot be achieved by strategic investment. In sectors such as the music industry, investment in the 'research and development' of independent production has beneficial economic *and* cultural consequences. Happy marriages of economic and cultural benefits will not, unfortunately, always be achievable. The involvement of people on low incomes in cultural consumption may create a richer culture, for example, but it will never be a recipe for making lots of money.

There has been a tendency for advocates of the cultural industries approach to gloss over this potential contradiction. Cultural profit and economic profit do not, unfortunately, automatically go hand in hand. Public investment in the cultural industries can have both economic and cultural objectives. Nevertheless, if we are to construct a coherent policy at either level, these two motivations, in the first instance at least, need to be kept distinct. As I have already argued in chapter 4, a cultural industries perspective enables us to rethink the role of public subsidy and investment. Public money does not need to be spent on saving cultural dinosaurs from extinction. It can be invested in commercial industries in order to extend their social and cultural value. It can be used to manipulate markets, to create new demands, to stimulate new trends of cultural activity, to *build* upon the popularity of many commercial cultural forms. These are cultural objectives, and while they have economic consequences, we should recognize them as such.

The confusion of economic, social, and cultural aims in the provision of art and culture is not simply the result of sloppy thinking. It derives, in part, from a radical critique of the subsidized sector – both alternative and mainstream. This critique, developed in recent

publications such as *What a Way to Run a Railroad, Saturday Night or Sunday Morning*, or *Art – Who Needs It?*, argues that the failure of the subsidized or 'alternative' cultural sectors to develop the efficient organizational and marketing skills of the commercial cultural industries has negative effects on *every* level. It makes it less profitable, more inaccessible, and reduces its cultural impact or effect.

The role of marketing is particularly important. Marketing not only increases your economic viability, it enables you to reach more people. As a tool, it has both economic *and* cultural benefits; it forces us to recognize the importance of cultural consumption, in terms of *who, how many*, and *how* people consume a product or performance.

The suspicion or ignorance of marketing in both subsidized and alternative cultural sectors has led to cultural and economic inefficiency, yet it is equally foolish to embrace it without understanding it. Just as a cultural industries strategy can be described in terms of economic and cultural objectives, so a marketing strategy has specific and distinguishable effects. The critiques of the subsidized and 'alternative' cultural sectors have, on the whole, made the distinction between the economic, social, and cultural effects of marketing quite clear. While these critiques naturally push us in the direction of the cultural industries and the marketing acumen therein, the problem arises when people go on to embrace those things as generalities.

It follows that if, as I have argued, we need to be clear about the cultural effects of investment in cultural industries, we should also understand the cultural effects of particular marketing strategies.

MARKETING

Marketing value and values

Marketing art and culture is beginning to become not only respectable but fashionable. This is not so surprising – it is, after all, thoroughly in keeping with the times. The 1980s witnessed a developing obsession with style, design, and the market place. The design industry, from magazines to table lamps, prospered as never before. It was, for example, a decade during which the Labour Party performed an extraordinary about-turn on the subject of marketing, viewing it with contempt and suspicion in the 1983 general election, only to embrace it with a slick professional abandon in 1987, producing American style broadcasts in a generally 'presidential' campaign.

Marketing is the process of identifying a target group of people to which a product might be designed and sold, and then selling it to

them. It is not just about publicity. It involves finding out about the needs, interests and desires of your audience or consumers (market research), ensuring your product meets these interests, and then using the most efficient means of promoting it. Marketing is, in essence, neither a good thing nor a bad thing. It is simply a way of understanding a process of communication.

The ethics of marketing depend upon the way it is approached. The marketing process may or may not have notions of *need* or *benefit* built into it. It is possible to ignore these notions, and to come up with a product that panders to or exploits people's desires and interests. This product can then be sold as a source of satisfaction and amusement. The marketing of cigarettes follows this pattern – people certainly don't need them, and any possible benefits derived from them are outweighed by a whole range of negative effects. Need, in a free market, is not a necessary ingredient in the process of commodity production and consumption.

The ways in which needs and benefits are defined are, of course, neither simple nor straightforward. It leads us into a discussion of a number of other vague and imprecise concepts like 'quality of life', 'happiness', or 'fulfilment'. While I do not want to get drawn into this complex philosophical area, it needs emphasizing that it informs assumptions about the marketing of art and culture. Marketing is a way of controlling the world of commodity exchange that surrounds us. How we use that control is a political issue. If we use it to make money or to have power over people, then the concepts of need and benefit are only useful if they can be manipulated to these ends. If, on the other hand, we want to improve people's lives, then these concepts become paramount. Since most cultural producers – particularly those in the subsidized sector – would argue that they were concerned with improving the quality of life, the process of marketing must be viewed accordingly.

Viewed in this context, it is easy to see how the dominant cultural aesthetics of the subsidized sector have contributed to their failure to market themselves successfully. The aesthetics of the subsidized arts revolve around the producer, the artist, and the *intrinsic* value of the product. Cultural production is not seen as a process of commodity exchange at all. The value of the product is seen to be *inscribed* within it, something that we may or may not have the cultural competence to recognize. The needs of the consumer are ignored until the last possible moment, when it becomes necessary to sell what has been produced. The claim that this commodity will improve the quality of

people's lives can only be based upon arrogance or ignorance, since people's needs (as consumers) have been completely disregarded during the production process. The assumption that people 'need' the cultural product on offer is based on nothing more than the artist's or producer's own view.

It is for this reason that the marketing approach is so culturally significant. If an intervention into the world of cultural production is to take 'the quality of life' seriously, people's needs must be incorporated into the production process at some stage. The product is then designed *for* people. When John Matthews, formerly of Cardiff Arts Marketing, says that 'the head of marketing in an artistic organization should be the artistic director', he is making the point that marketing not only ends with the consumer but begins with him or her. The artistic director, artist, or producer should design their product informed by the consumer's needs or interests. To ignore this is not just to ignore the process of marketing, but to relinquish thereby any control over the exchange of cultural commodities.

This does not mean *all* cultural production should be 'consumer orientated'. The cultural value of an activity is not always reducible to the moment of consumption. Experimental or innovative work, or work focusing upon broadening participation in cultural production, can have cultural value in its own right. The cultural value of such activity depends upon its position in relation to a process of commodity exchange. If it filters through into that process, so that it enters the social world where we, as consumers, can have our cultural options and experience extended, then it is of real cultural value. Such a role was played by independent record labels in the late 1970s and early 1980s (see chapter 4). Much of the music they tried to promote was obscure and inaccessible. Their role was significant, nevertheless, because of their position in relation to the popular music industry, which became more diverse and innovative as a result.

Experimental theatre or dance on the other hand, is in a more ambiguous position. If it permeates into a popular cultural form, such as television drama and film, its significance is more profound than if it remains tied to a self-referential elitist cultural form.

The value of marketing should, I would argue, be seen in this context. We need to examine its premise, its purpose, and its effect, within the process of commodity exchange.

Marketing: agencies and strategies

There are three general method of the marketing of art and culture. The first is to take into account people's needs and how a product might be of benefit to them. This approach is, unfortunately, unusual in both the commercial and subsidized sectors. It involves, for one thing, a fairly sophisticated method of market research. A second approach takes into account people's desires in an attempt to manipulate them for profit. This characterizes the way in which the commercial cultural industries work.

Within this framework, it should be said, a number of organizations will float somewhere between these two approaches. Some record companies, publishers, or broadcasters, because of the value they place upon the cultural significance of their product, will incorporate a notion of 'public service' or a commitment to cultural development into their work. The *raison d'être* of TV or record producers will often be more than simply a desire to make money.

A third possibility is to ignore marketing altogether. This approach is prevalent within the subsidized sector. While it is now fairly commonplace to have people involved in publicity, promotion, and sales, it is unusual for groups, venues, or organizations to develop this into a marketing approach. There are exceptions, such as the Theatre Royal in Stratford East, which has identified target markets – the local black communities, for example – and carried out appropriate audience research. It has then attempted to gear productions towards the identified needs and interests. The Theatre Royal remains, none the less, an exception.

Struggling to change this unfavourable climate is a small group of arts marketing agencies working up and down Britain. Some of these agencies are tied to regional arts associations, while others, such as Cardiff Arts Marketing or Solent Arts Marketing, are relatively independent, linked more to a range of arts agencies than to any one organization.

These organizations, between them, carry out a number of functions. On the basis of the experience of five organizations, Cardiff Arts Marketing, Portsmouth Arts Marketing, North East Arts Marketing, Solent Arts Marketing, and Swansea Arts Marketing, these can be described as follows.

Organization of mailing lists

These can vary in size, from around 10,000 to 80,000 names and

addresses. Most marketing organizations will base their lists upon those of their client organizations. These will be combined, updated, developed and put onto computer. Mailing lists can include both individuals and groups/organizations. North East Arts Marketing, for example, includes subject heads of local schools, Womens Institutes, Townswomens Guilds, mother and toddler groups, and social centres. Most organizations will attempt to break down people on their mailing list by a number of categories. These will involve where they live (postcode), their interests, and relevant sociodemographic data (such as age, sex, or whether they have children). Mailing lists are then used in various ways. Some agencies, like Solent Arts Marketing, will organize mail-outs of publicity material themselves, while others will supply clients with sticky labels with appropriate names and addresses printed on them. The lists can be used generally for 'universal' mail-outs to everyone on the list or, more effectively for *targeting* certain people. For example, a venue or organization may want to target young people interested in music in certain districts. The computer will then be able to produce a list of people classified under all these three variables.

Marketing agencies will use various ways of adding to mailing lists. Any visitor to a cultural venue in the region will, in one way or another, be encouraged to join it.

Distribution networks

Most marketing agencies will build up a network of arts venues, shops, pubs, civic centres, social centres, libraries, workplaces, department stores, hotels, restaurants, and, as Julie Eaglen of Solent Arts Marketing puts it, 'anywhere else with a counter'. These places will be used to display publicity material (usually leaflets or posters), which will be regularly delivered by van, with a driver/deliverer employed full- or part-time. The deliverer can be much more than a pair of hands. For Cardiff Arts Marketing, the deliverer is described by John Matthews as 'an ambassador from the arts in the region – the friendly face of the arts in Cardiff'. He or she will be able to monitor the take-up of publicity material and provide feedback on what shifts and what doesn't. Some agencies will also supply outlets with display racks for material.

Discounts on publicity

Marketing organizations, by representing a number of venues and

organizations, will be in a position to negotiate for discounts on publicity costs, either in newspapers or poster sites. They will also be able to arrange joint publicity for groups in forms that would be too expensive for any individual organization on its own – such as large poster sites or local/regional broadcast media. Cardiff Arts Marketing, for example, carry out this function for their clients.

Audience research

Some agencies will carry out audience surveys – either for individual clients, or on the cultural interests of the local population. All agencies emphasize the importance of this, although not all of them are in a position to carry it out. This, says John Matthews, 'is the first thing any arts marketing organization should do'. John Matthews also argues the case for qualitative (in-depth discussion groups, for example) rather than quantitative research (such as street-based questionnaires). These allow for a detailed explanation of people's motivations, interests, and fears. Their own qualitative survey based upon five discussion groups, for example, yielded valuable information about people's positive and negative images of various places, their emphasis upon the social characteristics of a night out ('the event in itself was just part of the picture') and their preferred information sources. This enabled Cardiff Arts Marketing to develop marketing strategies accordingly.

Market research by arts marketing organizations, when it is carried out, usually focuses upon the group described by Keith Diggle (*Guide to Arts Marketing*, 1984) as 'intenders' (rather than 'attenders'). These are people with an interest in particular arts or cultural forms but who actually attend events fairly infrequently. If the purpose of the research is to increase box office sales (as it usually is), this is the most profitable constituency to target.

Other promotional methods

While mailing lists, distribution networks, and bulk advertising remain the staples of marketing agencies, some use other promotional devices. North East Arts Marketing produces a monthly listings magazine called 'On the Town', a publication that finances itself through advertising. They have also collected a set of clothes dummies that can be dressed up for window displays in places like banks or building societies.

Cardiff Arts Marketing, taking advantage of the Office of Arts and Libraries (OAL) Arts Marketing Scheme, set up a telephone sales service for various arts venues in the area, which successfully generated 1,000 per cent of its own cost in sales (so, for example, for £200 they were able to generate £2,000 worth of sales). The scheme also provided feedback from people, as well as a way of updating mailing lists.

Advice and marketing audits

Most agencies will offer advice to clients on an individual basis. This will cover everything from leaflet designs to a full-scale marketing audit. A marketing audit will consist of a complete review of an organization's marketing strategy, involving not only promotion and publicity, but an examination of the product and the audience it is intended for.

Subscription campaigns

Keith Diggle argues with considerable supporting evidence that the most effective way of increasing attendance at arts events (particularly performance art) is not to attract new audiences, but to persuade those already inclined to attend to go more often: 'while you are selling one thing you might just as well set out to sell several.... Your product, therefore, is a package' (*Guide to Arts Marketing*, 1984). This means aiming at two groups: firstly, those people who already attend performances or events; secondly, those who are 'favourably inclined ... who have perhaps often thought about visiting ... but haven't quite got around to it' – the 'intenders'.

Keith Diggle's own experience at the Churchill Theatre in Bromley certainly suggests that encouraging people to subscribe to a package of events significantly increases overall turnover. Arts marketing organizations, aware of this success, have used a number of ways of promoting subscription. Cardiff Arts Marketing produced a twenty-minute promotional cassette tape of music from a forthcoming season, aimed at moving people from single to seasonal bookings for musical performances. They also produced a 'Youth Card' for under-nineteens, which, for £4, gave young people discounts on a series of events (plus a monthly newsletter). Swansea Arts Marketing, under the OAL scheme, undertook the ambitious 'Flights of Fancy' campaign, aimed at both 'attenders' and 'in-

tenders'. The campaign involved a competition to win a trip for two on Concorde. 'Flights of Fancy' cards were delivered to homes throughout West Glamorgan, as well as distributed to arts venues (140,000 were printed). To enter the competition, the card needed to be stamped at a certain number of local arts venues. The scheme was also used to add people to the mailing list (a freepost entry card was attached), with some success.

While these schemes are not based upon subscription in the literal sense, they adopt the general principle of building upon an existing market by increasing consumption within it, or maximizing consumption within your easily attainable potential market ('intenders'). A scheme run by Portsmouth Arts Marketing attempted this by encouraging crossover audiences from one venue to another. The campaign linked four local arts venues, in order to build up a more mobile, more frequent group of attenders in the area.

Building new audiences

Reaching beyond the 'attenders' and the 'intenders', to the large number of people who are not in the habit of going to activities or events at all, is much more difficult. Not surprisingly, it is not attempted very often. One of the most serious attempts to do this has been undertaken by Cardiff Arts Marketing. They produced a large number of 'special offer' leaflets, designed specifically for a non-arts-going audience. These were then distributed door-to-door in working-class neighbourhoods (5,000 homes) and to adult education classes (20,000 people). The campaign was, perhaps surprisingly, four times more successful, in terms of rate of response, amongst those who had received them through their letterboxes.

Other schemes that reach both 'intenders' and new audiences are based upon workplaces. Solent Arts Marketing, for example, initiated a party bookings campaign, offering discounts and targeted at local workplaces and businesses. Swansea Arts Marketing have exhibition units, promoting activities and events, that go round foyers and canteens in local workplaces. An imaginative version of this approach has been adopted by the Spring Street Theatre in Hull, who have negotiated deals with local restaurants at Christmas time, in order to include a visit to the theatre in an 'office party' package.

Crossover campaigns do not just involve encouraging visitors to one arts venue to go to another; they can also be targeted at users of arts-related or social activities. Swansea Arts Marketing have, for

example, focused upon people going to pantomimes. Audience research has repeatedly shown that this is the only time that working-class people go to the theatre in any significant numbers. Once they have visited a pantomime, this group can then be targeted to become theatre-goers in general.

Another approach involves the use of non-arts themes. North East Arts Marketing attracted large audiences to an otherwise unremarkable series of events by promoting them as 'Australia Week'. This involved 'twinning' with Newcastle in New South Wales, and working on a joint promotion with Castlemaine 4X in local pubs, a campaign that earned a great deal of local publicity, including television coverage.

There are a number of other marketing strategies and ideas aimed at building new audiences referred to in chapters 3 to 6 – such as Bloodaxe Books' colourful posters on local buses, trains, and ferries featuring poems from their anthology of local children's poetry. While many of them feature 'crossovers' of one kind or another, they are invariably most successful when the *product itself* has been designed for a particular target audience. This applies whether it's a play by Tic Toc or Hull Truck, a book from Bristol Broadsides, a soap opera by Amber Films, a photographic exhibition by the Mount Pleasant Photography Workshop, or a fireshow by Cultural Partnerships or Noname Community Arts. Arts marketing agencies are in an ideal position to make an input into this creative process.

The cultural role of marketing

The role of arts marketing agencies, like marketing itself, is ambiguous. The many potential functions that I have described intervene in the cultural process in different ways. These fall, generally, into two categories. The first, and probably most common, can be called the *saturation* approach. This is based, primarily, on an economic motive: to maximize audiences (and therefore income) at the lowest possible cost. This economic motive is supported by the rather general desire on the part of performers, venues, and audiences to see places full rather than half empty. Who fills them doesn't really matter.

The second approach is based upon a cultural imperative: to use marketing to increase the number of people involved in cultural consumption and to accrue the maximum possible cultural benefit to the population as a whole. This approach, in the subsidized arts,

revolves around building up new audiences. The saturation approach, on the other hand, will tend towards activities such as subscription marketing. Since the basic premise of the saturation approach is to increase turnover, the most cost-effective way of doing that is to get the same people to go more often.

The first approach recognizes that the audience for the subsidized arts is narrowly based upon middle-class people with lots of education and, happily, lots of money. The aim will be to saturate this market, to promote the highest possible level of attendance within it. This will necessarily reinforce existing patterns of cultural consumption. It will, for this reason, usually involve fairly low levels of intervention in the programming or production process. The subsidized arts have, after all, already established a formula for attracting members of social classes A and B.

The second approach inevitably adopts a more flexible attitude toward cultural provision. If subsidized cultural forms are to move beyond the confines of existing patterns of cultural consumption, to embrace new people and more people, then new ideas are needed. These may involve building upon popular commercial cultural forms, or redesigning traditionally elitist forms. Either way, the marketing process may involve fairly high levels of intervention in the programming or production stages.

Of the two, it is the cultural rather than the saturation approach that has taken ideas of need and benefit most seriously. The cultural approach focuses upon the needs of people as consumers, and translates these back into the production process in order to meet those needs. The saturation approach, on the other hand, is product based. It assumes the importance of certain forms of cultural production, and attempts to maximize their success in primarily economic terms. The appeal of the saturation approach for the 'arts lobby', for arts funders, and for central and local government cannot be underestimated. For artists and producers, it reduces dependence upon grant aid, and, at the same time, frees them from the obligations of providing a public service. For funders and for the state, it relieves an economic burden. From the point of view of both the subsidizers and the subsidized, it gets both parties off each other's backs. While this may be an efficient economic policy, it is not a cultural policy.

The role played by arts marketing agencies will be determined by these approaches. They will undoubtedly be able to maximize audiences and income, just as they are able to play a part in the cultural development of our society. When John Matthews of Cardiff Arts

Marketing said that 'we exist to service the audience, not the arts', he was making an important point about the role of his organization. It was to assert people's rights to cultural choices, their right of access to a diverse, exciting, and interesting world of cultural consumption. John Matthews envisages developing a network of community representatives, or 'audience animateurs', whose aim would be to stimulate and generate cultural consumption in local communities. They would be responsible for distributing information, generating 'word-of-mouth' publicity through social networks and marketing door to door. This is, in many ways, a revolutionary idea. It combines the consumer orientation of the commercial culture with the animateur function within the community arts. It recognizes, above all, the significance of cultural consumption with a social context.

The 'audience animateur' is, potentially, a two-way communication channel. She or he not only stimulates audiences, but feeds information back to producers about people's needs and interests. Marketing, in this sense, becomes a radical tool in the development of cultural forms.

A society that is interested in the cultural development of its members, that inspires diversity, innovation, social pleasure, and public aesthetics regardless of educational and class boundaries, must develop a sophisticated marketing approach. This must start with people's cultural needs in order to deliver cultural benefits.

8

CHANGING THE SYSTEM

ALL CHANGE, PLEASE

I began this book by looking at general issues at the heart of arts and cultural funding. The current values that determine funding patterns are, I have argued, elitist and largely irrelevant to most people's lives. Commercial cultural forms, on the other hand, while they may be more popular, fail in a free market to promote a range of cultural values. I have, in this context, tried to identify a set of cultural values that might form the foundation of funding strategy, values that a free-market cultural economy is unlikely to guarantee (see chapter 2). This entails public investment and regulation to promote diversity, innovation, participation in production, environmental aesthetics, and economic regeneration. These values should not operate within a vacuum, but in relation to the social and cultural realities of British society, and the needs of the populations that compose it.

In chapters 3 to 7 I have explored the potential development of these values in some detail, looking at specific cultural sectors and artistic forms. This involved close consideration of the problems with existing patterns of funding in both the commercial and publicly subsidized sectors. I have paid particular attention to the barriers that have distanced most people from various cultural forms, and to ways of overcoming those barriers.

If we are to create a dynamic, diverse, and egalitarian culture, a number of radical changes need to be made. We need, first of all, a cultural strategy based upon popular cultural forms such as music, television, and publishing. The aim of public regulation and investment would be to promote the cultural values I have described (see chapter 2) using a sector-by-sector analysis (of the kind I have attempted in chapter 4). This would mean, for example, regulating

151

the broadcasting industry to protect and stimulate diverse and inno-
vative programming, and, if necessary, making strategic investments
in order to broaden the base of programme production and the range
of people involved within it. While regulation and investment in the
popular cultural industries would form the central thrust of a cultural
strategy, this would not necessarily entail a wholesale ditching of the
art forms that subsidy currently supports. Although a great deal of
the £500 million spent on art and culture would certainly need to be
reallocated, there are clearly areas of potential value that should not
only be retained but developed. These areas – such as art in the
environment, popular photography projects, and popular theatre –
have been described in chapter 5. Their development would involve
promoting participation in production *and* consumption, using ap-
proaches outlined in chapter 3 and chapter 6.

The cultural review necessary for implementing these changes
would need to consider their economic implications. There may, for
example, be areas of cultural subsidy in elite and prestigious arts
activities and venues that can be justified on economic grounds,
because they earn more money – principally through tourism and
subsidiary industries such as catering and transport – than they cost
in subsidy. There may also be areas of strategic investment in cultural
industries that generate economic activity. Investment in distribution
and marketing agencies – described in chapter 4 and chapter 6 – may,
for example, increase the economic viability of a whole cultural
sector.

These changes would undoubtedly mean a major reorganization of
resources, based as they are on a complete change in approach, using
different definitions of cultural value. This will not be easy. It will
inevitably entail cutting subsidy to a large number of the beneficiaries
under the current system, and involve restricting the freedom of large
corporations – in areas such as broadcasting and newspaper publish-
ing – to maximize their profits. This means making, in the short term,
a number of powerful and vocal enemies.

ORGANIZING CHANGE: PICKING UP THE PIECES

The management of such a cultural revolution will require new forms
of administration and control. This does not necessarily mean the
disestablishment of bodies such as the Arts Council or local authority
arts departments, but it does mean a significant change of approach,
function, and scope. A national cultural agency, such as the Arts

Council, will need to take on a whole new range of powers and forms of investment. It will, for example, need a broadcasting department, with control over the allocation of franchises to TV and radio companies, the allocation of radio licences, and the regulation of the broadcasting network. This department will require authority delegated by government to impose quotas and responsibilities upon broadcasters. It will also need the power and the resources to work in partnership with broadcasting companies, investing in training and community access, where appropriate, and in the broadening of the production base. Other departments, covering areas such as music and cinema, will need similar power and resources. A national body must also have legal support to prevent and restrict the growth of monopolies in cultural sectors. It must be able to enforce, for example, a restriction on the number of newspaper titles any one corporation may own, and to enforce legal rights, like the right of reply.

The rationalization of cultural powers within national government has been a subject of debate within the British Labour Party – it was an issue, indeed, that lost Norman Buchan his job as Shadow Arts Minister in 1986. The Labour Party has, none the less, acknowledged the strength of the case for a rationalized 'cultural' or 'arts and media' ministry, and has begun to move, rather tentatively, in that direction.

Investment and funding policies carried out by such a body should be proactive rather than reactive. Grants should be made where they are needed, not where they are asked for. Reactive funding – responding to the demands of artists and producers – is full of injustice and inefficiency. It means funding venues, organizations, and projects in areas where artists and producers – rather than those that *need* cultural activity – are based. The GLC's Community Arts Sub-Committee, for instance, funded far more projects in the London Borough of Camden than anywhere else – not because Camden particularly needed them, but because as a reactive funding body, they were simply responding to the enormous demand from the large number of artists and projects who happened to be based in that borough (GLC, *Campaign for a Popular Culture*, 1986). To be reactive is, moreover, to abandon a strategic role. The development of the independent video sector is a good example of this. Based upon a reactive funding system, the sector has developed an inefficient production-led approach. A proactive funding policy could have created an effective distribution and marketing-led cultural sector.

A national agency with these functions – in keeping with a new

cultural approach – would have a far wider remit than a body like the Arts Council. It would replace – and in some cases dispense with – the Arts Council's general responsibilities, and it would take on a range of tasks currently dealt with (in one form or another) by other branches of government. It is hardly surprising, given the number of different government agencies and departments that have an interest in cultural policy in Britain, that we have no co-ordinated cultural strategy. The Home Office is formally responsible for broadcasting, although the Department of Trade and Industry (DTI) is also involved in matters such as the enforcement of legislation governing television and radio frequencies. Other agencies, such as the IBA and the Cable Authority, complicate the picture still further. Investment and regulation in the cultural industries is the concern of the DTI, the Manpower Services Commission (MSC), and the Department of Employment, while the Department of the Environment, the Department of Education and Science, and the Office of Arts and Libraries have a role in, respectively, the aesthetics of the environment, the use of culture in education, and cultural policy in general. Trying to steer a cultural strategy through all these channels would be a bureaucratic nightmare. The reallocation of cultural functions to a single body – even if that body subsequently breaks up into smaller units – is a prerequisite for any serious development in this area.

LOCAL DIFFICULTIES

While a national body would play a vital co-ordinating role, funding and investment strategies will nearly always need implementing at a regional or local level. The way this is organized at the moment is almost as ad hoc and untidy as it is at the centre. The main funding bodies will usually be local authorities. Arts departments, where they exist, can be found sometimes within a Leisure Services Department, or sometimes within an Arts and Recreation Department, or perhaps an Arts, Libraries, and Museums Department, an Arts and Entertainments Department, or a Community Services or Cultural Services Department. The budget allocated to cultural projects will not always be the responsibility of these departments, but may pass through a Grants Unit, a Finance and General Purpose Committee, or some other local authority channel. Many other local authority departments have an involvement (potential or actual) in cultural development: planning departments are responsible for the local environment, and will negotiate 'planning gains', 'percentage for the

arts', and co-ordinate or commission other environmental or public art work; education departments or local education authorities will be involved where projects concern children, young people, or adult education, or where the boundaries of art and education cross; youth and community services may incorporate cultural activities in their provision, as may social services; economic development units may be a focal point for cultural industries initiatives; and so it goes on. The links between local authority departments are usually fairly weak, making strategic planning a bureaucratic struggle. It is more typical for departments to be in dispute rather than in harmony about responsibility, funding, and resources.

Regional initiatives are, in this context, difficult to organize as they need the co-ordinated involvement of several local authorities at once. This is difficult enough if this responsibility is delegated to arts officers from each authority, with equivalent powers and functions. It is well-nigh impossible if it involves – as it might – an Arts Officer, an Economic Development Officer and a Leisure Services Officer from different authorities.

Although local authorities are the biggest public spenders at this level, they are not the only agencies involved. Regional Arts Associations (RAAs) and other grant-giving bodies, whether local (like the London Boroughs Grants Unit in the capital) or national (like the British Film Institute or the Arts Council), will also fund local initiatives. Perhaps the agency best placed to co-ordinate regional and local strategies is the RAA. It is, at the moment, impossible for them to do this while they only control a percentage of the total arts budget.

The separation and dispersal of power and responsibility for art and culture at a local level carries with it, as it does at national level, an in-built failure to plan and implement a coherent cultural strategy. This limits the potential to broaden the scope of such a strategy, to extend it into the realm of, for example, education and the environment. It is also, even on its own terms, extremely inefficient. An organization, project, or venue may well be funded by three or four different public bodies. This will involve the organization going through the time-consuming and cumbersome process of filling in a number of different grant applications and following them up through various bureaucracies. It will also involve several people, in the different funding bodies, processing these grant applications. A number of people will be doing the job that might, in a unified set up, be carried out by one person. It might also entail a project adopting

(or appearing to adopt) an incoherent set of policies and functions in order to appeal to the different funding criteria of different funding agencies.

This duplication of bureaucracy is often defended on the grounds that it prevents venues, projects, or organizations being dependent on any one source of subsidy. The problem with this argument is that it assumes that funding has to take place on a precarious, year-by-year basis. It is far simpler to guarantee the security of an organization by using longer-term funding mechanisms. Funding organizations could, fairly easily, use three- or five-year contracts instead of repeating the same process every year. Their obligations would then be limited to simply monitoring the terms of the contract – and, ideally, providing advice and support.

The whole system of grant aid has, in most cases, been poorly designed. The history of grant aid in the arts has bound it to the concept of a 'guarantee against loss'. Organizations (usually theatres or theatre companies) were funded on the basis that subsidy would allow them to take financial risks, the funder guaranteeing that it would subsidize an organization to the tune of the amount of money that the organization might lose. The funding agency would, therefore, step in to balance the books. This principle is now inscribed within most agencies' 'grant conditions'. A grantee will have to prove, at the end of the financial year, that it needed the grant it received in order to break even. This, in effect, acts as a disincentive to earn money, or to spend it economically, since to do so will merely result in loss of grant in the future.

The grant-making process is also limited by the framework of 'negotiation' it is usually modelled upon. The funder and the funded will often bargain with one another, in order to minimize/maximize (depending on which side of the grant application you're on) the amount of money involved. This process is not conducive to careful planning. Because it is run by artistic people, an organization will tend to sacrifice subsidiary rather than artistic resources. It will, for example, place a higher priority upon its budget for production than its budget for publicity, ending up with insufficient resources to market what it produces. It will also be encouraged, in the interests of lowering costs, to cut down the amount of capital investment needed at any one time even if this jeopardizes its future development.

Substituting the 'negotiation' model for a genuine partnership goes hand in hand with a move from a reactive to a proactive approach. The funding agency – perhaps in partnership with other groups –

would develop coherent plans for various cultural sectors. The implementation of these would not be a vague request for grant applications, but a process of development and consultation with venues, projects, organizations, and individuals in meeting the objectives of those plans. This might involve setting up an organization – an independent video marketing agency for example – where nothing previously existed.

These various local difficulties are too numerous and too widespread to be easily patched up. Local authorities and RAAs could, nevertheless, take a number of steps to improve the situation. Local authorities, in particular, could develop their cultural role by creating a department with clearly defined powers throughout the authority, responsible for the cultural aspects of planning, education, housing, and other departmental areas, working in conjunction with those departments. The demarcation between 'bricks and mortar' (such as planning, transport, economic development, and housing) and more 'superstructural' provision (such as education and culture) needs to be broken down. Cultural provision can then reach beyond the confines of the traditional arts and into people's everyday lives.

The grant-making process needs to be adapted accordingly, in order to become more flexible and efficient. This would entail:

1) Incorporating investments and loans into funding practices, in the style of Economic Development Units. This might involve substantial capital investment in buildings and equipment or subsidy that assumes decreasing dependence upon grants and increasing levels of income generation (50 per cent say, in year one, 30 per cent in year two, 15 per cent in year three).

2) Using a proactive rather than a reactive funding policy, based upon specific plans for cultural development.

3) Treating funded organizations as 'cost centres' rather than loss-making ventures using grant aid to balance the books. This means that any profits made by an organization can be invested in its future development (an idea elaborated in LSPU, *No Business Like Show Business*, 1987).

There is, of course, only so much a local authority – particularly one with dwindling resources – can do on its own. Ideally local authorities would form part of a three-tier (national/regional/local) structure, partly resourced by a national cultural development agency. RAAs could become *regional* cultural development agencies,

with responsibility for regional rather than local initiatives. They would also be in a position to help co-ordinate local authority involvement in such initiatives. An organization such as the North East Media Development Council would, for example, be funded solely by the regional agency, while local authorities would take responsibility for local production companies.

Any new cultural strategy is dependent upon structures of funding and regulation, support, and development. If these structures are clumsy or inefficient, then the implementation of a cultural strategy will be difficult and slow.

The administrative upheaval involved in the changes I have briefly outlined would probably meet at least as much resistance as the new cultural policies I have argued for. Bureaucracies are, by definition, conservative creatures, resistant to structural change. Sorting out the bureaucratic structures might not be as exciting as developing new cultural policies, but it is as necessary. A new popular cultural strategy depends upon the structures that will carry it out.

REFERENCES

d'Abreu, Anthony, 'The future of broadcasting', *Broadcast*, 14 August 1987.

Arora, K. and Lewis, J., *Off the Shelf*, London Strategic Policy Unit/Independent Film, Video and Photography Association, 1987.

Arts Council of Great Britain, *Writers and the Arts Council*, Report, 1981.

Baker, B. and Harvey, N. (eds), *Publishing for People*, London Labour Library, 1985.

Barthes, R., *S/Z*, New York: Hill & Wang, 1974.

Barwise, T. and Ehrenberg, A., *Television and its Audience*, London Business School, 1984.

Battram, A. and Segal, S. (eds), *Arts and Unemployment*, CASA/RTI, 1984.

Binch, N., *Towards an ILEA Policy on the Arts*, ILEA, 1987.

Blanchard, S., *Film and Video Distribution and Exhibition in London*, GLC, 1983.

British Market Research Bureau Ltd (Unit 2), *Summary Report of Qualitative Research, October 1983 to May 1985*, 1985.

Chaney, David, 'The department store as a cultural form', *Theory, Culture and Society*, vol. 1, no. 3, 1983.

Comedia research, *A Survey of Arts and Leisure Activities in Islington*, Islington Council, 1987.

Diggle, K., *Guide to Arts Marketing*, London: Rhinegold, 1984.

Docherty, D., Morrison, D., and Tracey, M., *The Last Picture Show*, Broadcasting Research Unit, 1987.

Drummond, P. and Paterson, R. (eds), *Television in Transition*, London: BFI, 1985.

Dungey, J. and Dovy, J., *Videoactive Report*, Videoactive, 1985.

Economist Informatics Ltd, *Radio Broadcasting in the UK*, 1984.

Ehrenberg, A., 'What is the BBC worth?', *New Society*, 14 February 1985.

Ellis, J., *Visible Fictions*, London: Routledge & Kegan Paul, 1982.

Fiske, John, 'Meaningful moments', *Critical Studies in Mass Communication*, vol. 5, 1988.

Garnham, N. and Williams, R., 'Class and culture – the Work of Bourdieu', *Media, Culture and Society*, vol. 2, no. 3, 1980.

159

Greater London Council, *Campaign for a Popular Culture*, 1986.
 The London Industrial Strategy, 1985.
 'Public opinion on the arts in London', Unpublished report, 1983.
Greater London Enterprise Board, *Altered Images*, undated.
Hardy, Phil, *The Book Industry*, GLEB, 1983.
Helm, Deiter, 'The business of art', *New Society*, 20 February 1987.
Higney, C., *et al.*, *Will the Centre Hold?*, Report on arts centres, London
 Association of Arts Centres, 1986.
Hoggart, Richard, *The Uses of Literacy*, Harmondsworth: Penguin,
 1958.
Hutchison, R. and Forrester, S., *Arts Centres in the United Kingdom*,
 Policy Studies Institute, 1987.
Kelly, Owen, *Community, Art and the State*, London: Comedia, 1984.
Landry, C., Morley, D., Southwood, R., and Wright, P., *What a Way to
 Run a Railroad*, London: Comedia, 1985.
Lewis, J., *The Audience for Community Radio*, GLC, 1985.
Lewis, J., Morley, D., and Southwood, R., *Art – Who Needs It?*, London:
 Comedia, 1987.
Local Radio Workshop, *Nothing Local About It*, London: Comedia,
 1983.
London Strategic Policy Unit, *No Business Like Show Business*, 1987.
Macdonald, Irene, *Arts Centres, Education and the Community*, London
 Association of Arts Centres, 1987.
Merseyside Arts, *The Economic Importance of the Arts on Merseyside*,
 1986.
MORI, *Attitudes to Radio Listening in London*, 1982.
Morley, D., *Family Television*, London: Comedia, 1986.
Moss, Linda, *Art for Health's Sake*, Manchester Hospital Arts, 1987.
Mulgan, G. and Worpole, K., *Saturday Night or Sunday Morning*,
 London: Comedia, 1986.
Murals, Thamesdown Community Press, 1986.
Neville-Hadley, Peter, *Making the Most of Marketing*, Parkgate Press,
 1987.
Peacock, Alan, *Report of the Committee on the Financing of the BBC*,
 London: HMSO, 1986.
Perry, R., Noble, P., and Howie, S., *The Economic Influence of the Arts
 and Crafts in Cornwall*, South West Arts, 1987.
Pick, John, *The Theatre Industry*, London: Comedia, 1985.
Power, N., and Lewis, J., *Twenty Years On: a Review of the Independent
 Film and Video Sector in London*, LSPU/IFVPA, 1987.
Radway, Janice, *Reading the Romance*, Chapel Hill, NC: University of
 North Carolina Press, 1984.
Savage, J., 'The BPI Awards', *Observer*, 14 February 1988.
Shaw, P., 'Blurred vision', *National Campaign for the Arts News*, no. 8,
 1987/8.
Sheffield City Council, *The Cultural Industries*, Report, 1988.
Sheffield TV Group, *Cable and Community Programming*, GLC/
 Sheffield City Council, 1983.

REFERENCES

Shelton Trust, *1986 Culture and Democracy Manifesto*, London: Comedia, 1986.

Sketchley, Peter, *Fast Forward or Pause?*, National Youth Bureau, 1985.

Snoddy, R., 'Paying for TV at the checkout', *The Listener*, 14 February 1985.

South East Economic Development Committee, *On the Town*, South East Economic Development Strategy Report, June 1987.

Stewart, Robert, *The Arts: Politics, Power and the Purse*, Report, ACGB, 1987.

Struthers, J., *Glasgow's Miles Better*, Struthers Advertising and Marketing Ltd, 1986.

Townsend, Peter (ed.), *Art Within Reach*, London: Thames & Hudson, 1984.

Twyman, T. *et al.*, *The Psychology of Radio Listening*, Research Bureau Ltd, 1984.

Verway, Peter, *Survey of Arts Attendance in Great Britain*, ACGB, 1986.

Vick, David, 'The use of radio – a research perspective', *Independent Broadcasting*, October 1982.

Worpole, K., *Reading by Numbers*, London: Comedia, 1984.

INDEX